IMAGES
*of America*

# CHALDEANS
# IN DETROIT

IMAGES

*of America*

# CHALDEANS
# IN DETROIT

Jacob Bacall

ARCADIA
PUBLISHING

Published by Arcadia Publishing
Charleston, South Carolina

Library of Congress Control Number: 2014952632

For all general information, please contact Arcadia Publishing:
Telephone 843-853-2070
Fax 843-853-0044
E-mail sales@arcadiapublishing.com
For customer service and orders:
Toll-Free 1-888-313-2665

Visit us on the Internet at www.arcadiapublishing.com

*This book is dedicated to my mother, Najeba Karim Bacall,
who died tragically at age 40. As I grew up, she taught
me to be proud and diligent, to work hard, to have a thirst
for learning, to never give up, and to not be afraid.*

*One hundred percent of the author's proceeds and royalties
of this book will be donated to the Adopt-a-Refugee Family
Program of the Chaldean Federation of America.*

# CONTENTS

# FOREWORD

No story about Detroit can be complete without a discussion of the role, history, and contributions of the Chaldean community. Jacob Bacall has set the record straight in *Chaldeans in Detroit*, filling an important void in Arcadia Publishing's Images of America series. From 6000 BC in ancient Mesopotamia, to the conversion of the Chaldean people to Christianity by St. Thomas the Apostle in the first century AD, to Henry Ford's assembly lines, Bacall uses photographs, interviews, and historical documents to retrace the story of the Chaldean people.

This publication could not be timelier. With successive wars in the traditional homeland of Iraq and the persecution of Christians throughout the Middle East, the Detroit metropolitan area has become the largest and most concentrated center in the civic, religious, and business life of the Chaldean community. This continues today as victims of the Chaldean diaspora continue to land in Detroit both as immigrants and refugees.

While the first documented immigrant arrived in 1905, the first small group of Iraqi Chaldean men sailed the Atlantic Ocean and arrived in Detroit, through the Port of New York, in 1926. Today, with a dozen churches, a 92,000-square-foot community center, an upcoming cultural center, its own chamber of commerce, publications in Arabic and English, a thriving entrepreneurial class, and a burgeoning professional class, Chaldeans in Detroit are an important ingredient in the great American melting pot.

The importance of this book is directly proportional to the rise in influence of the Chaldean community in the civic and social fabric of southeast Michigan. Bacall touches on these topics in his chapters on Chaldean social life, businesses, and organizations and clubs. In Bacall's final chapter, "New Chaldeans of America," the book celebrates the success of the second-, third-, and fourth-generation Chaldeans as the assimilation process continues.

Most importantly, this book will remind future generations of the history, sacrifice, and promise of their parents. God willing, future generations will be inspired to honor Chaldean history and traditions for time immemorial.

—Michael G. Sarafa
President, Bank of Michigan

# ACKNOWLEDGMENTS

First and foremost, I am immensely grateful to this great country the United States of America, not just for granting the freedom to write without censorship, but for embracing me and so many of the unfortunate and helpless people of my community. We now live in peace and enjoy the freedom left by our founding fathers, which is a great gift for each and every proceeding generation.

This book was written for those who have more questions than answers about the Chaldean migration to the United States, specifically Detroit. It is a tribute to the many people who wanted to share their stories through pictures, and it would not have been possible without the contributions of many die-hard Chaldeans. I wrote this book to add to and enrich what has already been published locally and abroad. I would like to express my sincere gratitude to those who have taken the time to be interviewed and graciously shared photographs, documents, and artifacts that portray the stories of their ancestors. Some material in this book may have appeared in other publications, including church bulletins, Bryon Perry's *The Chaldeans*, and the Chaldean Federation of America booklet, all of which are acknowledged with gratitude.

The completion of this book can be attributed to many people, starting with Martin Manna, Eric Younan, and Joyce Wiswell for taking the time to read and critique early drafts, and Oak Park mayor Gerald Naftaly for his encouragement and support. A special thanks to Nadia Kallabat and Lubna Seba of St. Thomas Chaldean Catholic Diocese; Showki Konja and Fawzi Dalli, hosts of the *Chaldean Voice*; Saher Yaldo, a devoted and good-hearted volunteer; and Jane Shallal and Clair Konja of the Chaldean American Ladies of Charity. To all of my friends at Shenandoah Country Club who understood my absence on Tuesday evenings and love me regardless, thank you.

I also wish to thank Fr. Wisam Matti, Mary Romaya, Nadine Rabban, Deacon Khairy Foumia, my dear friend Burt Kassab, and attorney Steven Samona. Additionally, I would like to recognize the late Dr. Mary Sengstock for her comments and insight and for allowing me to interview her.

I am forever grateful to my family, especially my wife, Anne, for her patience; my daughter Christina, for continued love and support; and Avita, my daughter-in-law, for her knowledgeable input. Most importantly, my loving gratitude goes to my daughter Caroline for her hard work, her strong will, and for being awake long after most people have gone to bed. I am grateful to so many other people; if I have forgotten some, please forgive me.

# INTRODUCTION

Over the past few decades, I have enjoyed the hobby of frequently writing about local issues and events in community publications. This book project was more of a search through the history of Chaldeans in America and Detroit. I had the urge to record and document the lost and forgotten historical facts to add to other publications out there, and maybe many others to come, to discuss past events and tell the fascinating history of characters and major ongoing stories. Many of the old and memorable tales were passed along by word of mouth from one generation to the next. Many of the images in this book have a unique story to tell as they take the reader on a historical journey. The past is the most important heritage we have, and we have the responsibility to preserve it.

This book is dedicated to those who are interested in the history of their ancestors who lived back in the old country of Mesopotamia, the cradle of civilization. It is today called Iraq, a name derived from the ancient city of Uruk. I share this book with those seeking knowledge about a small community that immigrated to the Detroit area around 1900 called the Chaldeans: descendants of the original inhabitants of Mesopotamia. These Iraqi Christians, who are affiliated with the Catholic Church of Rome, have their own patriarchs known as the Chaldean patriarchs of Babylon.

Mesopotamia was the center of early civilization, where the earliest scripts, writing tablets, architecture, and early breakthroughs in astrology emerged. Iraq was, and continues to be, the most turbulent spot in the world.

Chaldeans living before the Christian era believed in many gods: the God of Sun, the God of Wind, the God of Rain, and the Chief God. In Chaldean mythology, men were created to serve the gods and to die because the gods retained life for their own keeping.

The Chaldeans were among the first Christians converted by the Apostle Thomas in the first century AD, and they retained their faith even after the Arab armies invaded the land that would one day be Iraq in the year 634 AD. As recently as the early 20th century, many Europeans still referred to Iraq as Mesopotamia or Chaldea. "Aside from Israel, the Bible contains more references to the cities, regions, and nations of ancient Iraq than any other country in existence," stated US congressman of Virginia, Frank Wolf.

Aramaic, the language spoken by Jesus Christ, remained as the language of the common people until the conquest of the Muslims in the seventh century AD. The Muslims introduced the Arabic language to the Near East. The Christians of Mesopotamia (Iraq), Iran, Syria, Turkey, and Lebanon kept the Aramaic language alive domestically, scholastically, and liturgically. Despite pressure from the ruling Muslims to speak Arabic, Aramaic is still spoken today in many dialects, especially by Chaldeans and Assyrians.

No one knows for sure whom the first Chaldean was to immigrate to the United States. Many names have been put forward as the first to reach the new world of America, as well as Canada,

Mexico, and Argentina, but none have any proof or evidence to back up that claim. The oldest documented entry of record is George Bino, who in July 1905 made his lawful entry in New York. Daisy Kory was the first Chaldean on record to be born in America, in 1917. Eddie Najor was the first Chaldean to be born in Detroit, in 1921.

The vast majority of Chaldeans came from a small village called Telkaif, less than a 10-minute drive from the ancient city of Nineveh. Others followed decades later from other smaller northern villages, such as Alkosh, Araden, Baqofa, and Batnaya. Most were peasants working their small piece of land on the outskirts of the village, selling their crops as means to support themselves and their families.

In 1913, when Henry Ford started his wage revolution by offering a $5 a day (more than doubling the wage at the time), a small, scattered group of Chaldeans in America and Canada rushed to his factory, and the migration to Detroit began. It was the start of the "Kaypha de Shimeon," which means "Rock of Simon" in Aramaic. The Chaldeans, being hard workers and dedicated to their jobs, succeeded in their enterprise. Others followed their lead. New arrivals would learn the trade and eventually open their own businesses. Thus, an occupational pattern was established.

Sam Dabish interviewed Zia Acho and Jajo Kas-Marougi, each claiming to be the first Chaldean to set foot in the city of Detroit in either 1912 or 1913. After more than a decade, they found they had arrived in Detroit a day apart. This was confirmed by some of their Maronite friends living in Detroit, who acknowledged that both men had been seen mingling with some of their community members within days of each other, so it is obvious that both arrived as single men, by train, a day apart.

Today, Chaldean Americans have embraced the mainstream society of the United States while retaining the rich culture heritage of their ancestors. It is paramount that we never forget the contributions of our people. Their achievements should serve as an inspiration to all of us to make positive contributions to our society today.

In America, families now live in nuclear households, but they still frequently socialize with extended family members to celebrate happy occasions together, and they provide emotional and financial support in times of need. Couples today choose their own spouses, but families still play a role in recommending and screening potential spouses.

A big part of the social life of Chaldeans is what that brings any family together: food. There are fascinating differences among cultures in the varieties of food. The Chaldean kitchen was founded on what are called the "seven species" in Deuteronomy 8:8: wheat, barley, grapes, figs, olives, pomegranate, and dates.

Chaldeans have owned and operated businesses of all kinds in Detroit since the 1930s. A considerable number of Chaldean businesses remain in Detroit today, mainly owning and operating grocery store businesses. Tobia Kas-Gorgis (Tom Kory) was the first Chaldean to purchase a small grocery store, on Brush and Vernor Streets, in the late 1910s or early 1920s, according to Sam Dabish. Despite the growing success of Chaldeans in Detroit, we will not forget those who lost their lives at their place of work while trying to earn a living and never to be seen again by their family.

As Chaldean immigrant families continued to increase year after year, there was a need to congregate in a designated area. Many Chaldean organizations and clubs have formed since the 1930s in Detroit and its surrounding areas. Among them are the Chaldean Iraqi Association of Michigan (1937), the Chaldean American Youth Club (1954), the Chaldean American Ladies of Charity (1961), and the Chaldean Federation of America (1980).

The first and second generations of American-born Chaldeans have had a greater pursuit of higher education than their elders. Chaldeans born and raised in America have been encouraged to branch out from store ownership and pursue stable professions such as law, engineering, education, medicine, construction, and real estate development.

Today's Chaldeans take advantage of the opportunities in America by achieving a much higher level of academic success, which any person can admire and respect.

# One

# THE CHALDEANS

The Chaldeans are the descendants of the ancient inhabitants of Mesopotamia. They stem from one of the ancient groups that inhabited the land presently known as Iraq. In ancient times, this area was called Mesopotamia, "the land between two rivers," and many tribes desired to inhabit the so-called Fertile Crescent. Since the time of the Sumerians, Akkadians, Assyrians, and Chaldeans, it has been a land of many firsts and enormous contributions to civilization.

These contributions include the world's first empire, where the Gilgamesh epic unfolded, where the Towers of Babylon were constructed, where Abraham originated in Ur of the Chaldee, where Hammurabi developed the first code of laws, and where the Chaldean king Nebuchadnezzar built the famous Hanging Gardens of Babylon, one of the seven wonders of the ancient world. Other contributions include the discovery of the wheel, the use of bronze weapons, horse-drawn chariots, highly developed irrigation systems and aqueducts (long before the Roman Empire), a sophisticated culture in art, music, architecture, philosophy, and literature, an advanced math system using zero and a decimal point, time instruments, a calendar, astronomy, medicine, the world's first libraries, hospitals, commerce, and record-keeping systems, and an alphabet and language, Aramaic, which became the lingua franca (bridge language) of the ancient world.

The Chaldeans, Catholics from Iraq, are a unique immigrant group that has been emerging in the Metropolitan Detroit area. They came to America for the same reasons as other immigrant groups: in search of better economic, religious, and political freedom and opportunities. In the beginning of the 20th century, the Chaldeans began immigrating to America. Over many decades of political and economic unrest in Iraq and with the new immigrant laws of 1965, more and more Chaldeans settled in the Greater Detroit area—and continue to come. Today, there are approximately 150,000 Chaldeans in the Detroit area and another 50,000 scattered in California, Illinois, Arizona, and other areas of the United States.

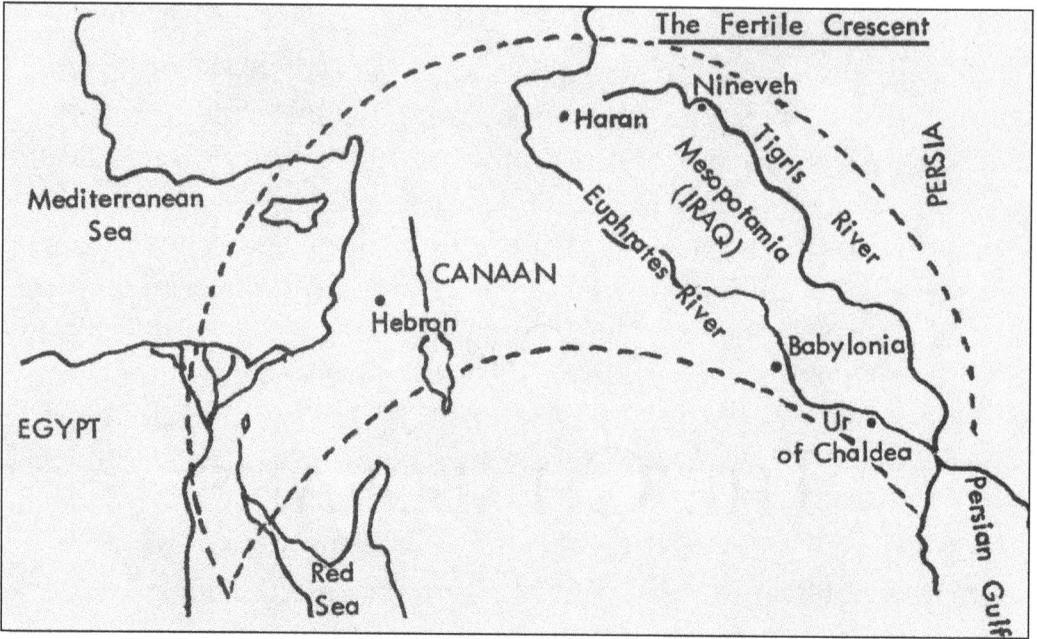

**THE HEART OF FERTILE LAND.** The Fertile Crescent is a region that arches over the deserts of what are now eastern Jordan, Jerusalem, Iraq, Iran, and Saudi Arabia. On the northeastern end of the crescent is Mesopotamia, once home to several biblical kingdoms. "Mesopotamia, with its traditions and values, is a land of pure souls, free spirits, and true believers," said Maria Theresa Asmar, author of *Memoirs of a Babylonian Princess*. Mesopotamia, watered by the Tigris and Euphrates Rivers, was fertile land. It was a major regional source for barley, sesame, linseed oil, flax, and wheat. Southern Mesopotamia also specialized in dates and fish. (Courtesy of Louis Stephen and Nabby Yono.)

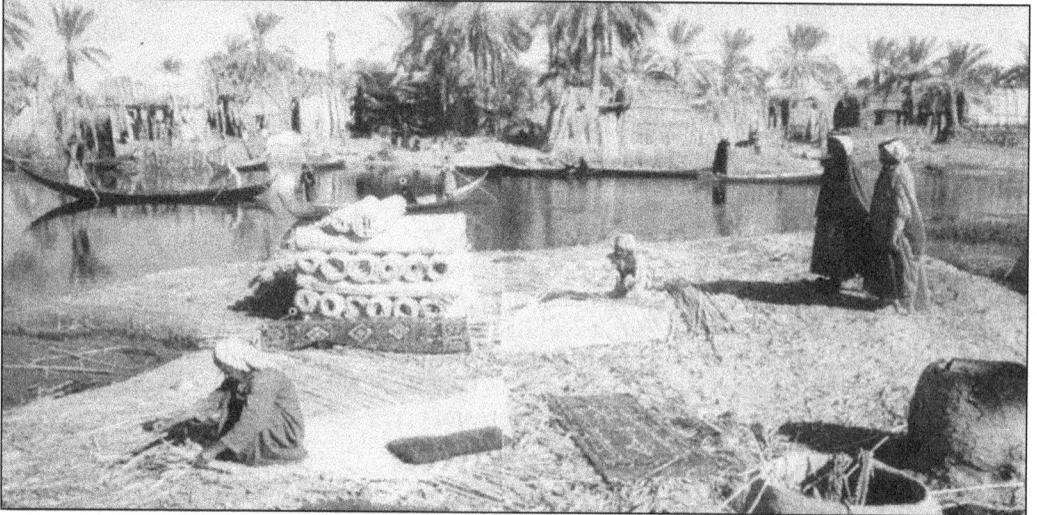

**TRADE MASTERS.** The earliest settlements in southern Babylonia were small villages in areas near lakes, swamps, or small streams fed from the Euphrates. The Marsh Arabs still exist today, just as the Babylonians did thousands of years before them. They survive by fishing, collecting edible plants, and raising water buffalo for their milk. Chaldeans played an important role in trade with regions adjacent to the Persian Gulf. They had a tradition of being experienced traders before their arrival in south Babylonia. (Courtesy of Al-Ekha'a Press House.)

THE EPIC OF GILGAMESH. Gilgamesh is an ancient story from Iraq, created on a dozen clay tablets in the ruins of Nineveh, near Mosul in northern Iraq. Gilgamesh was the most famous hero of the Sumerians, an ancient king of Mesopotamia. Western literature began with the Babylonian poem of Gilgamesh and his quest to find the secret of immortality. (Courtesy of Sabah Wazi.)

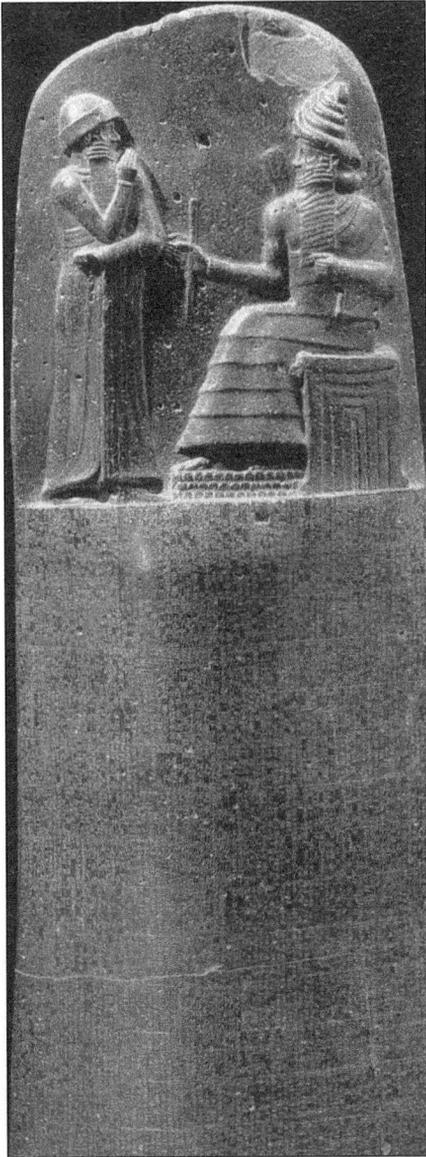

FIRST CODE OF LAW EVER. King Hammurabi of the Babylonians (1792–1750 BC) is remembered for his establishment of law, the Code of Hammurabi. The code contains 282 laws, addressing commercial trade, marriage and divorce, labor, and personal injury, including "eye for an eye" punishment. The king was known as the protector of the defenseless. The code, which has survived on a high basalt stele, is now housed at the Louvre in Paris. (Courtesy of Louis Stephen and Nabby Yono.)

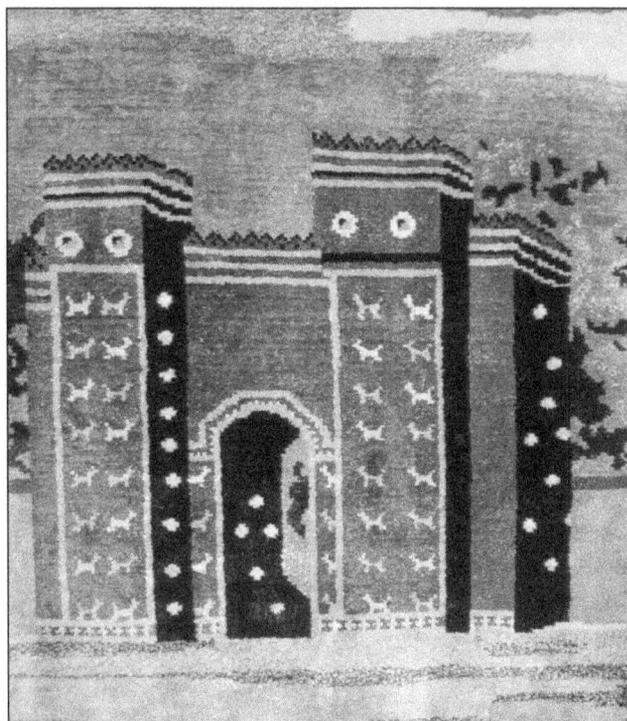

GATEWAY OF THE GODS. Babylon was rectangular in shape and had a double wall built around it for protection. There were eight gateways into the city, and a god or goddess protected each one. The most famous and beautiful gate was the Gate of Ishtar, which was dedicated to Ishtar, the goddess of love and war with its ornate bulls, dragons, and bright blue glazed tiles. The Ishtar Gate gives the impression of what the city would have looked like. Everything that is expensive, lavish, and precious was brought to the city of Babylon at the height of its power. (Author's collection.)

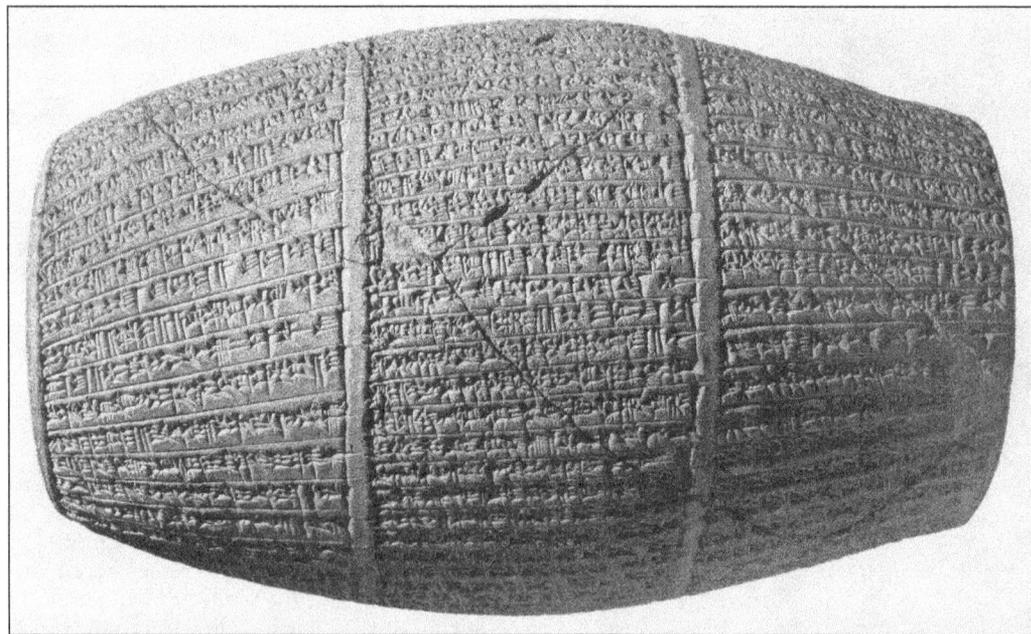

ANCIENT WRITING TABLETS. Hundreds of baked clay cylinders were found with long, cuneiform inscriptions of Nabonidus (555–539 BC) in Nineveh, Iraq. Nabonidus recorded his famous dream concerning the restoration of the temple of the moon god in Harran. Many clay tablets were used as a form of record keeping for dealing with everyday life. Clay cylinders were often the size of a modern smart phone, so they could conveniently be held in one hand. (Courtesy of Louis Stephen and Nabby Yono.)

THE COURAGEOUS MARIA. Maria Theresa Asmar was born in 1804 in the Chaldean village of Telkaif, Iraq, the daughter of a wealthy and noble man, Emir Abdallah Asmar. Maria was talented, smart, observant, and above all very brave. She is the most influential woman in modern Chaldean history. Maria traveled abroad on her own and met many distinguished European leaders. "She received me very graciously, and manifested a deep interest in my welfare," said Maria Theresa Asmar of Queen Victoria upon meeting her. (Author's Collection.)

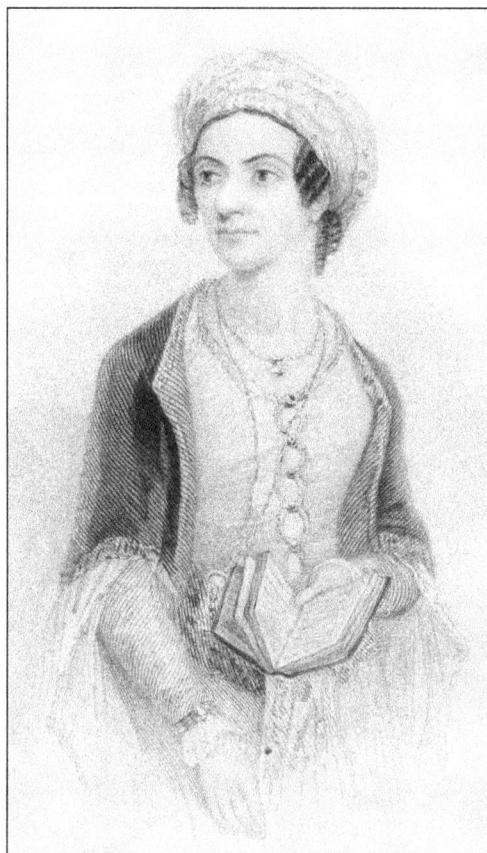

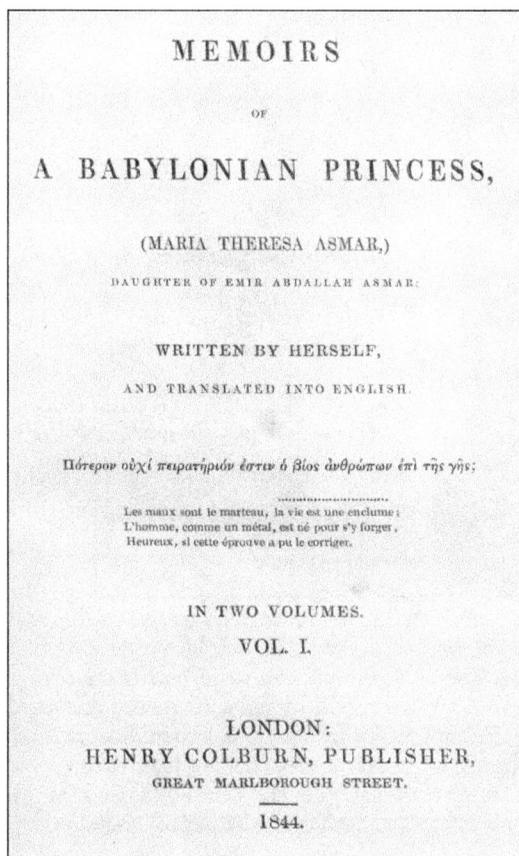

MEMOIRS

OF

A BABYLONIAN PRINCESS,

(MARIA THERESA ASMAR,)

DAUGHTER OF EMIR ABDALLAH ASMAR;

WRITTEN BY HERSELF,

AND TRANSLATED INTO ENGLISH.

Πότερον οὐχὶ πειρατήριόν ἐστιν ὁ βίος ἀνθρώπων ἐπὶ τῆς γῆς;

Les maux sont le marteau, la vie est une enclume ;
L'homme, comme un métal, est né pour s'y forger,
Heureux, si cette épreuve a pu le corriger.

IN TWO VOLUMES.

VOL. I.

LONDON:
HENRY COLBURN, PUBLISHER,
GREAT MARLBOROUGH STREET.

1844.

LOST VALUED TREASURES. Two volumes of *Memoirs of a Babylonian Princess* were written by Maria Theresa Asmar and published in 1844 by Henry Colburn Publishing in London, both describing the social affairs and culture of Mesopotamia. Maria intricately explained the suffering of Christians at that time under the brutal ruling of the Ottoman Empire. (Author's Collection.)

**IRAQ'S RELIGIOUS REGIONS**

MUSLIM REGIONS
- Predominantly Arab Shiite
- Predominantly Arab Sunni
- Predominately Kurdish Sunni and Shiite

CHRISTIAN TOWNS
Alquosh
Telkaif
Ankawa

ARMENIA

AZERBAIJAN

TURKEY

DUHOK
✝ Alqosh
✝ Telkaif
MOSUL  ✝ Hamdaniya
✝ Ankawa
ARBIL

IRAN

SYRIA

TIGRIS

BAGHDAD

IRAQ

EUPHRATES

JORDAN

DUHOK  ✝ Aradan
✝ Alqosh
✝ Telskuf
✝ Bagofah
✝ Batnaya
✝ TELKAIF
✝ Bartella
MOSUL  ✝ HAMDANIYA
(NINEVA)  ✝ ANKAWA
ARBIL

KUWAIT

SAUDI ARABIA

TIGR

**THE CHRISTIANS OF IRAQ.** For more than 6,000 years, Chaldeans have lived in the traditional geographic land of Mesopotamia, known today as the nation of Iraq. It is the place of origin of all Chaldeans in the world, including in Turkey, Iran, the Gulf States, and neighboring countries. "The early Christians of Mesopotamia were Jews who worshipped in the synagogues and read the Hebrew Bible as their Holy Book," wrote Dr. Suha Rassam in her book *Christianity in Iraq*. Christians have been consistently marginalized in Iraq, a war-torn country that has taken a dramatic turn towards fundamentalism. Today, Chaldeans are scattered all over the world as a result of the ethnic cleansing of Christians and non-Muslim minorities; nonetheless, their roots remain deep in Iraq. (Art by Alex Lumelsky.)

VILLAGE OF ORIGIN. Telkaif, or Telkeppa, is located eight miles northeast of the ancient city of Nineveh (Mosul) in northern Iraq. Telkaif was the largest Christian village in the area. Early Chaldean immigrants to America link their roots to Telkaif. It reached a population of 20,000 Chaldean inhabitants in the 1800s. Telkaif had been neglected and humiliated throughout the ages, and its people suffered religious discrimination and lawless executions. As a result of wars and religious and political instability, less than 100 Chaldeans live in Telkaif today. (Courtesy of Zuhair Shaaouni.)

SIGN OF PRIDE AND HONOR. This photograph was taken in 1929 in the village of Telkaif. Jajo Sarafa is holding a sign in Arabic that reads, "Deacon Jajo Sarafa," proudly showing his ability to read and write in two languages: Arabic (the official language of Iraq) and Aramaic (the mother tongue language of Chaldeans). About 90 percent of people in Iraqi villages were illiterate. Pictured from left to right are Sarah Sarafa, Salim Sarafa (standing in back), Karim Sarafa (standing in front) and Deacon Jajo Sarafa. (Courtesy of Anmar Sarafa.)

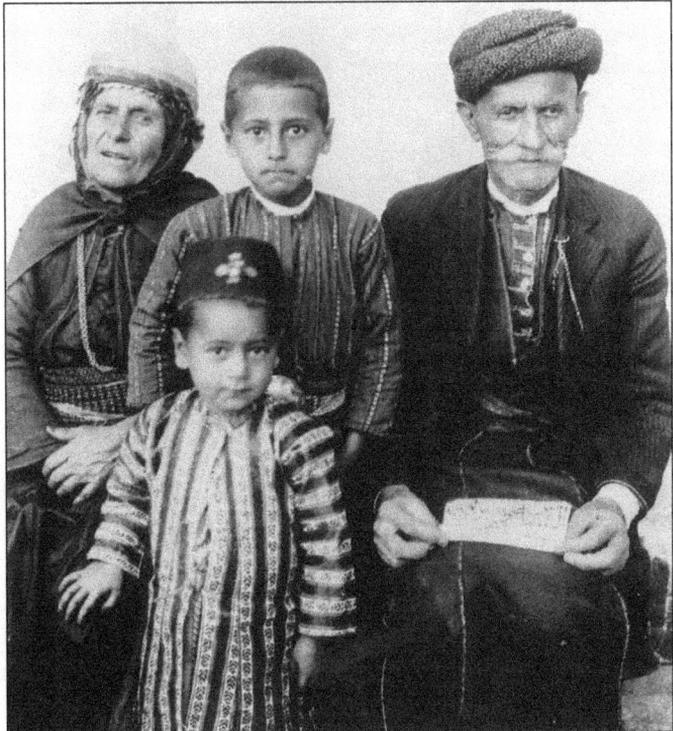

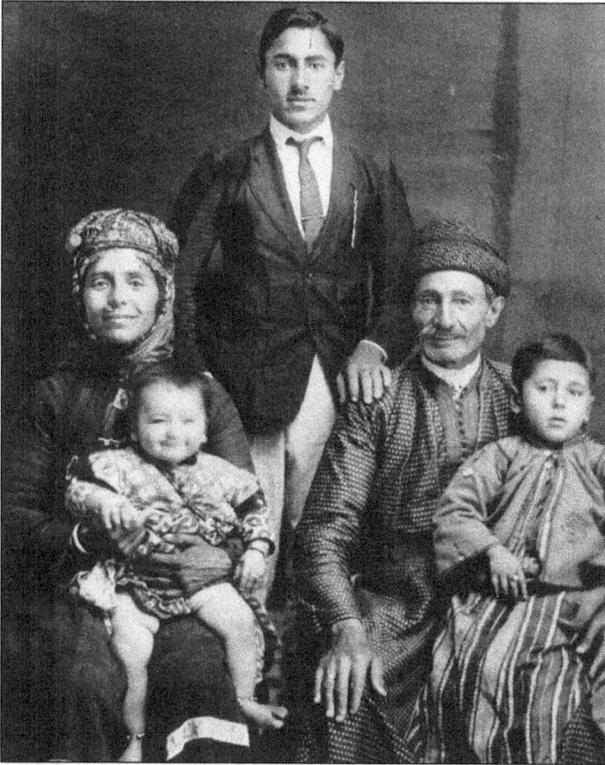

**SIBLING AGE GAPS.** This family photograph was taken in 1926 in the village of Telkaif. Yousif and Zarefa Sarafa are with their children Naim (1906–2002), Salim (1921–2000), sitting in his father's lap, and Karim (1925–2014), sitting in his mother's lap. Their daughter Rajo (1910–1985) is not pictured. The large age gap between siblings Rajo and Salim is over 10 years. Their father, Yousif, was picked to serve in the "gendarmes" (Ottoman army); he was gone for about 10 years serving in World War I without a word of his fate. (Courtesy of Anmar Sarafa.)

**WOMEN OF POWER.** Chaldean women enjoyed a higher position in society. Some tribes and cultures considered women as property, to be owned and treated as slaves, but Chaldean women of Babylonian times had legal and economic rights; they also entered the trades and professions and even became priestesses. A profession for a woman (self-independence) means not only self-support but to have a say in things that matter to her. (Courtesy of Julia Najor Hallahan.)

**ARAK IS IT.** Straight up, right from the bottle: it is the Telkaifee way of a "toast" to celebrate the wedding of a newly married couple, as seen here at the wedding of Mr. and Mrs. Gorgis Dallo in 1953. All invitees are allowed to drink; there is no age limit. Similar to moonshine liquor, arak is known to Iraqis as the "milk of the grown-ups," and it is usually made by locals of the village of Telkaif in the *bekarae* (basement). (Courtesy of Julia Najor Hallahan.)

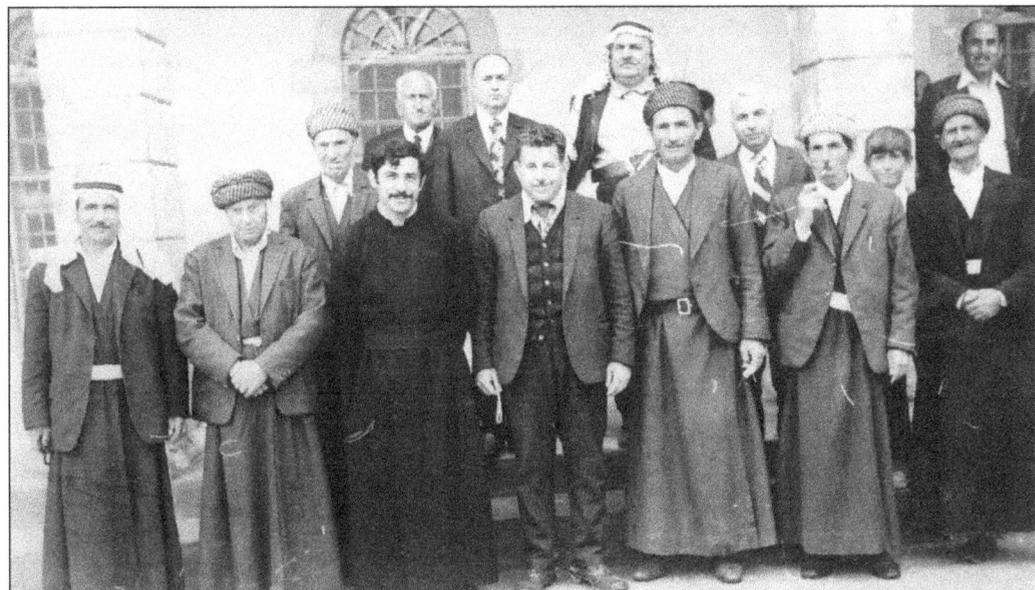

**LIFE IN THE VILLAGE.** The people of Telkaif were devoted to church and family. People walked to church every Sunday and after Mass dropped by the market to buy meat, vegetables, fresh eggs, yogurt, honey, and fresh *samoon* (an Iraqi baguette) and then returned home with a full *alaka* (basket). Seen in this 1969 photograph are, from left to right, Zia Kasgorgis, Shaker Kizy, Karim Kinnaya, Fr. Manuel Boji, Deacon Hanna Bashi, Jamil Butti, Daniel Jiddo, Salim Kirma, Yousif Bizzi, Rahim Shayota, Zia Summa (smoking a cigarette) and Mikha Jiddo (crossing hands); the young boy and man to the far back right are unidentified. (Courtesy of Samir and Bernadette Bashi.)

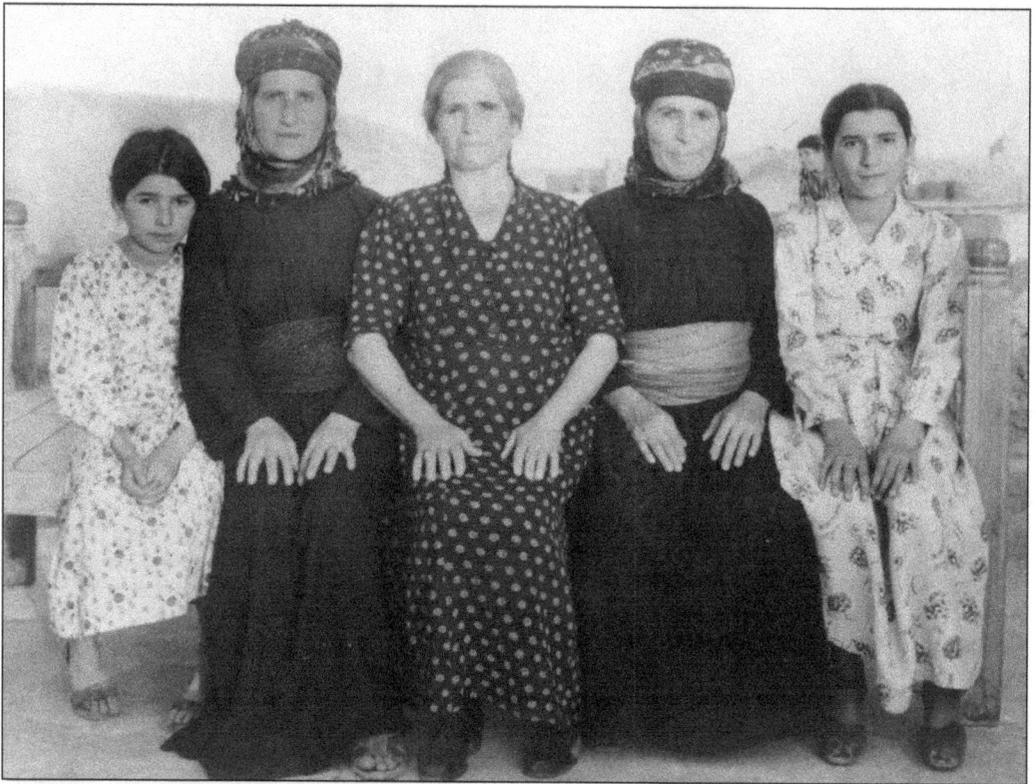

**EYES ON THE CAMERA.** Women from the Christian village of Telkaif wore traditional dress in the 1950s. The younger women, like the pair on the far left and right of this image, did not wear the traditional *kuchma*, or headdress, which was a custom in Chaldean villages. One custom that was passed down from mother to daughter was the duties of a homemaker. All young girls were taught at a very early age how to cook, clean, and help their future husband in the field. (Courtesy of Tobia Hakim archives.)

**ARRANGED MARRIAGE.** This photograph was taken in Telkaif in 1935, when Norma Dalaly was 10 years old. She is standing on the right, holding her younger brother. Norma was promised to be married to Karim Hakim by her parents, as it was a common custom at the time to marry within the family circle. At age 12, Norma married Karim, and the two moved to America. Norma Dalaly Hakim currently lives in Southfield and is 86 years old. (Courtesy of Tobia Hakim archives.)

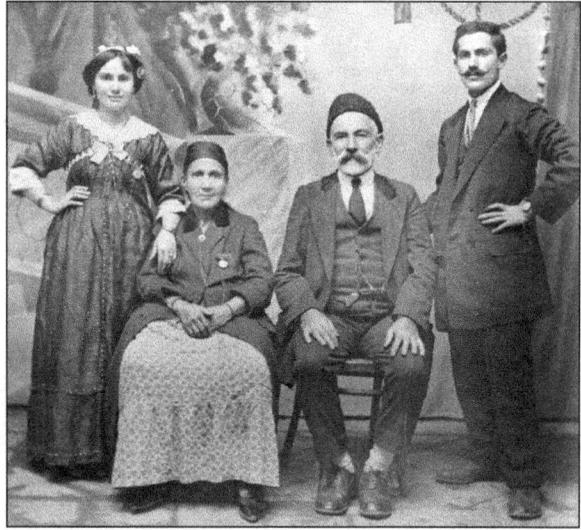

EAST MEETS WEST. The changes in generations from father to son or mother to daughter can be very different depending on various factors, such as the place of upbringing, age, surroundings, and life-changing events. It is obvious to see the differences in how this Chaldean family dressed and how they looked (from the village of Ankawa) in this 1908 photograph. The clothing style represents two different eras and reflects Baghdad society at that time: traditional Ottoman attire worn by the older seated couple, Yousif and Mariam Shaya, and Western attire worn by their adult children standing on either side. (Courtesy of Tobia Hakim archives.)

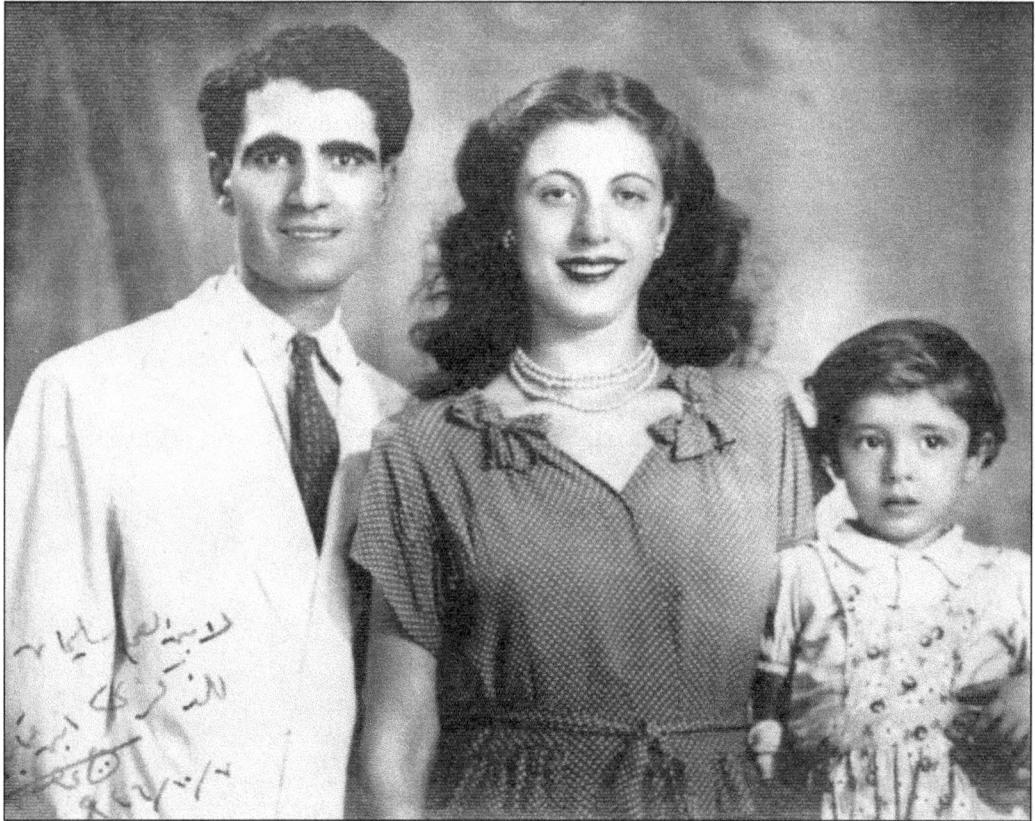

ART PIONEER OF IRAQ. Issa Hanna Dabish was a notable pioneer artist, born in 1919. At age 12, he began to use chalk, pen, and ink to draw well-known figures in his hometown. Dabish was a colleague of Jawad Salim and Faiq Hassain, two leaders of Baghdad's modern art movement. Dabish became the lifetime honorary chairman of the Iraqi Artist Association (IAA) and was a founding member of Baghdad's first officially recognized artist group, the Friends of Art Society, in 1940. This is a 1946 photograph of Dabish with his wife, Helen, and son Khaldoun. (Courtesy of Mary Dabish.)

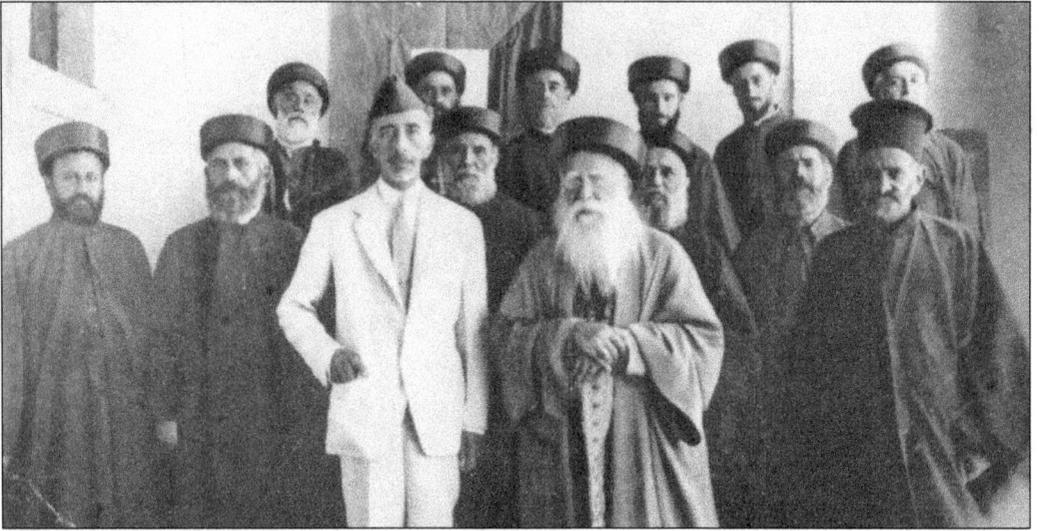

**KING TO SERVE ALL PEOPLE.** After the inauguration of King Faisal I on August 23, 1921, Iraqi Christians were set free for the first time from paying *jizia*, a tax that had been imposed on non-Muslims (Christians and Jews) since the Islamic conquests of Iraq in the mid-seventh century. Under King Faisal I, non-Muslims were able to build churches, synagogues, and religious schools. King Faisal is in a white suit, with Chaldean patriarch Mar Emmanuel II Thomas (standing next to King Faisal) and other priests. This photograph was taken in 1931 at Mar Oraha Monastery in northern Nineveh. (Courtesy of Julia Najor Hallahan.)

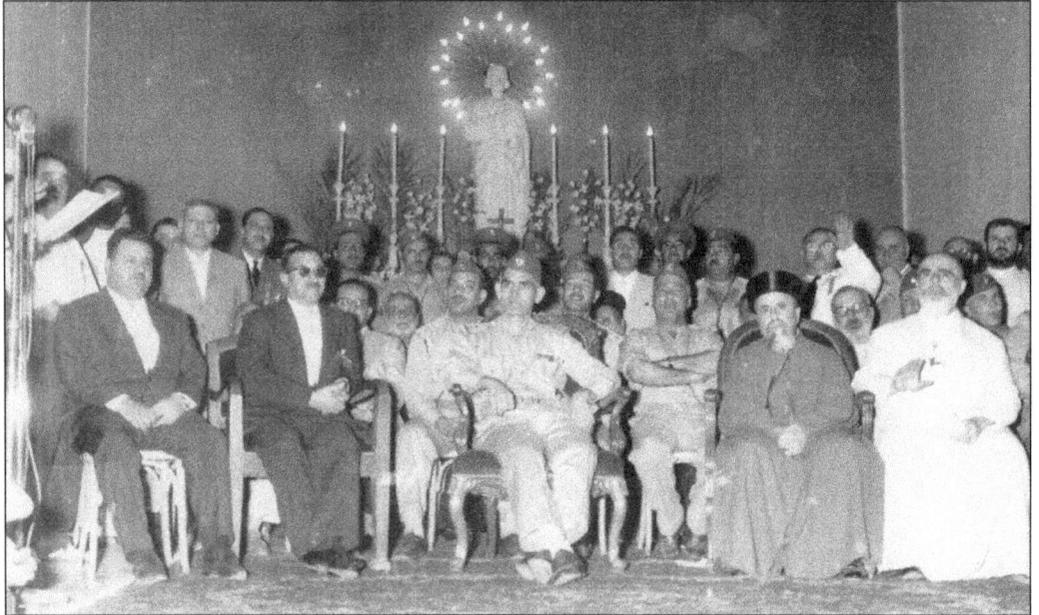

**RELIGIOUS EQUALITY.** After the July 14, 1958, revolution in Iraq, major changes took place, most notably the change from a kingdom to republic, with the abolition of the monarchy. In this photograph, Gen. Abdul Kareem Kassem (in military attire) sits next to the Chaldean patriarch of Babylon, Mar Paul II Cheikho (in black hat), observing one of the Christian holidays in Baghdad. General Kassem assured the spiritual leader by saying, "All Iraqi citizens are equal in rights and duties." (Courtesy of Eddie Bacall.)

# Two

# RELIGION AND LANGUAGE

Christianity flourished in Mesopotamia among the descendants of the two great and ancient nations of Chaldea and Assyria in the third quarter of the first century AD.

By the end of the fifth century, the Eastern Church in Mesopotamia succumbed to Nestorianism, which stressed independence of the divine and the human natures of Christ, in effect suggesting that they were really two persons loosely united by a moral union (there was Christ the man and God the son as a sort of divine counterpart). Nestorianism had already been condemned by the Catholic Church at the Council of Ephesus in 431 AD.

Chaldeans were converted to Christianity by St. Thomas the Apostle and his disciples Mar Addai and Mar Mari in the first century AD. Presently, Chaldeans belong to the Eastern Rite of the Roman Catholic Church.

In May 2002, an apostolic decree was issued to divide the diocese into two: the Diocese of St. Thomas, in the eastern part of the United States of America, and the Diocese of St. Peter, in the western part of America. The Diocese of St. Thomas, as of the end of 2012, includes:

| Diocese | Faithful | Clergy | Churches | Parishes |
|---------|----------|--------|----------|----------|
| St. Thomas | 150,000 | 21+1 Bishop | 9 | 10 |

Chaldeans speak Aramaic, the language of ancient Babylon, which was used by Jesus Christ and is the oldest language continually spoken in the world. The Chaldeans of today still speak the Aramaic (Chaldean, also called Sourath) language, which is an important aspect of Chaldean identity. Classic Aramaic is used in the Chaldean liturgy. The vernacular Aramaic Chaldean is used at home and in daily life. Aramaic has an alphabet of 22 letters and is the mother tongue from which Hebrew and Arabic were later derived. Chaldeans educated in Iraq also speak and read Arabic. Many Chaldeans are trilingual, understanding Chaldean, Arabic, and English. A number of families also speak Spanish, having settled in Mexico before their immigration to the United States.

The Chaldeans joined the Vatican and accepted the authority of Pope Julius III in 1552, led by patriarch John Sulaka. It recognizes the authority of the Pope, but it retains its own rites.

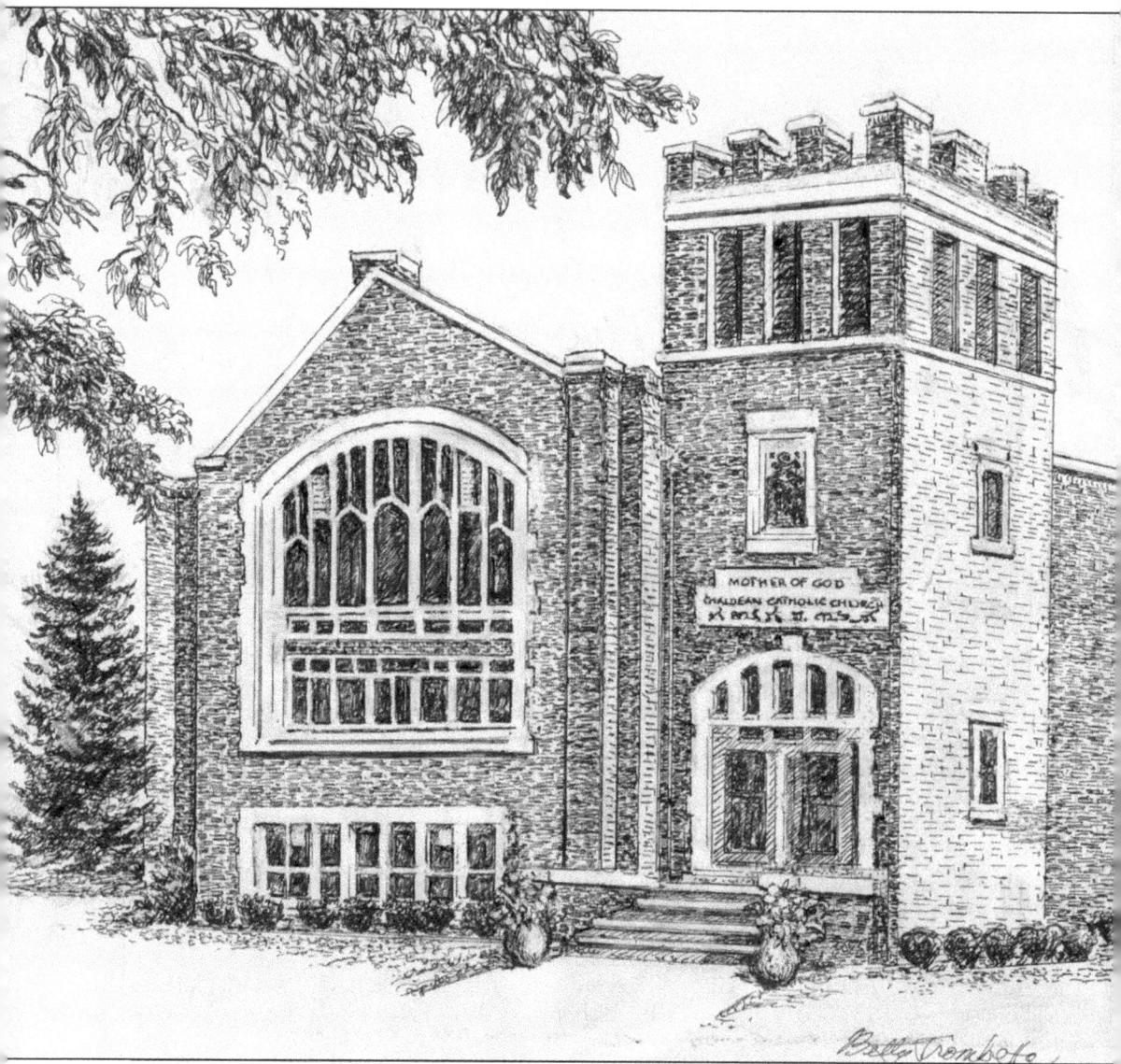

**MOTHER OF GOD.** On January 15, 1948, Detroit became home to the first Chaldean Catholic church in Michigan, and only the second in the United States after St. Ephrem Parish in Chicago, in 1904. The small Chaldean community, about 80 families at the time, finally had a sacred place of worship. "Identification with the Chaldean religion and language remains strong, even among those who no longer speak the ancestral language," said Dr. Mary Sengstock, professor of sociology at Wayne State University. Located at the corner of Euclid and Hamilton Avenues, Fr. Toma Bidawid named the church Mother of God on August 15, 1948. As the Chaldean community has grown in the United States, particularly in the Detroit area, there has been a need to build more churches for the Chaldean- and Arabic-speaking worshippers. At the end of 2013, in Michigan alone, there were 11 churches and 24 priests serving over 150,000 Chaldeans in the greater metropolitan area. (Art by Betty Trombetta.)

YOUR PRAYERS HAVE BEEN ANSWERED. Fr. Toma Bidawid, the first Chaldean priest in Detroit, who arrived on February 24, 1947, established the first Chaldean parish in Detroit. He was the only priest who served in both churches: the first Chaldean Catholic church in Detroit (1947–1952) and the first Chaldean Assyrian church, established in 1904, St. Ephrem in Chicago (1952–1966). Father Bidawid had a great voice and managed to keep the faith of Chaldean worshippers alive. He was elected Bishop of Ahwaz, Iran, in 1966 and was then asked to serve in Cairo, Egypt, where he died and was buried. (Courtesy of Peter and Samira Essa.)

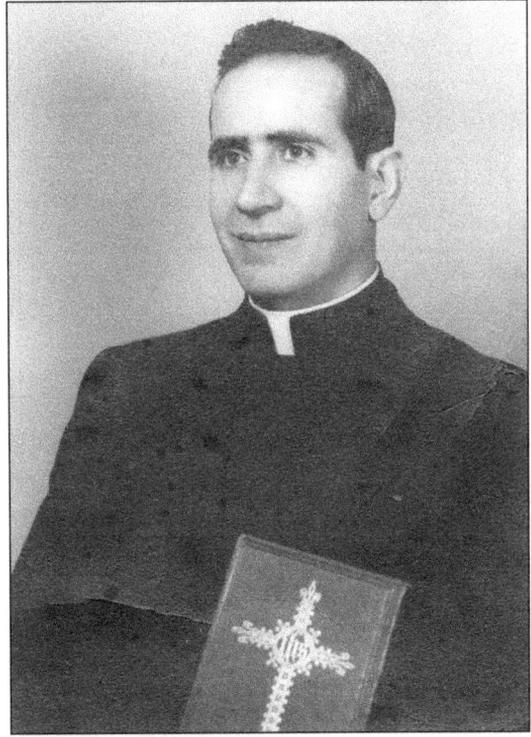

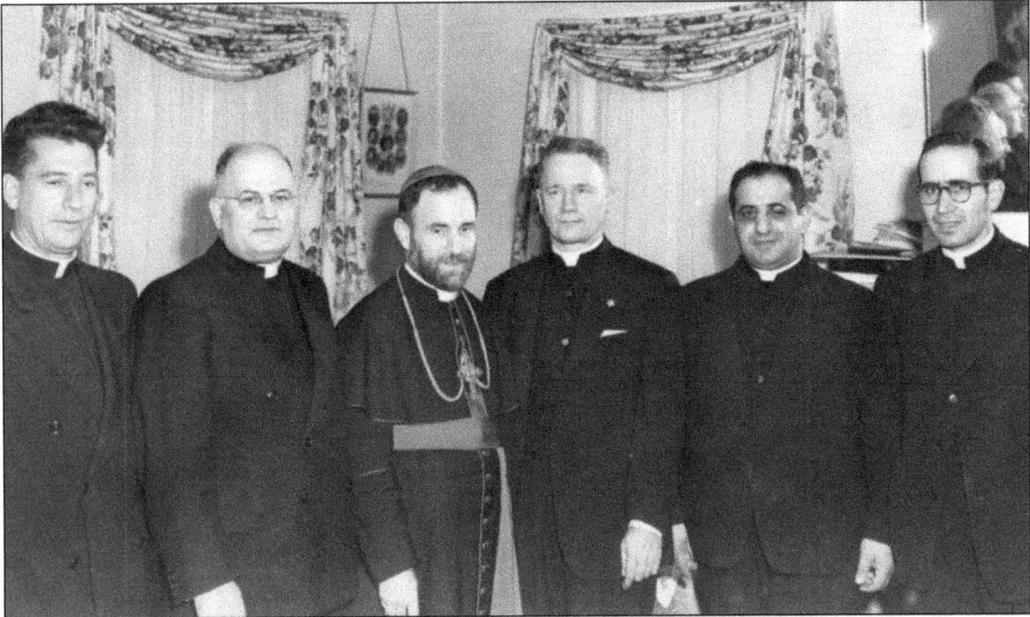

COMMUNITY-SERVING PRIESTS. Early Chaldean worshippers used to celebrate their Mass at a Maronite Lebanese church in Detroit, decades before the establishment of the first Chaldean church. Msgr. Mikhael Abdo (second from right) was known to be the "faithful friend and guiding father of the small Chaldean community," said Sam Dabish, author of *The History of the Iraqi Community in America*. Local priests are seen here at Tobia Hakim's house in October 1950. (Courtesy of Tobia Hakim archives.)

"SHINO DENICK?" OR "WHAT IS YOUR RELIGION?" In most Muslim countries, individuals are identified by their religion before they are identified by their country of birth. But, in the United States, it is illegal and discriminatory to ask for or demand documentation of a person's religion. In Iraq, the official personal identification, or driver's license, required disclosure of religion among general particulars such as full name, date of birth, height, and eye color. Pictured here is Aziz M. Najor's certificate of Iraqian nationality. (Courtesy of Julia Najor Hallahan.)

GENERAL PARTICULARS. Line 13 asks for "Religion" of the individual, and Christians and Jews, being non-Muslims, may have felt offended and discriminated against. "Indeed, the discomfort they felt living in a predominately Muslim world is often mentioned by Chaldeans as a major impetus for emigrating," said Wayne State University professor Dr. Mary Sengstock. Iraq is predominately Muslim and the official state religion is Islam. (Courtesy of Julia Najor Hallahan.)

ANCIENT LANGUAGE. "*Lishana aramaya*," which means "Aramaic language," the language spoken by Jesus Christ, is still used in most Chaldean homes today. Aramaic is the language of ancient Babylon and is also the mother tongue from which Hebrew and Arabic were later derived. The language has an alphabet of 22 letters and is written and read from right to left. Aramaic is sometimes referred to as Sourath. (Courtesy of St. Thomas Chaldean Church.)

People: Baban dy-leh bish-may-ya, pa-yish mqudh-sha shim-mukh, ath-ya malkuthukh, hawe ij-bo-nukh, dikh dy-leh bish-may-ya hawa hum b-ara. Hal-lan lukh-ma sun-qana d-id-yu; wishwoq talan gna-han wikh-ty-ya-than, dikh d-hem akh-ny shweq-lan ta ana dim-tu'-dela illan. La ma-by-rit-tan b-ju-raba, illa mkha-lis-lan min by-sha; msab-bab dy-yukh y-leh mal-ku-tha, whayla, w-tishboh-ta l-'alam almyn. Amen.

*Our Father who art in heaven, hallowed be thy name, thy kingdom come, thy will be done on earth as it is in heaven. Give us this day our daily bread and forgive us our trespasses, as we forgive those who trespass against us, and lead us not into temptation, but deliver us from evil. For the kingdom, the power, and the glory are yours, now and forever. Amen.*

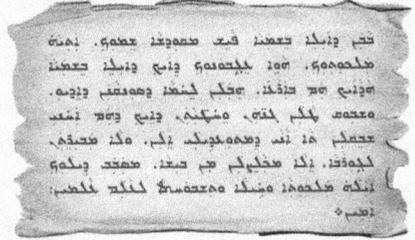

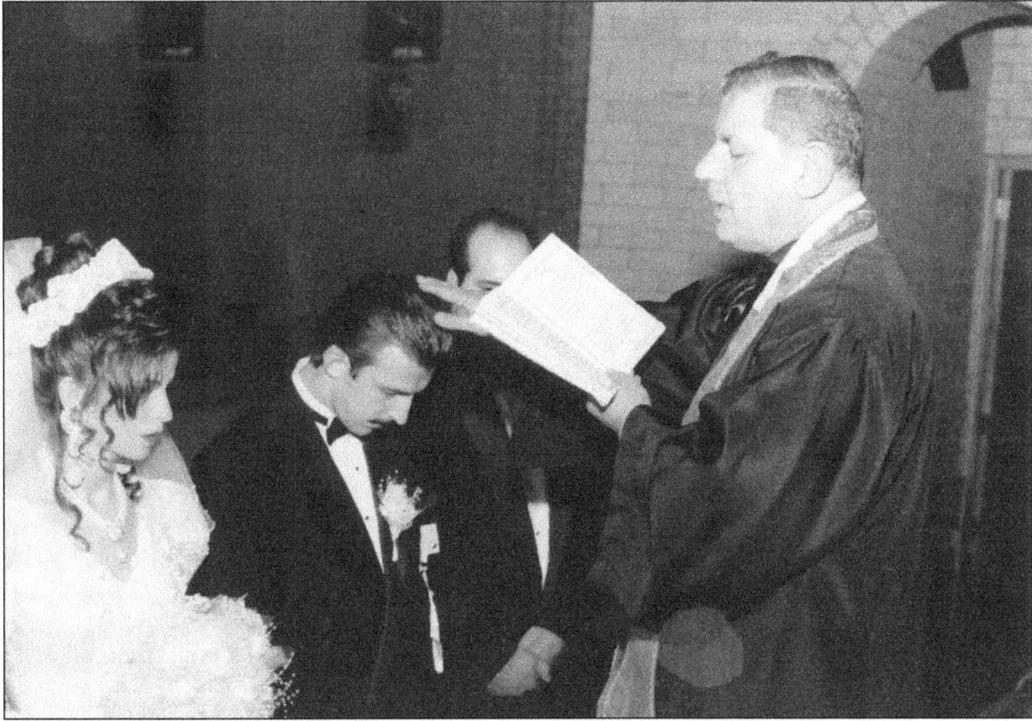

A CATHOLIC MARRIAGE. In Eastern churches, the sacrament of marriage is conferred by a priest's blessing after receiving the couple's consent, "I do." Pictured here in the early 1990s is Rev. Jacob Yasso blessing the groom, Jimmy Yasso, in Aramaic: "O groom who has bent his head. Humbly before the priest, may Christ raise your head and grant you prosperity in heaven and earth." The church as a whole responds after every verse, "Amen." (Courtesy of Rev. Jacob Yasso.)

27

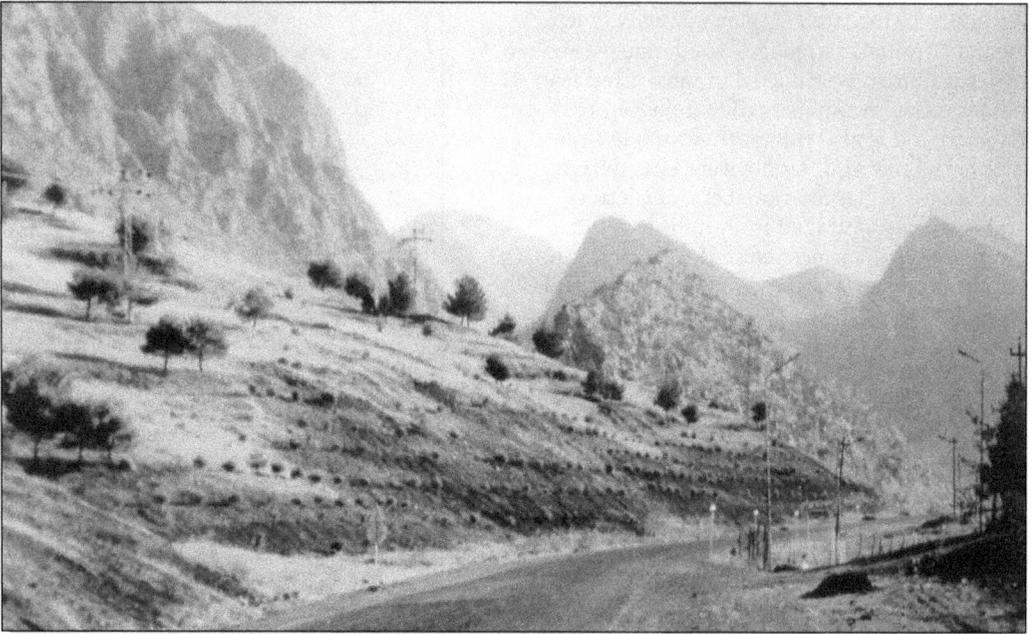

CENTURIES-OLD TRADITION. *Baoutha* is an Aramaic word that means "pleading." It is a three-day period of fasting. It originated in the ancient city of Nineveh (Mosul), the original home of the Chaldean and Assyrian people. Pictured here is the ancient city of Nineveh. The long-carried tradition is to ask God for forgiveness of sins and to focus on God's love and mercy. Not eating meat for three days and fasting from 12:00am until 12:00pm is the traditional ritual. Baoutha is celebrated three weeks before Lent. (Courtesy of Issa Hanna Dabish.)

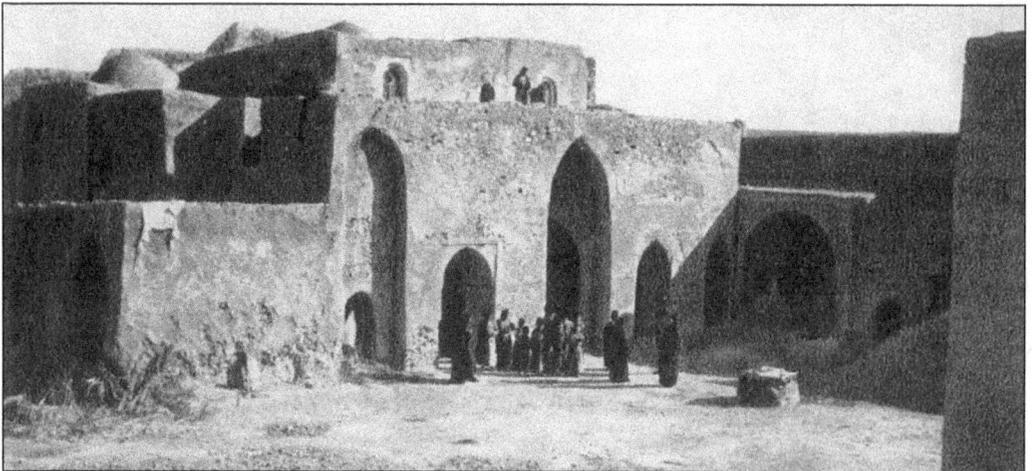

MONASTERIES: TREASURES OF TOMBS, 1914. Since the beginning of Christianity, Mesopotamia was fertile ground for many monasteries, convents, and churches, about 30 kilometers southwest of Mosul. Mar Behnam (pictured here) is one well-known monastery with a powerful inscription: "Carry yourselves with respect and compunction, and prostrate yourselves before the holy cross, and pray to our saint so that the Lord will have mercy on us, and will not forsake us, thanks to his intercession." Mar Behnam was killed and became a Christian martyr. (Courtesy of Al-Ekha'a Press House.)

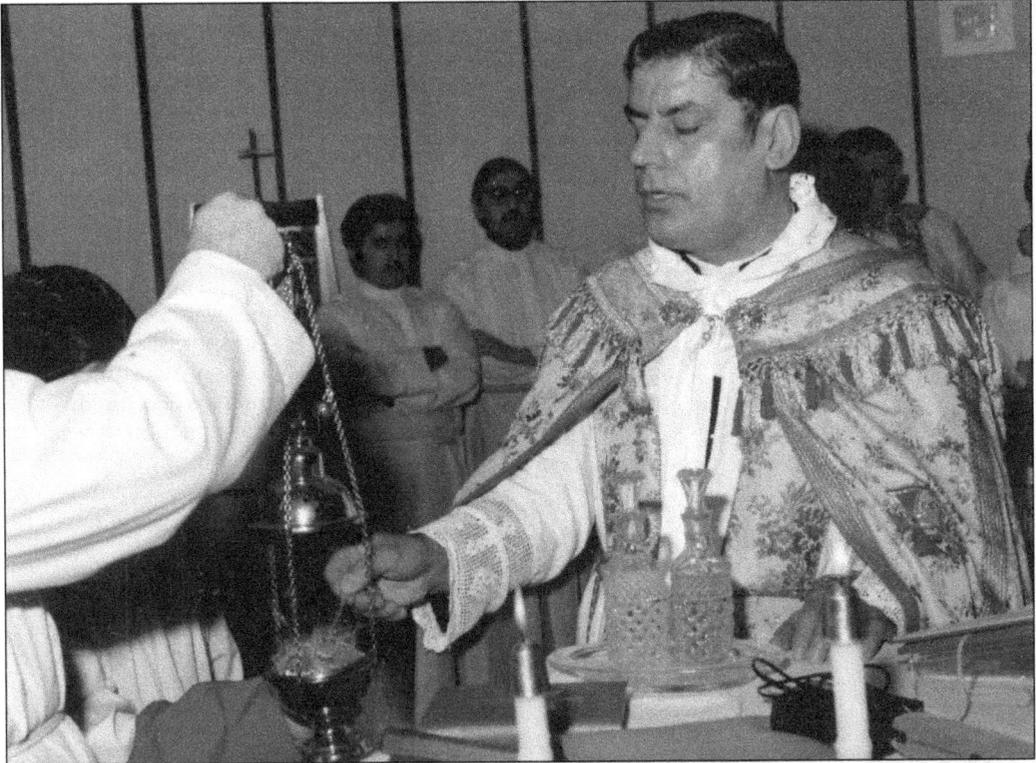

IDDANA DA-SLOTHA MEANS "THE TIME OF PRAYER." With candles lit upon the altar, this photograph was taken of Rev. Jacob Yasso in the 1980s as he burned incense at Sacred Heart Parish in Detroit. Incensing the altar is a common Catholic ritual during Masses and funerals. Burning incense is a sign of respect to Christ and his sacrifice made present at the altar. Rev. Jacob Yasso is the longest serving priest in North America (1964–2011). (Courtesy of Rev. Jacob Yasso.)

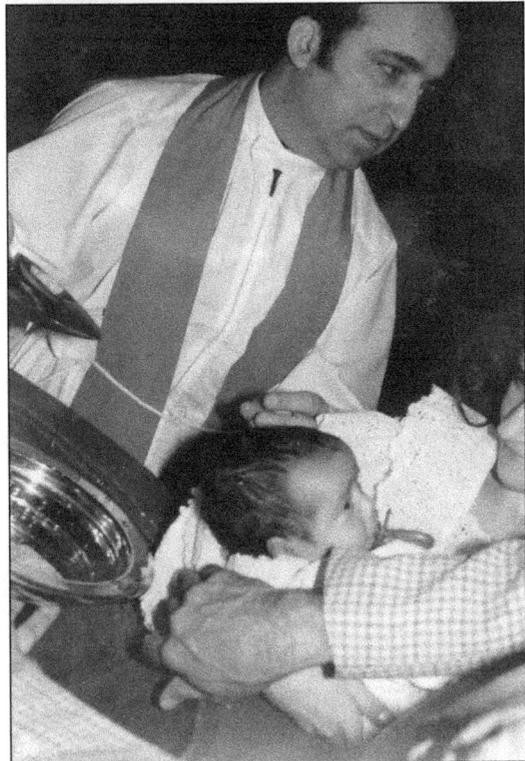

SPIRITUAL RENEWAL. Baptism is one of the Christian religious rites, blessing the person with holy water, symbolizing purification, regeneration, and admission into the Christian church. Here, Christina (Bacall) Oraha is baptized in January 1981 at Mar Addai Chaldean Catholic Church in Oak Park. Rev. Stephen Kallabat is holding the blessed water. (Author's collection.)

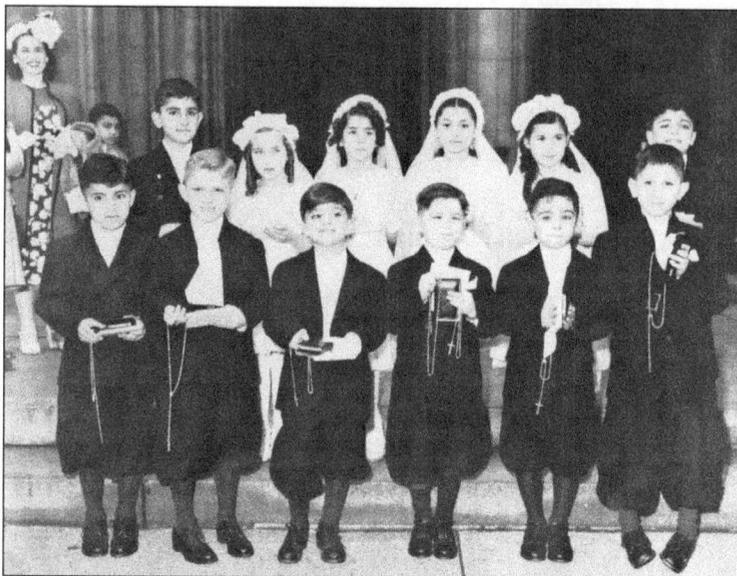

**FIRST COMMUNION.** In May 1947, angelic Chaldean second-graders make their First Communion at Blessed Sacrament Cathedral at Woodward Avenue and Belmont Street in Detroit. Students would attend Mass every school day, five days a week. Religion class at that time was preparation for First Communion. It was taught by Sr. Janet Sullivan. (Courtesy of Julia Najor Hallahan.)

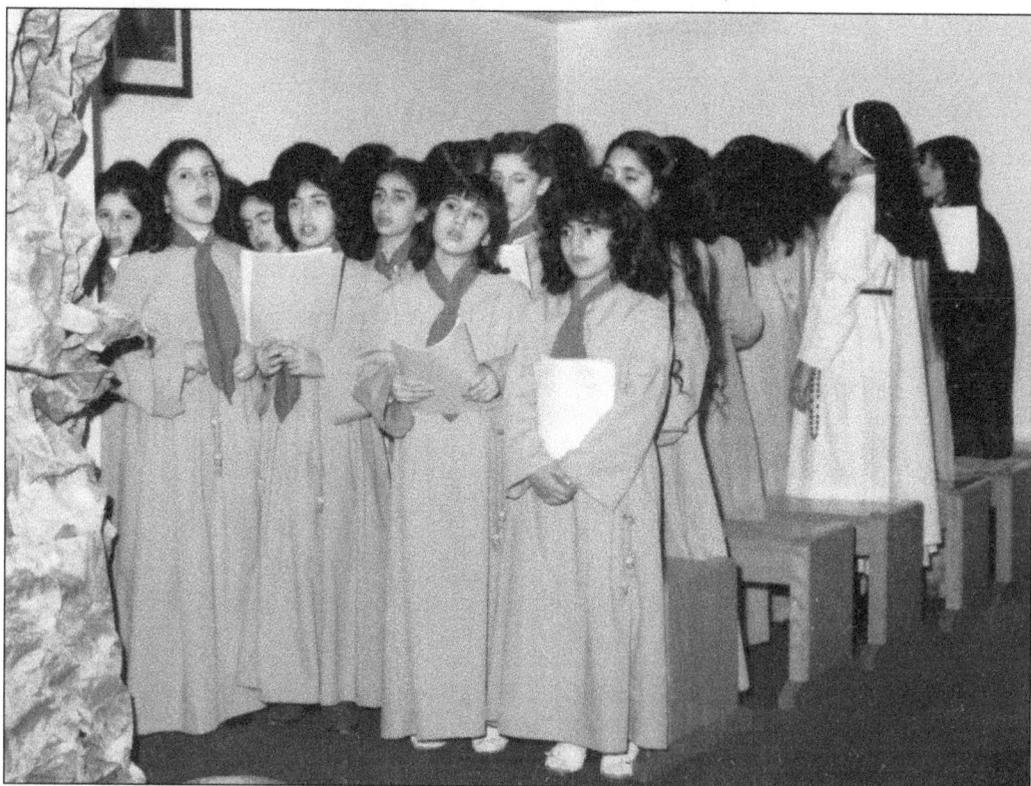

**SINGING IN PRAISE.** In this photograph from the early 1980s, the choir of Sacred Heart Chaldean Church in Detroit warms up before beginning Sunday Mass. Practicing vocal harmonizing was essential for Sunday Masses and holiday Mass celebrations. Young girls were taught to attend church and were also encouraged to serve in church. Nuns would train the choir, as they still do today, to sing the prayers in Sourath as well as English. (Courtesy of Rev. Jacob Yasso.)

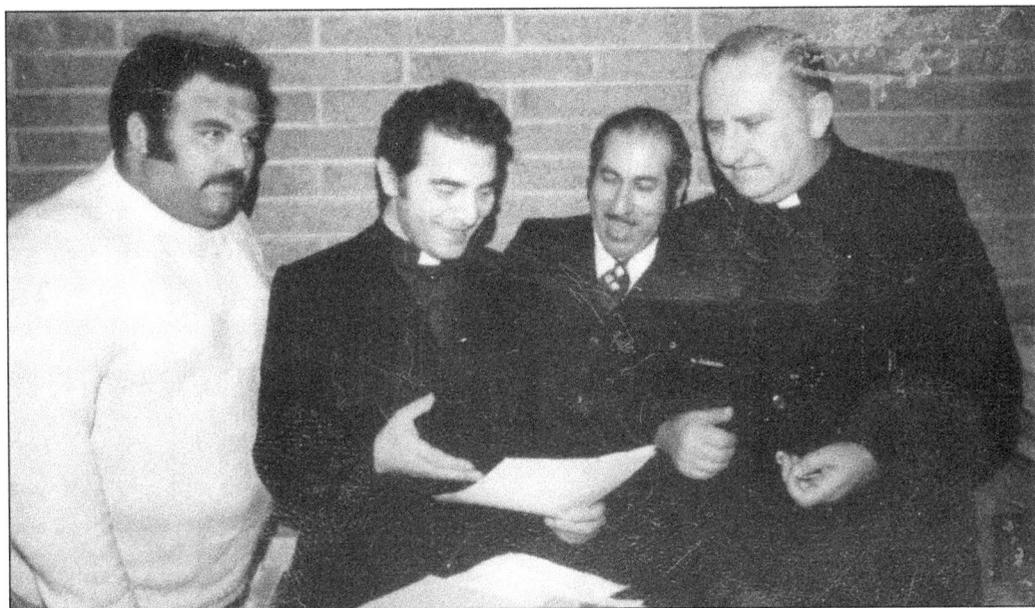

**UNITY INDEED IS NEEDED!** In the early 1980s, a strong voice of unity was on a high-frequency beam. Chaldeans and Assyrians both speak the same language, share history, and practice nearly the same Eastern rites of the church. The number-one crusader for unity was Rev. Sarhad Jammo. He was backed by a deep thinker and consequential politician, Rev. George Garmo. Here, they review the latest issue of *Al Mashriq*. From left to right are Talal Samona, Reverend Jammo (now bishop), *Al Mashriq* publisher Napoleon Bashi, and Reverend Garmo. (Courtesy of Samir and Bernadette Bashi.)

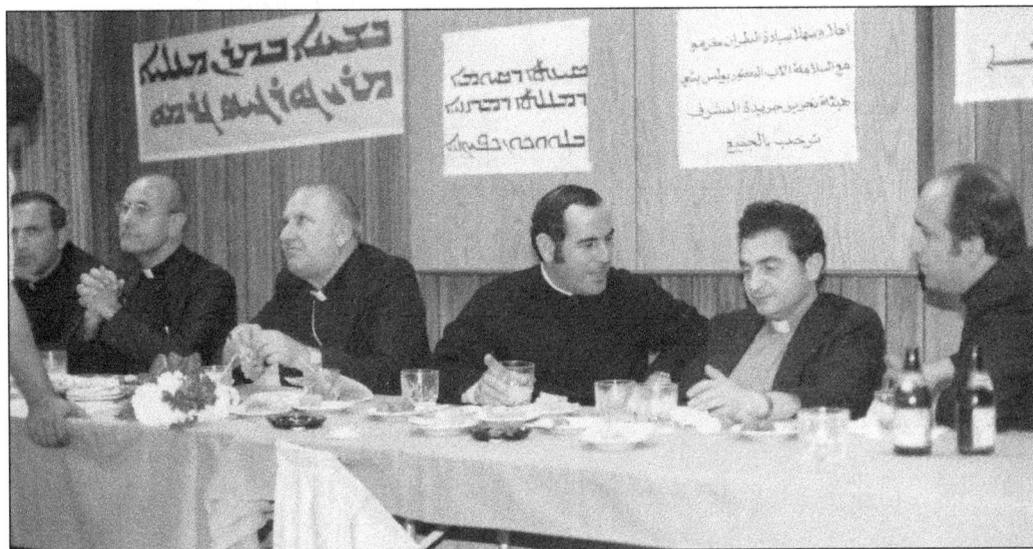

**WELCOME BISHOP GARMO, GOOD-BYE FATHER BASHI.** Pictured here are the local clergymen and Chaldean organization leaders in the early 1980s. They are celebrating the return of Bishop George Garmo, renewed as a consecrated archbishop of Mosul, Iraq, and the departure of Fr. Paul Bashi, a Chaldean priest serving in Marseille, France. From left to right are Rev. Michael J. Bazzi, Father Bashi, Bishop Garmo, Rev. Gabriel Kassab (now bishop), Rev. Sarhad Jammo, and Rev. Stephen Kallabat. (Courtesy of Najat Bashi.)

**PAPAL RECOGNITION.** A Chaldean patriarch, bishops, and priests are pictured here with Pope John XXIII during their stay in Rome. This photograph was taken in the early 1960s inside the Vatican. It has been a long and customary tradition for the pope of Rome to receive, welcome, and bless the Synod Annual Bishop meeting when it is held in Rome. Mar Paul II Cheikho is standing to the right of the pope with his clergymen. (Courtesy of Julia Najor Hallahan.)

**MAKING HISTORY.** "Through the apostles Thomas and Thaddeus, you are the spiritual heirs of Jesus Christ," said Pope John Paul II in his writings, reaffirming the Chaldeans' conversion to Christianity nearly 2,000 years ago. Pope John Paul II gave the Chaldean rite special attention and planned to visit Ur of the Chaldees, but the Iraqi president at the time, Saddam Hussein, refused the terms and conditions of the pope's program, which included a speech about the persecution of Iraqi people by its ruling government. (Courtesy of Bishop Ibrahim N. Ibrahim.)

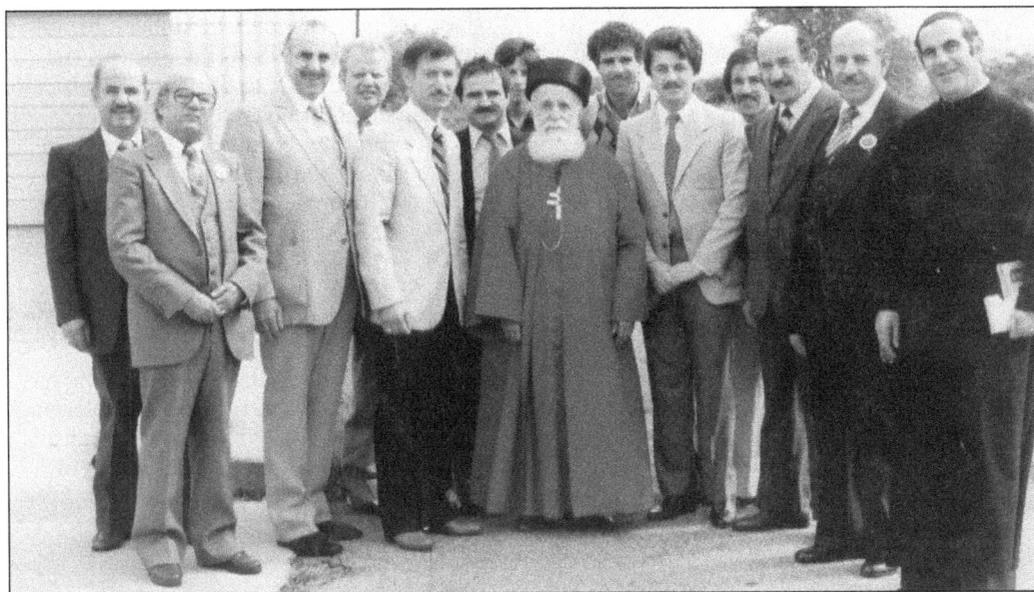

BABYLONIAN VISIT. Mar Paul Cheikho (center), the patriarch of Babylon, visited Michigan in 1984. He is standing here with Chaldean Americans originally from his home village of Alkosh, on the outskirts of Nineveh (Mosul). They are, from left to right, Azzat Kassab, Nouri Hesano, Abed Balo, Latif Garmo, Nuel Barno, Yonan Marogi, unidentified, Mar Paul Cheikho, unidentified, Yousif Shikwana, Azzat Sitto, Agied Mani, Waleed Bahri, and Fr. Gabriel Kassab. (Courtesy of Nouri Hesano.)

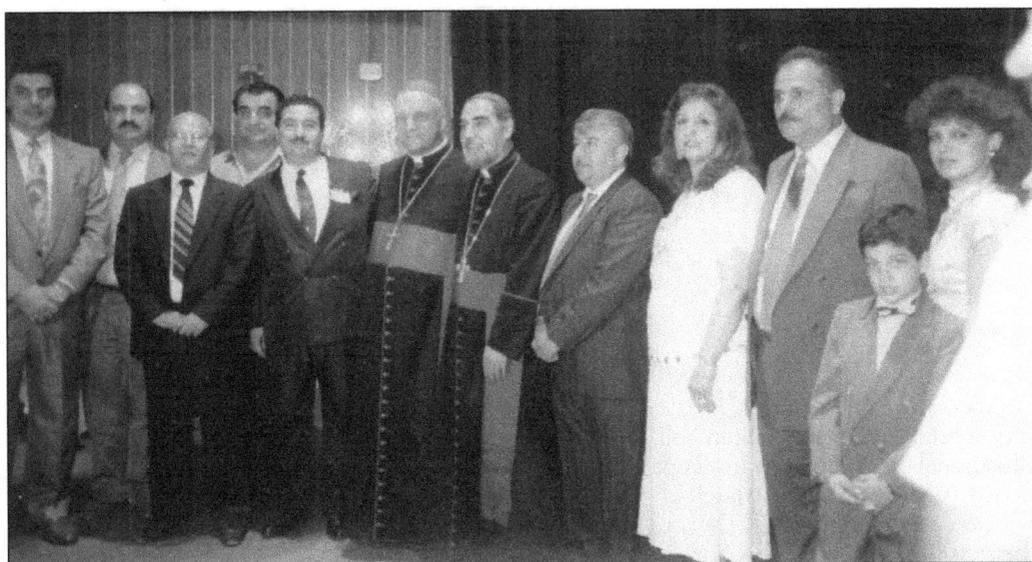

WELCOME HOME. Mar Raphael I Bidawid, the Chaldean patriarch of Babylon, welcomes a group of Chaldean delegators from Detroit headed by Mar Ibrahim N. Ibrahim, bishop of St. Thomas Chaldean Catholic Church. Also joining with the bishop are members of the Chaldean Federation of America (CFA) at a dinner reception at Babil Chaldean Club in Baghdad in 1989. From left to right are George Zaker, Zuhair Hesano, Nouri Hesano, Jamal Bidawid, Saad Marouf (CFA chairman), Mar Raphael I Bidawid, Bishop Ibrahim Ibrahim, Najeb Guma, Mrs. and Mr. Abedahead Salmo, Amria Mattia Marouf, and Marouf's son Alex. (Courtesy of Nouri Hesano.)

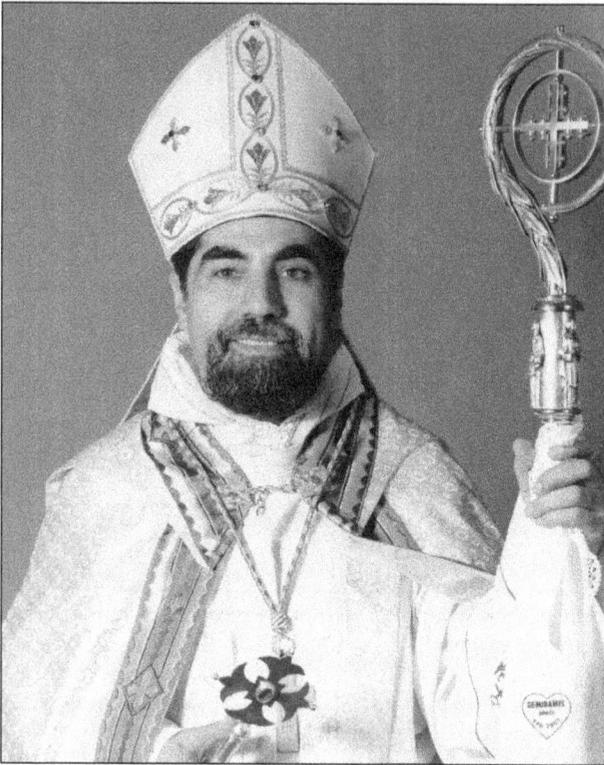

FIRST BISHOP. On January 26, 1982, Pope John Paul II confirmed the first Chaldean bishop in America, the most revered Mar Ibrahim Ibrahim, born in Telkaif, Iraq, in 1937. Mar Ibrahim entered the Chaldean seminary in 1951 and studied philosophy and theology in Paris. He was ordained a priest in 1962. In 1978, he was asked to serve at St. Peter Chaldean Parish in San Diego. Over 50 years of serving the church, he has enriched and touched the lives of many people inside and outside of the community. (Courtesy of Bishop Ibrahim N. Ibrahim.)

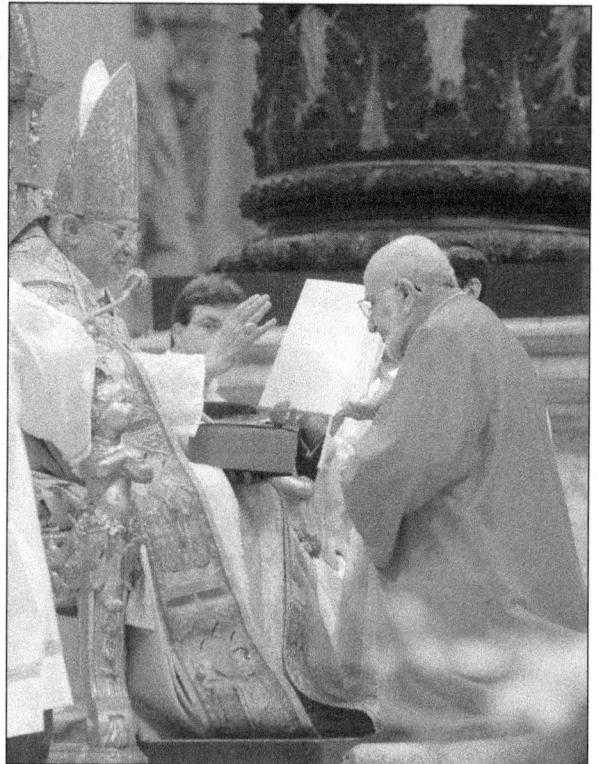

FINALLY. November 24, 2007, was a very special day in the Vatican and a historical day for Chaldeans. Pope Benedict XVI elevated patriarch of Babylon Mar Emmanuel III Delly to the status of cardinal. "This honor is not for me alone, but for all of the Iraqi people," said Cardinal Delly. Mar Delly died in April 2014 at the age of 86. He is the first and only Chaldean patriarch to be buried in the United States, in Southfield. (Courtesy of *The Chaldean News*.)

**POETRY OF THE HEART.** Here is the back of a robe with Arabic poetry in golden embroidery, describing one's love for his or her home country in connection with the people they lived with and how dear they are to one's heart. Despite the grief, struggles, disappointments, and hardship they may have caused, friends and relatives must always remain generous and respectable. Someone once said, "A man travels the world in search of what he needs and returns home to find it." (Courtesy of Masouda Karim.)

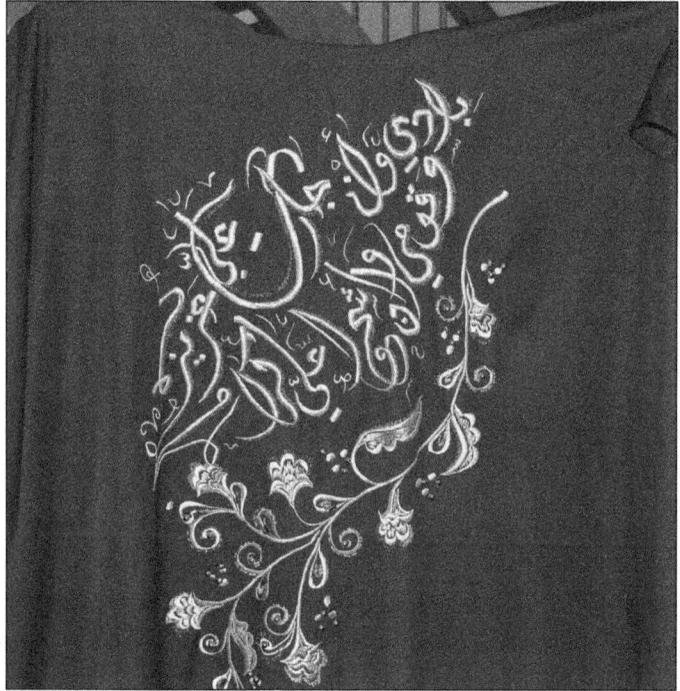

**TYPICAL DAY AT THE BAZAAR, 1918.** This image shows a typical hometown scene in Baghdad, with people mingling, greeting each other, shopping, eating, and enjoying life. Shopping in the old market felt almost the same whether one was in Baghdad, Mosul, or Basrah. Exploring a bazaar-like market takes one centuries back in history. (Courtesy of Al-Ekha'a Press House.)

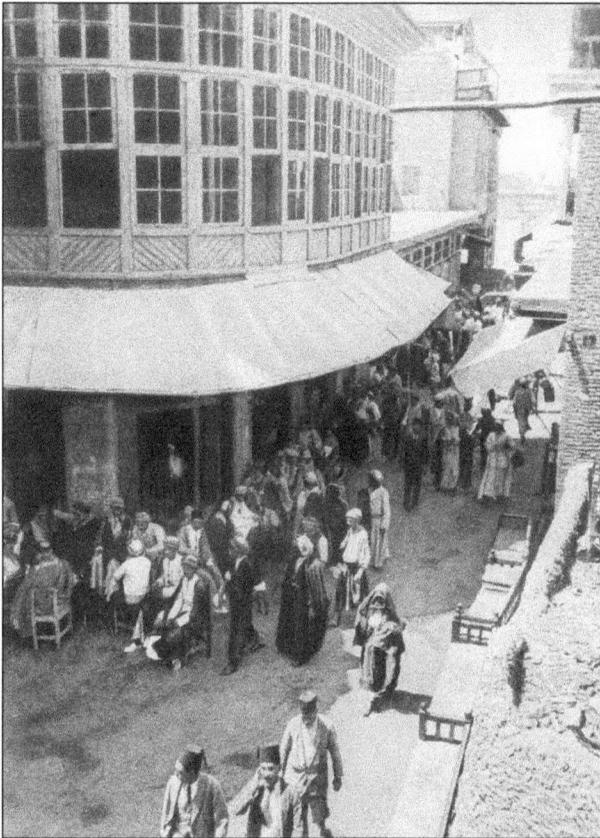

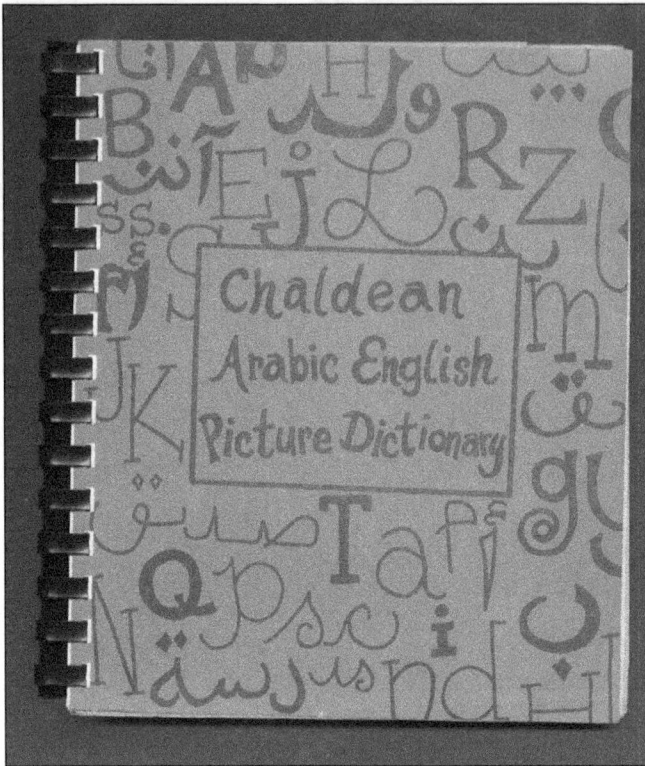

**BREAKING LANGUAGE BARRIERS.** Many Chaldean immigrants spoke both Aramaic and Arabic. The latter was and is the official language of Iraq. In the early years of the 1970s, Chaldean students had a considerable presence in classrooms. During that time, in 1975, the *Chaldean Arabic English Picture Dictionary* was incorporated into the curriculum of Detroit Public Schools, Region 6. This resource assisted Chaldean students in the bilingual program in Metropolitan Detroit. With the help of Fr. George Garmo of Mother of God Church, Karl Kado, and Julia Najor Hallahan, the picture dictionary became an important tool for teaching in the bilingual classroom. (Courtesy of Julia Najor Hallahan.)

# Three

# COMING TO AMERICA

In 1915 or 1916, soon after the massacre of the Chaldeans in Adana, Turkey (part of the Armenian Genocide), many ethnic groups focused their attention on the New World: America. This included the Chaldeans from rural Christian villages in northern Mosul, mainly the village of Telkaif.

Devastated by wars and decades of political and economic unrest, the Chaldean community was in search of an escape from religious persecution and oppression. Chaldeans were subjected to unspeakable practices of physical and sexual violence and exploitation merely for being Christian. America offered an opportunity for Chaldeans to openly practice their Christianity without persecution.

In addition to religious freedom, Chaldeans were looking forward to living the "American Dream," seeking freedom and the opportunity to provide a better life for their children. Many found their way to Detroit after Henry Ford revolutionized the automobile industry.

Much later, in 1965, during Lyndon Johnson's presidency, a new immigration law was passed that substantially benefited new immigrants in the Chaldean community. The wave of Chaldean immigration grew dramatically in the 1960s and 1970s. These arrivals came from the urban areas of Iraq, primarily Baghdad, Basrah, and Mosul. Many of these people were educated and came with professional credentials, unlike the early pioneers, who came from northern Iraqi Christian villages, among them Telkaif, Alkosh, Baqofa, Araden, Batnaya, and others.

Chaldean refugees seeking a place to settle chose America, and, given the option now, it remains the number-one choice.

**HISTORIC RECORDS.** Documents like George Bino's "Declaration of Intention" are of great historic value and also reveal the poor knowledge immigrant officials had about the ethnic complexity of Middle Eastern immigrants' backgrounds. Note that Bino's race was recorded in his immigration document as "Syrian," but his identity of origin is Chaldean. The document states his nationality as being "Turkish," reflecting Iraq under the control of the Ottoman Empire. It also reveals that Chaldeans began immigrating to the United States well before Iraq gained independence. Bino entered the port of New York in 1905. (Courtesy of Faisal Arabo.)

**JUST ONE DOLLAR.** Shown in the bottom left of this image is a receipt for services rendered for "alien's declaration and administering oath." This was issued by the American Consular Service in Baghdad, Mesopotamia, proof of an early Chaldean immigrant coming to the United States, when Iraq was still known as Mesopotamia and long before it became an independent state in 1932. Iraq was under the rule of the Ottoman Empire for almost four centuries, from 1546 to 1918. (Courtesy of Mary Ann [Jalaba] Yono.)

**PASSING INSPECTION.** Those who came to America between 1892 and 1954 traveled by steamship to a little island in New York Harbor, Ellis Island, known as the "Island of Hope." The medical inspection required by the state was rigorous. One condition health inspectors looked for at the time was trachoma, a contagious eye disease that led to blindness. About 20 percent of immigrants were detained for further inspection and treatment. Chaldean immigrants were no exception. Jamila Thomas, pictured here, traveled on the *Queen Mary* and arrived at Ellis Island in 1936. She was held there for a case of trachoma for six months before she was released. (Courtesy of Frank and Peter Thomas.)

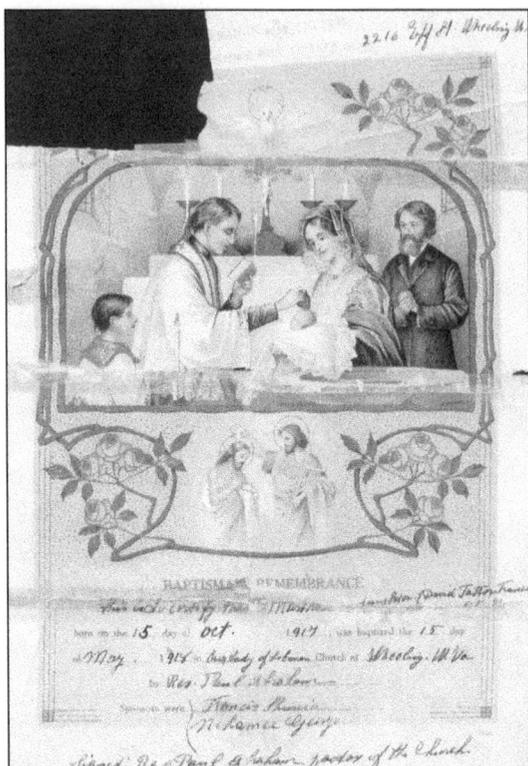

**BORN IN THE USA.** Daisy Kory is the first Chaldean on record to be born in America, on October 15, 1917, in Wheeling, West Virginia. Her father, David Kory, later moved from West Virginia to join other Chaldeans in Detroit. Daisy married Chaldean pioneer and long-serving deacon George Zia Jalaba in 1939. She died on August 21, 2013, at the age of 95. (Courtesy of Mary Ann [Jalaba] Yono.)

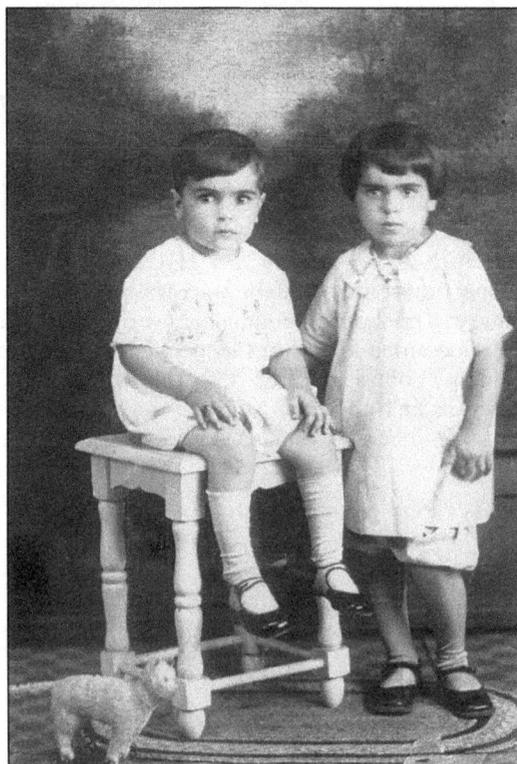

**BORN IN DETROIT.** Peter Paul Essa (sitting here at the age of three) was born in Detroit on June 8, 1925. Pictured with him is his sister Jean Essa, who was born on November 6, 1923, also in Detroit. Today, both siblings still enjoy talking to one another on the phone and visiting each other every weekend. Peter lives in Bingham Farms, Michigan, while Jean lives in Warren, Michigan. Peter is the only brother of six sisters who was born in Detroit. (Courtesy of Peter and Samira Essa.)

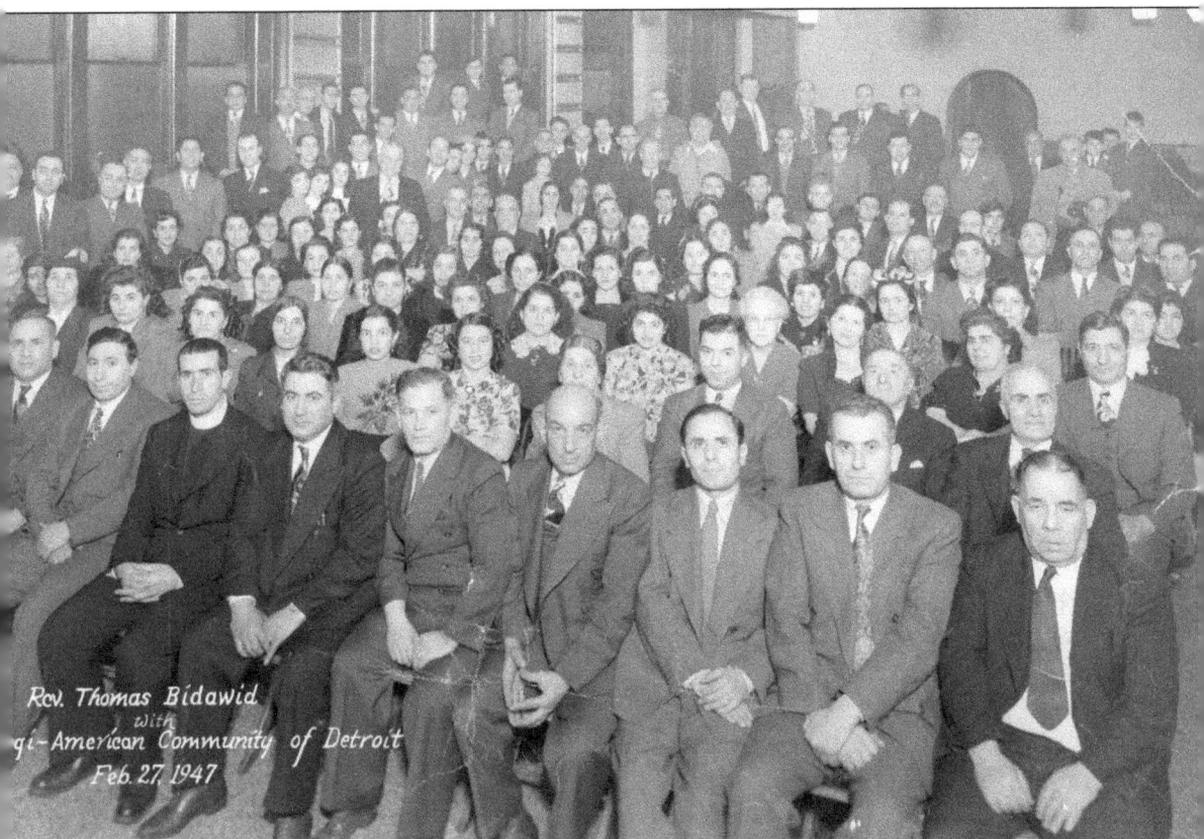

Rev. Thomas Bidawid
with
gi-American Community of Detroit
Feb. 27, 1947

AMERICA—A NATION OF ALL NATIONS. The most rewarding gift is credited to early Chaldean pioneers who came to this country. The vision and bravery of early immigrants paved the way for today's Chaldean community. Almost all of the men and women in this photograph have left this world; however, the legacy they created is a long-lasting one that proceeding generations have benefitted from greatly. A good deal of memories remains alive in the minds and hearts of Chaldeans who live in this great land of America, a nation of diverse culture. Pictured here is the Detroit Chaldean community of about 80 families officially celebrating the arrival of Fr. Thomas Bidawid at Danish Hall on 1775 West Forest Avenue in Detroit on February 27, 1947. (Courtesy of Mary Ann [Jalaba] Yono.)

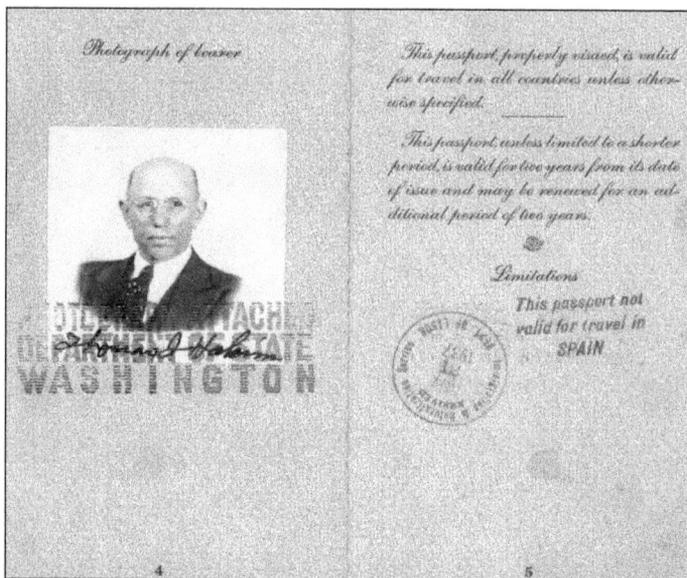

**PROUD NEW CITIZEN.** Tobia "Tom" Hakim applied for a passport as soon as he became an American citizen in 1937, a privilege appreciated by immigrants and less appreciated by those who have not tasted the bitterness of humiliation by government censorship. Like many Iraqi citizens coming to America, Hakim completed a long list of requirements to obtain a passport. (Courtesy of Tobia Hakim archives.)

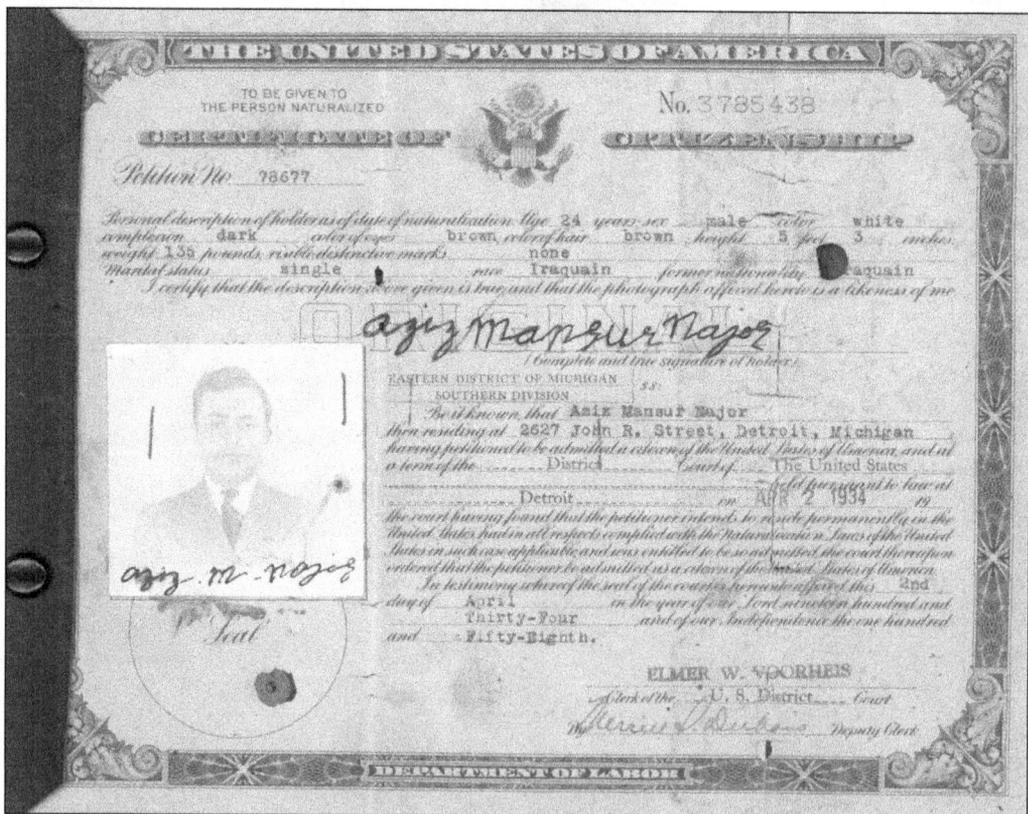

**EVERY IMMIGRANT'S DREAM.** At age 18, in April 1927, Aziz M. Najor arrived by ship in Providence, Rhode Island. After the death of his father, Aziz inherited the responsibility of supporting his family. He worked long hours at his cousin's store in Detroit while learning English with the help of coworkers. He earned American citizenship on April 2, 1934, in Detroit, and died on June 6, 2011, at the age of 101. (Courtesy of Julia Najor Hallahan.)

LUCKY STRIKE. In this 1957 photograph, the smiles of happiness are shown on the faces of the Big Dipper Market owners. From left to right are Salim Sarafa, Jamil "Jimmy" Jonna, Manuel Jonna, and Buddy Atchoo. They were an inspiration for other Chaldeans moving to Detroit from Iraq. In their country of birth, an equal opportunity never existed in any aspect of society, especially in the job market. Here, the owners are seen in their daily stand-up meeting discussing the daily specials. (Courtesy of Buddy Atchoo.)

CONTAGIOUS EXCITEMENT. Pictured here around 1950 are Joe Sesi (far left) and three factory officials of Ford Motor Company looking in the trunk of a new car model made by Ford in Detroit. "It is all about the people, the customer you serve, the people you work with—it's never one person. We are energetic, enthusiastic, and aim to please," said a Ford Motor official. (Courtesy of Josephine Kassab.)

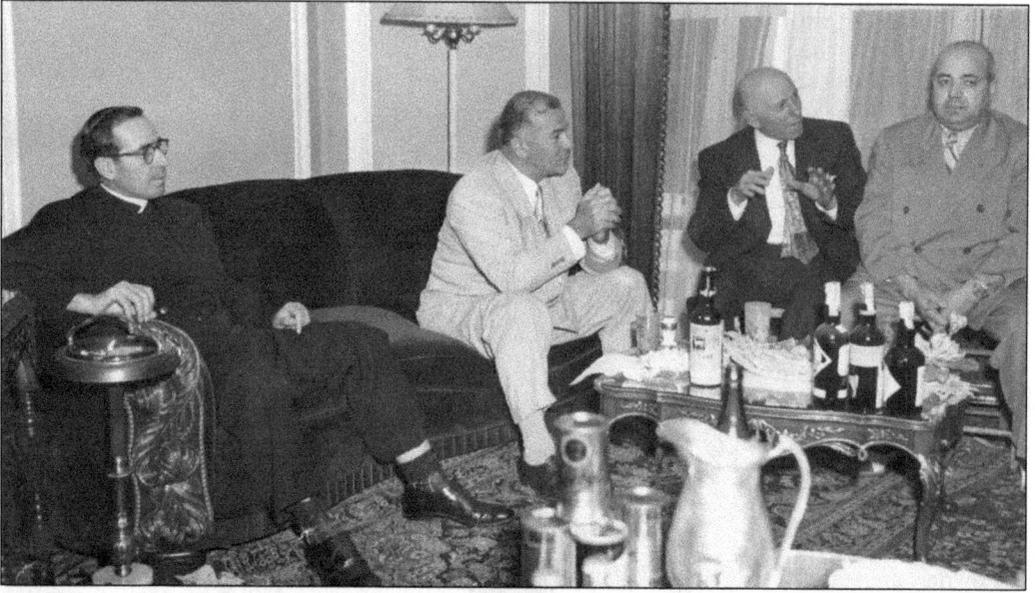

**THE VIRTUES OF HOSPITALITY.** The tradition of hospitality and generosity carried on to the new land of America. Chaldeans are known for being generous hosts to their visiting guests, treating them as if they were extended family. Quality time is spent at the house of the host, not at a restaurant. Said Ghazaz, the governor of Mosul, was a special guest at Tom Hakim's home during his visit to Detroit in 1951. Pictured from left to right are Fr. Toma Bidawid, Gov. Said Ghazaz, Tobia Hakim, and Joe Acho. (Courtesy of Tobia Hakim archives.)

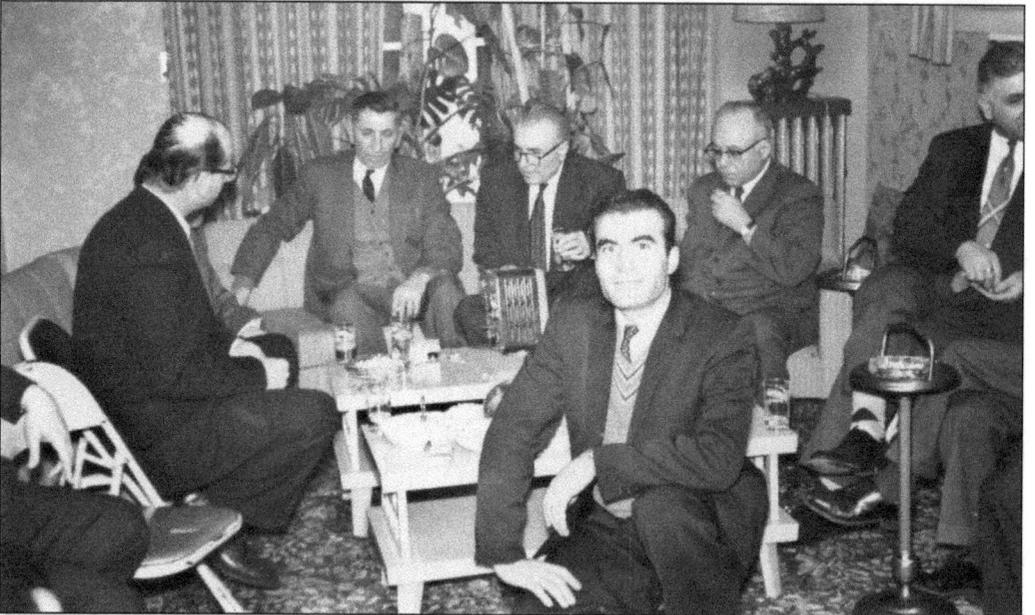

**THE FAMILY PROVIDER.** Chaldeans are a family-centered community, where both husband and wife provide the needs for raising and caring for their children. In a typical Chaldean family, the husband had the authoritative position in the household, providing financial support, making family decisions, and helping other family members move to America. In the 1940s, 1950s and 1960s, men also ran the affairs of the church. (Courtesy of Nadine [Dickow] Rabban.)

**ARABIC SCHOOL IN MICHIGAN.** In the early 1970s, the first Iraqi school to teach Arabic as a second language was established in Metro Detroit in the former St. Michael's School. Teacher George Jabboori is standing on the far right, wearing glasses. Jabboori brought his experience as an educator and principal from Baghdad. The operation of the school was short-lived due to lack of funding. (Courtesy of Tobia Hakim archives.)

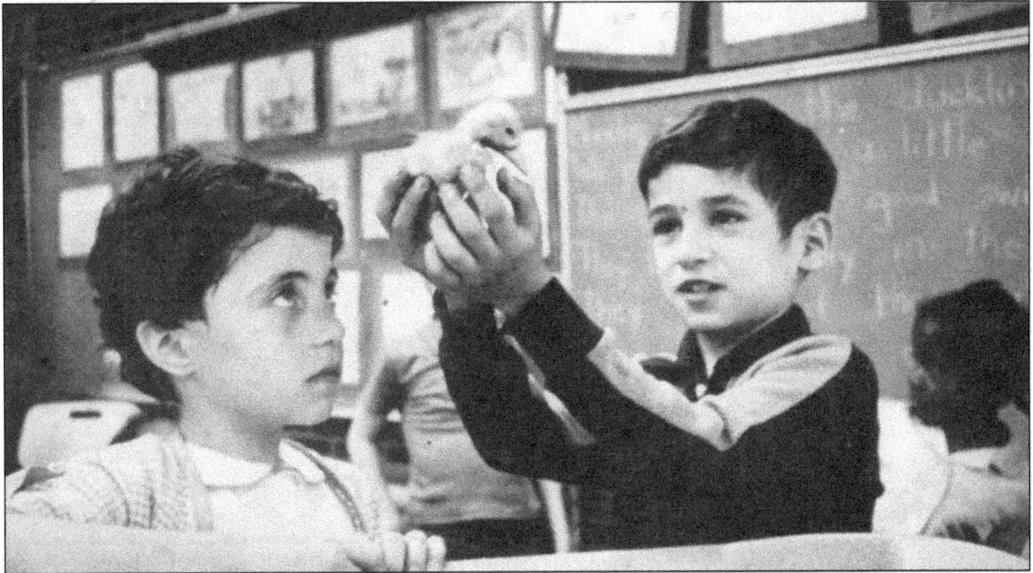

**ENGLISH TUNE-UP.** Their English is still imperfect, but the wonder in these students' eyes is plain to see. In 1962, teachers tutored kids after school at Cortland Elementary in Highland Park, within Detroit's city limits, to foster students' English skills. Participating in a hands-on reading and writing activity, Brenda Dickow looks on as Khalid Dalloo holds a soft new duckling. (Courtesy of Julia Najor Hallahan.)

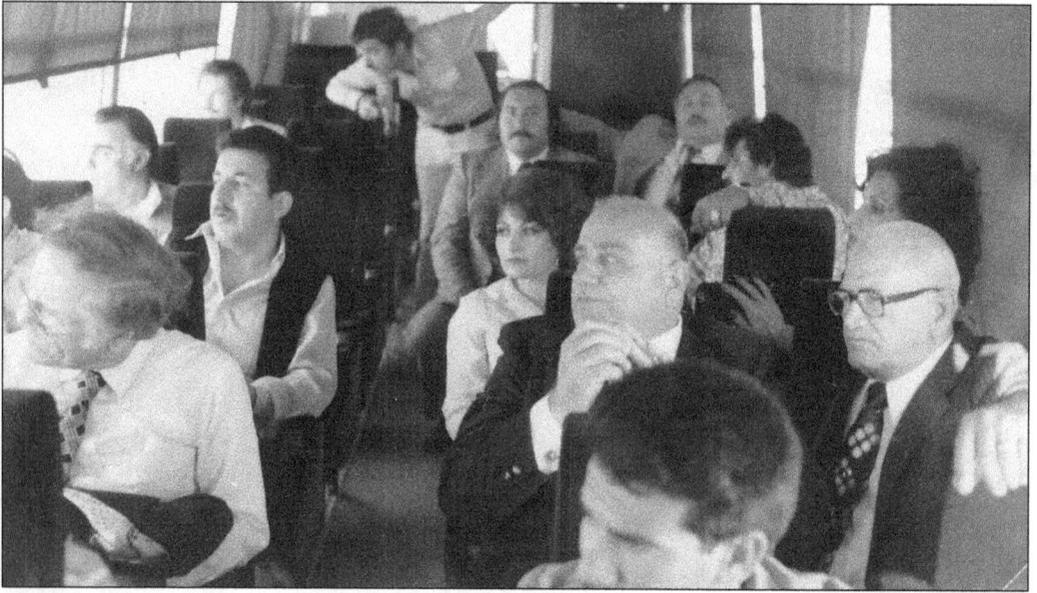

**TO BAGHDAD WE GO.** On July 17, 1979, a young Saddam Hussein, with humble roots, became the new president of Iraq. He decided to open the doors to Western investments. He emphasized the rebuilding of Iraqi infrastructure and improving all aspects of Iraq's society. A special invitation was made to Arabs and Iraqis in the United States. This photograph shows Chaldeans from Detroit and California on a bus during their tour in Baghdad in 1980. (Courtesy of Ismat Karmo.)

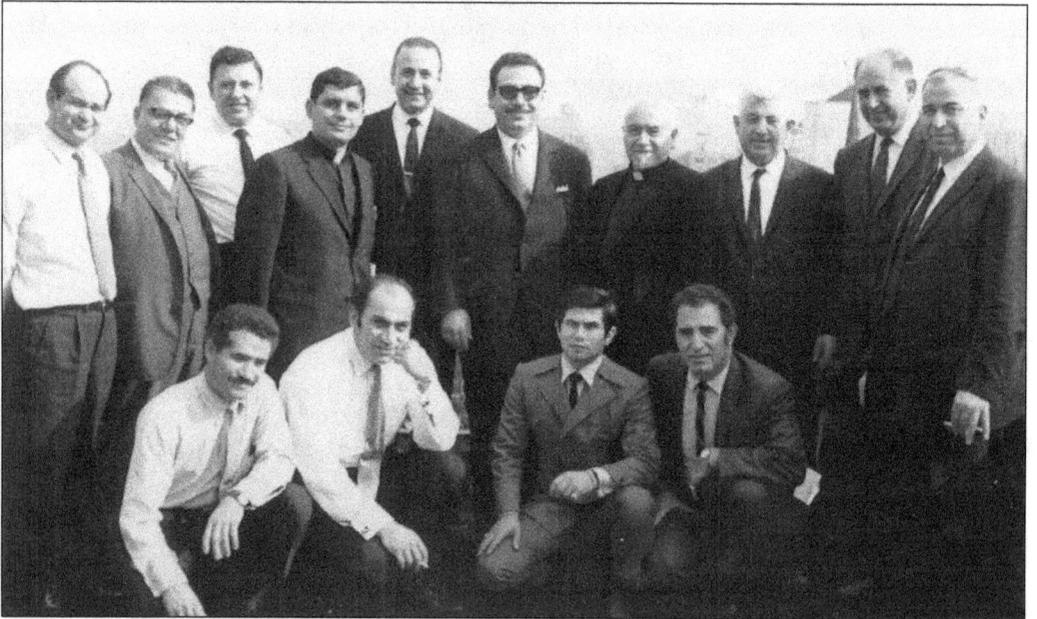

**AN ALLURING OFFER.** Iraqi foreign minister Abdel Karim Al-Shiekhly meets with a group of Chaldeans in 1970 during his visit to Detroit. The guest's message was about the new Iraq revolution of July 17, 1968, offering great opportunities for investment. From left to right are (kneeling) unidentified, Najeb Garmo, Sabah Najor, and Dawood Dalali; (standing) unidentified, Hanna Yatooma, Salim Sarafa, Rev. Jacob Yasso, Karim Sarafa, Abdel Karim Al-Shiekhly, Fr. Alfonse Shoriz, Jihad Hakim, Gabriel Sheena, and Yalda Saroki. (Courtesy of Anmar Sarafa.)

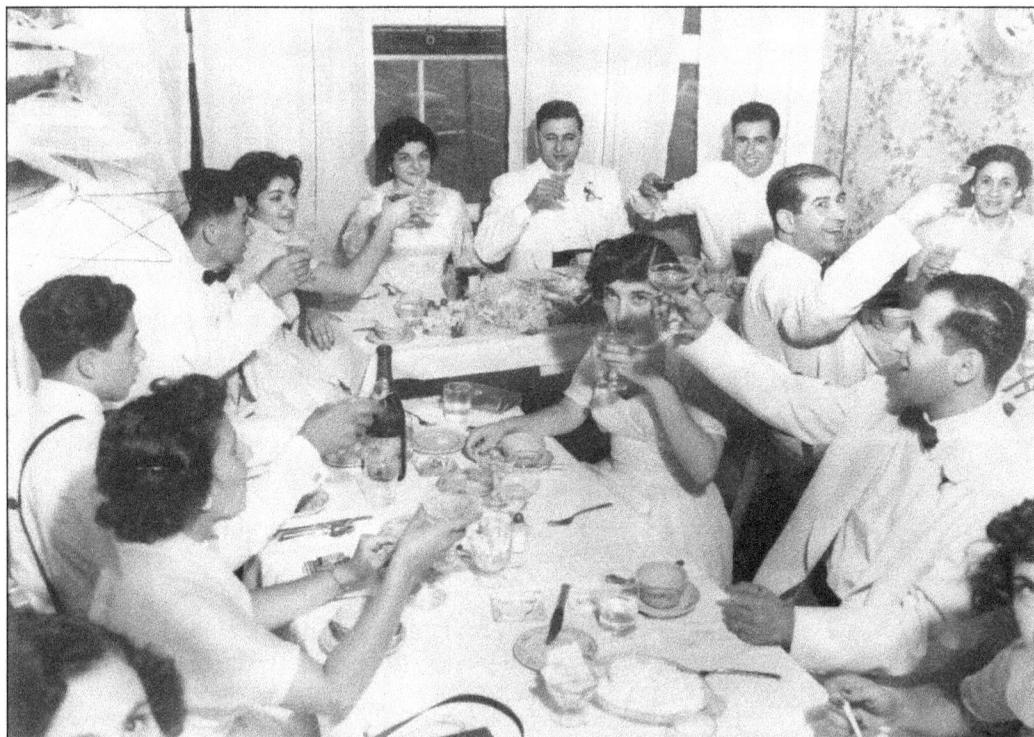

**CONGRATULATIONS TO THE NEW COUPLE.** Back home in Iraq, a wedding reception was limited to serving a piece of wedding cake with refreshments. A full-course dinner, a live band, a banquet hall usually decorated with fresh flowers, and using a professional photographer and videographer has become the norm at today's Chaldean weddings. Salim and Margaret Sarafa (back center) make a toast at their wedding reception, signifying vitality, love, and abundance. Newlyweds Salim and Margaret celebrated their wedding day on August 16, 1953, at Latin Quarters hall in Detroit. (Courtesy of Anmar Sarafa.)

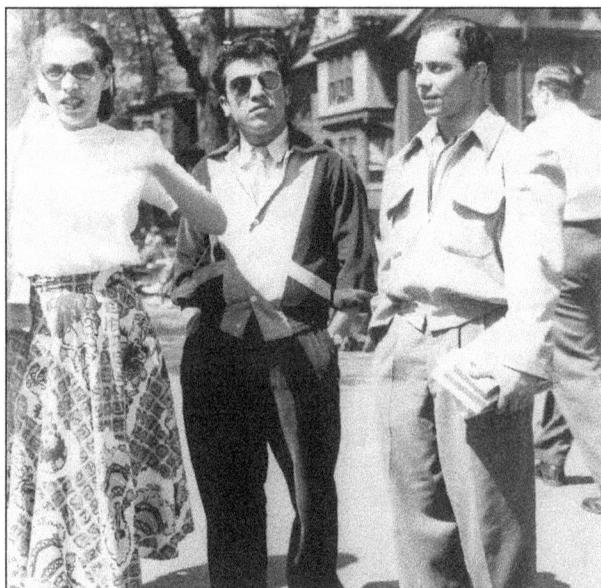

**CHALDEANS ON CAMPUS.** Like many Detroiters, numerous Chaldean high school graduates furthered their educations at Wayne State University. On campus in 1953 are, from left to right, an unidentified woman, Faisal Arabo, and George Ayoub Qashat living their dream studying in the United States. (Courtesy of Faisal Arabo.)

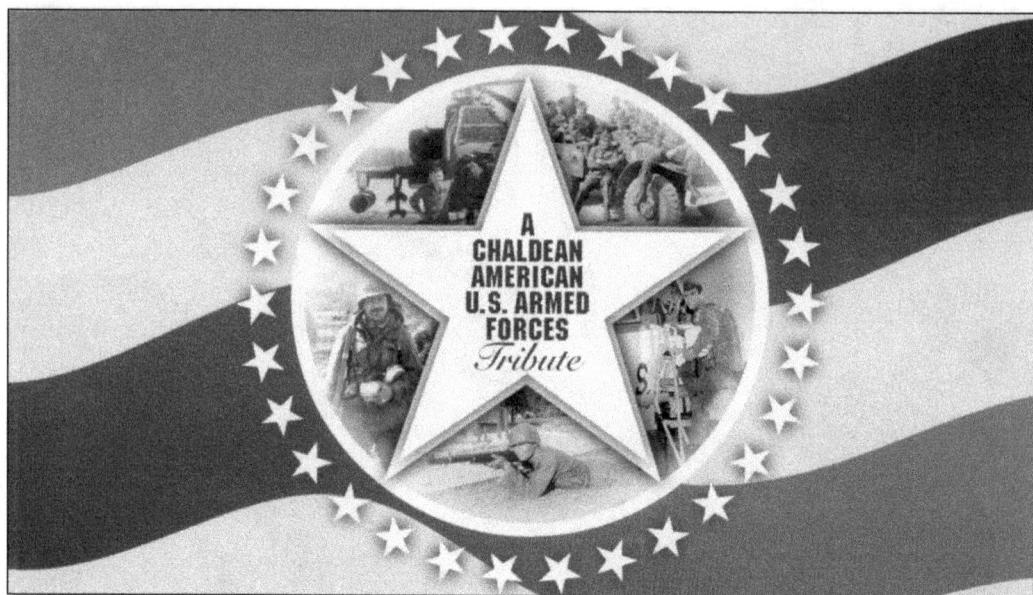

**CHALDEAN AMERICANS IN THE US ARMED FORCES.** The United States provided much for new immigrants and offered a home where they could practice their faith freely, elevate their living standards, and have hope for a better future. In Detroit and throughout the nation, Chaldean Americans have dedicated themselves to making a better life. The entire Chaldean American community takes pride in their long and honorable tradition of service to the United States and in being a part of America and embracing its values. "It is important to have a strong, national defense in order to preserve these principles . . . I salute the Chaldean servicemen and women for your commitment to our nation," said John Engler, governor of Michigan, in June 2002. Pictured here is the Chaldean immigrants' wall of honor. (Both courtesy of the Chaldean American Ladies of Charity.)

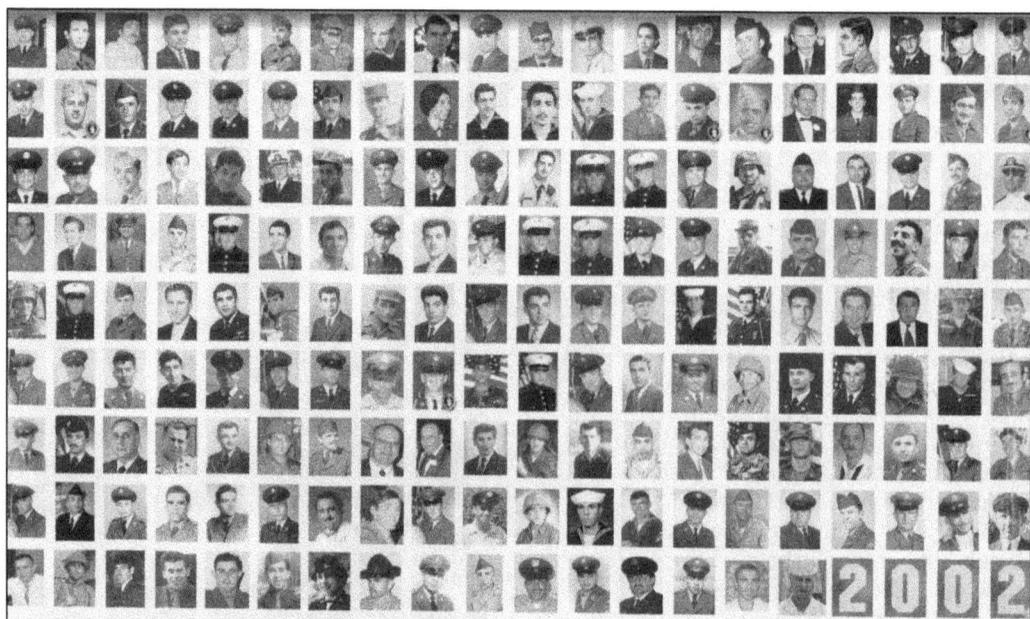

**THE ROAD TO AMERICA.** When the first Iraqi republic government was overthrown in 1963, the prime minister of Iraq, Abdel Karim Kassem, was succeeded by Abdul Salam Arif (a revolutionary officer and a comrade of Kassem). Christians were the target of an oppressive campaign; the president himself repeatedly made public remarks that were degrading toward the faith and its followers. Waves of mostly Christians began fleeing the country in large numbers. Pictured here is an early immigrant Chaldean Christian family who fled their country to settle in a country of freedom, the United States. (Courtesy of Anmar Sarafa.)

**THE BEST OF SUMMER.** Many well-to-do Chaldeans bought cottages on lakes as a getaway from long hours of work. Tom Peter (Tobia Khirkhir) was the first Chaldean to purchase a cottage on Cass Lake in 1936, followed by Tom Matti in 1939; many others followed their lead. Today, more Chaldeans live on Cass Lake than any other lake in Michigan. The community eventually spread out to other lakes in southeast Michigan, such as Orchard Lake, Walled Lake, and Walnut Lake, as well as other lakes throughout the state. (Courtesy of Nadine [Dickow] Rabban.)

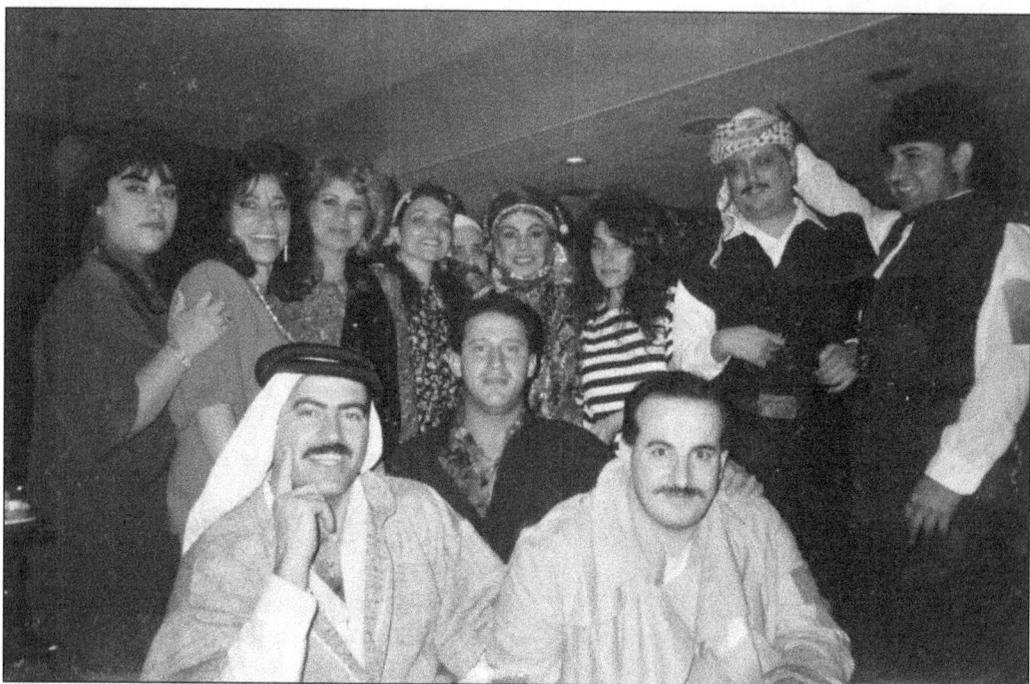

**CHALDEAN THEATRICS.** A young group of Chaldeans is seen here at a weekly practice for a theatrical play that portrays the clothing and lifestyle they were born and raised in and how it blends into the rest of America's fabric. This group brings to life the culture of living in a village or city in Iraq such as Baghdad, in theatrical form, while living in America. (Courtesy of Sohail Dayimiya.)

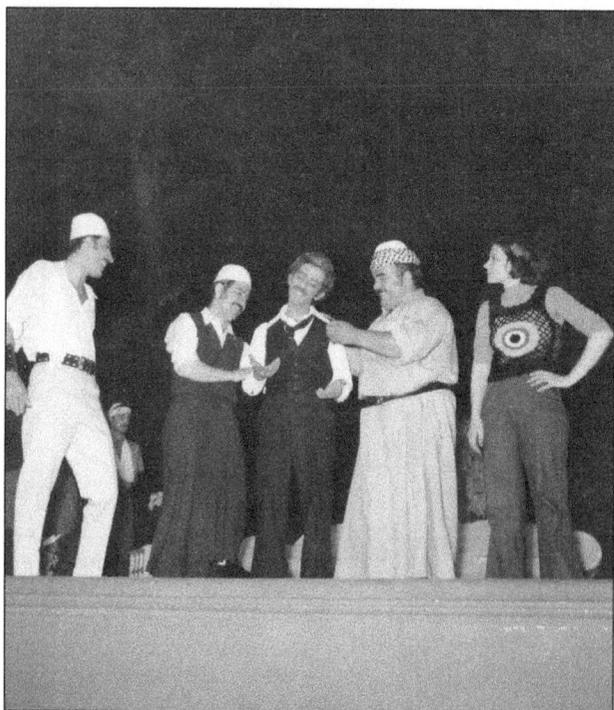

**LGALIG AL BALID, OR LAGOONS OF TOWN.** This was a sold-out show at the Detroit Institute of Arts in 1976. The theater hall was packed with people to see a play written and directed by local Chaldean Talat Misho, who was also a small-business owner. His passion and love for acting came to life, and he believed in how a theatrical play could impact and influence the lives of people. (Courtesy of Talat Misho.)

# Four

# DETROIT, THE MOTOR CITY

The first Chaldean who came to Detroit is still disputed among local historians. Zia Acho and Jajo Kas-Marougi each claimed to be the first Chaldean to set foot in the city of Detroit. Jajo—known as Jajo Azba (Jajo the Bachelor)—came from Chicago to take advantage of the high pay rate Henry Ford was offering; he had been earning half the amount working at a small business in Chicago.

In addition to job opportunities, Chaldeans found other essential reasons to settle in Detroit. Chief among them was an established Arabic-speaking community with a Lebanese Catholic Maronite church, as Chaldeans desired a place where they could worship. The Maronite community also provided opportunities for work in the grocery business, as many owned and operated local grocery stores. Another advantage was Detroit's proximity to Canada, which facilitated communication with Chaldeans who had immigrated to Canada before coming to the United States.

Before long, Chaldeans started buying and owning their own small grocery stores, and that slowly became the trademark Chaldean business in the Motor City. These businesses were concentrated on Jefferson and Woodward Avenues and near the Detroit River.

Most of the early immigrants lived and worked close to their workplace. Those who arrived in the 1920s and 1930s resided in neighborhoods on East Jefferson Avenue, Orleans Street, and East Grand Boulevard. They bought small grocery stores, worked long hours, and saved money. As time passed and they became more financially stable, many families moved to other neighborhoods on Chicago and Boston Boulevards and in Virginia Park and Highland Park and sent their children to parochial schools.

Those who immigrated in the 1960s and 1970s spread to different parts of Metro Detroit, but the vast majority settled within the city limits between Six and Eight Mile Roads, Woodward Avenue, and John R Street. Others found their way to the suburban cities of Southfield, Oak Park, and Farmington.

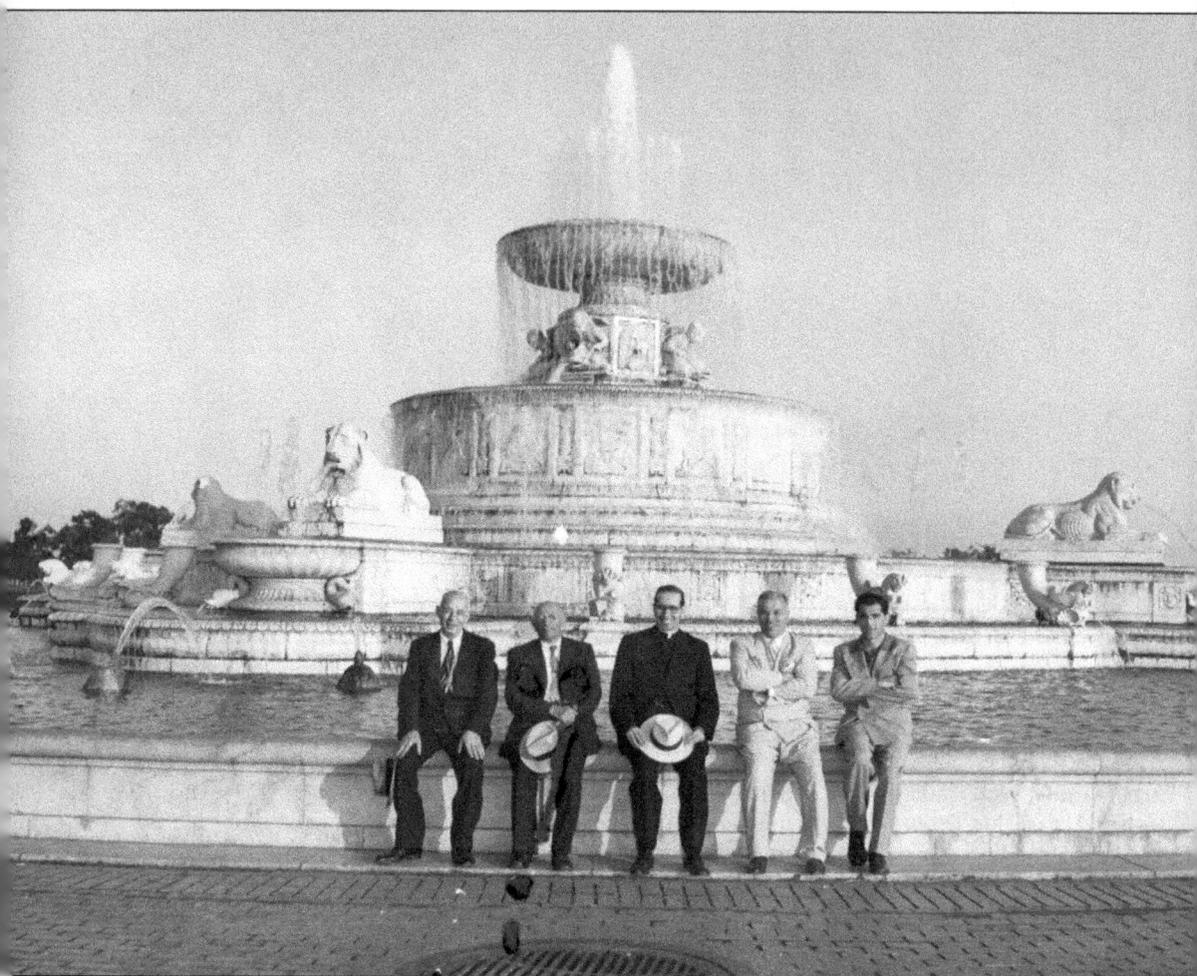

BELLE ISLE. Featuring the Scott Memorial Fountain, Belle Isle used to be the largest city-owned island park in the country. It was designed by Frederick Law Olmsted, the genius behind New York's Central Park. Belle Isle was the place to be in the middle of the Detroit River. The area had a children's zoo, a conservatory with beautiful exotic plants, picnic areas, floral gardens, swimming beaches, canoeing and sailing opportunities, food and ice cream, and a casino. In the 1930s and 1940s, Chaldean families would often spend the entire weekend on Belle Isle, sleeping under the stars, having coffee and breakfast at the casino, and enjoying all of the facilities of the island. Oftentimes, men would close their stores early on Sundays and join their families for the remainder of the weekend. This photograph, also seen on the cover of this book, was taken in September of 1950 during a visit at Belle Isle. From left to right are Peter Cassa, Tom Hakim, Rev. Thomas Bidawid (the first Chaldean priest to serve in Detroit), Said Ghazaz (the visiting governor of Mosul, Iraq), and Joe Dalaly. (Courtesy of Tobia Hakim archives.)

**TRAVELING BY TRAIN.** Since the opening of the Michigan Central Railroad depot in 1913, the train was a common mode of transportation for Detroiters and new immigrants to the city. Almost every immigrant passed through the station, and it was the first visual sign of downtown Detroit. At one time, more than 40 trains passed through the depot daily. (Courtesy Albert Duce.)

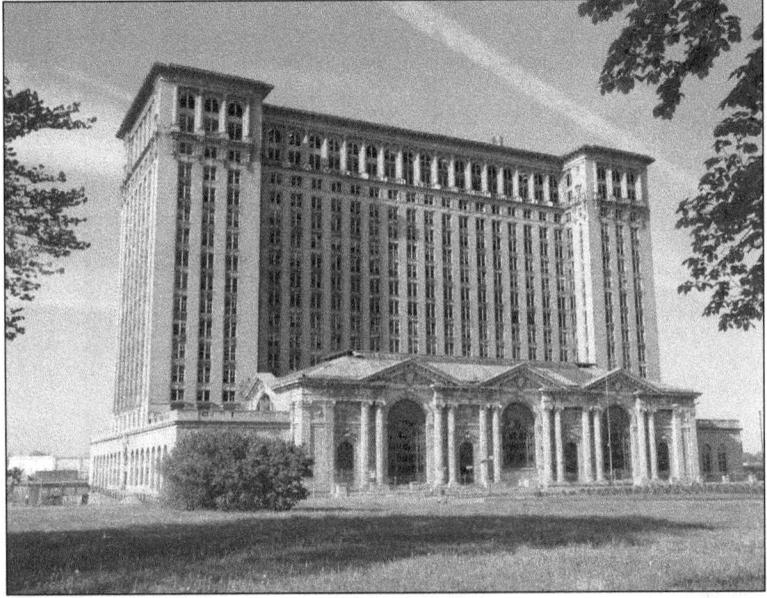

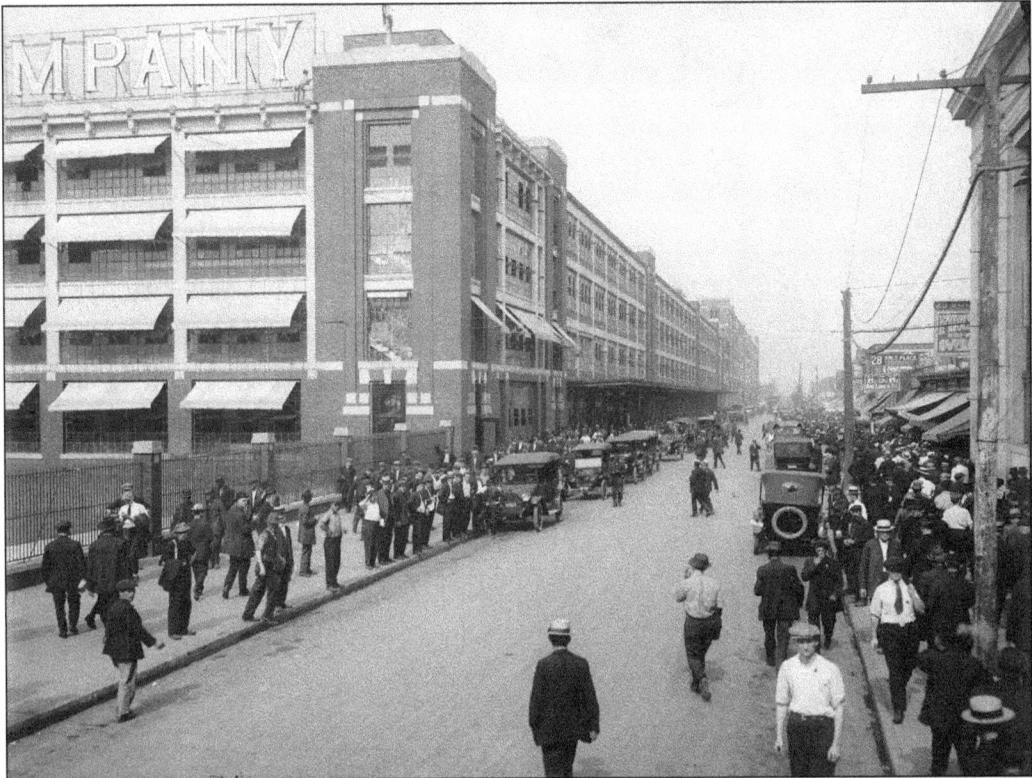

**ASSEMBLY-LINE JOBS.** Located in Highland Park, a Detroit enclave, the Highland Park Ford plant was a model for other factories in the 20th century. Henry Ford's offered wage of $5 a day changed American history. Many Chaldean immigrants were lured by the opportunities in Detroit, and many more moved to Detroit from Fort William, Ontario, Canada, to take advantage of an unheard-of wage. (Courtesy of Detroit Publishing Co.)

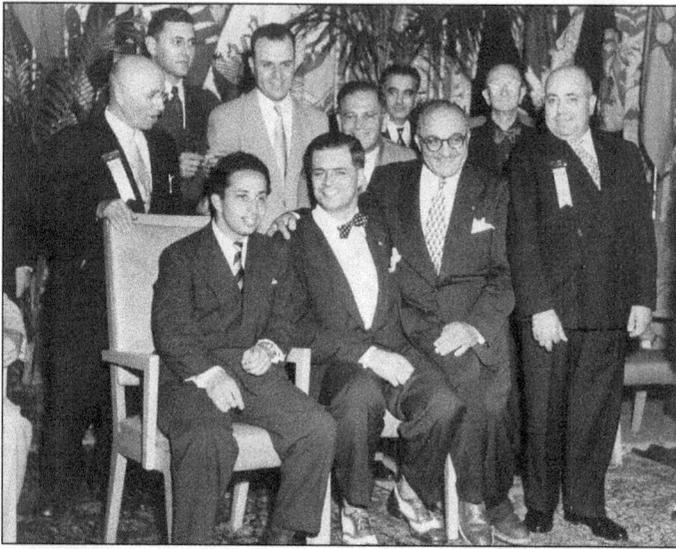

ROYAL VISIT. A 17-year-old King Faisal II of Iraq made his first official visit to the United States in August 1952. At the young king's request, Detroit was added to his itinerary in order to visit the Chaldean community. Seen here from left to right are (seated) Faisal II, Michigan governor G. Mennen Williams, Lebanese consul in Detroit George Bashara, and Joe Acho; (standing) Tom Hakim, Salim Sarafa, Joe Najor, Jack Najor, and two unidentified men. (Courtesy of Eddie Bacall.)

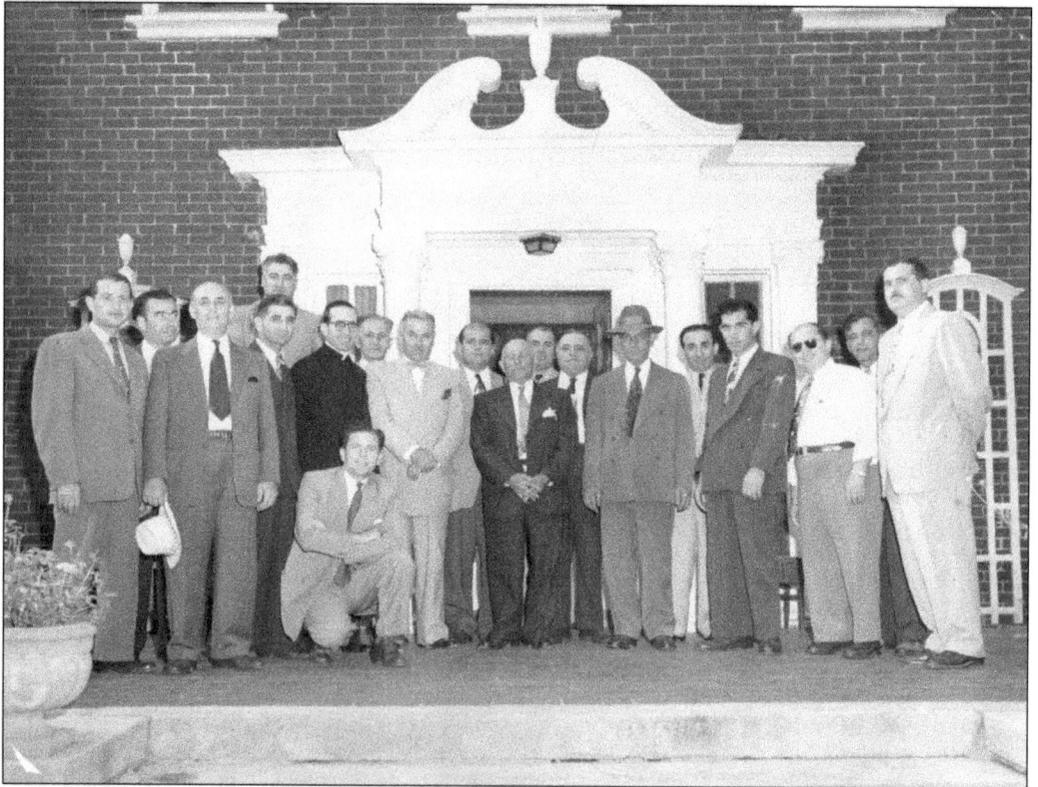

GUEST OF HONOR: SAID GHAZAZ. In 1951, the governor of Mosul visited Detroit and met with many Chaldean friends. The governor stayed at the home of Tom Hakim on Chicago Boulevard. Seen here from left to right are unidentified, Yalda Saroki, George Jonna, Elia Najor, Taleb Namen (behind Najor), Fr. Thomas Bidawid, George Cutsy, Said Ghazaz, David Esshaki, Tom Hakim, unidentified, David Kassa, David Koury, Elias Kinaya, Joe Dalaly, Karim Hakim, Tom George, unidentified, and Salman Sesi (kneeling). (Courtesy of Tobia Hakim archives.)

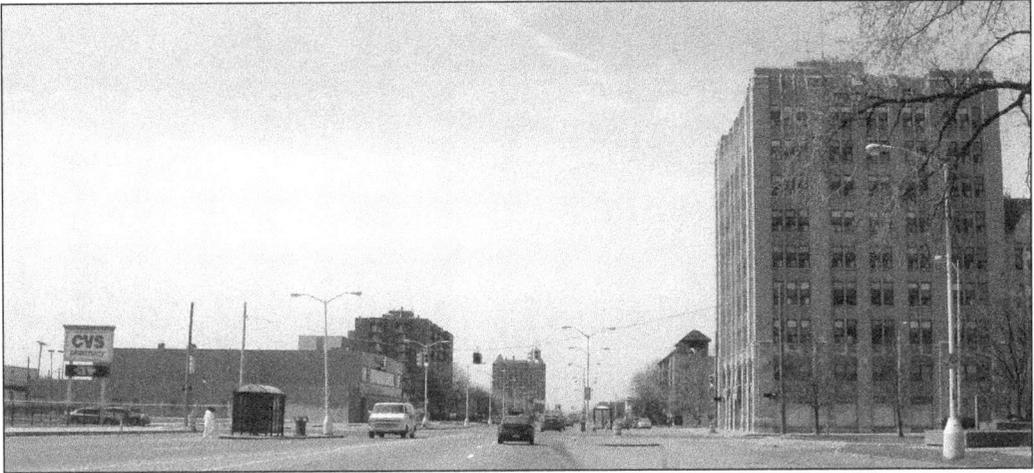

THE DETROIT RIOTS. On Saturday, July 23, 1967, at a bar then known as the Blind Pig on the city's near west side, one of the deadliest and most destructive riots in US history began. The result of the riot was dramatic: massive repairs were needed due to damage to buildings and landscapes. There were significant decreases in business revenue and supermarkets closed down in the area. The void left behind was quickly filled by business-hungry, hardworking Chaldeans. Since that time, Chaldeans have prospered a great deal through their courage, patience, and hard work. Pictured here is West Grand Boulevard at Twelfth street 45 years after the riot. (Courtesy of Mike Russell.)

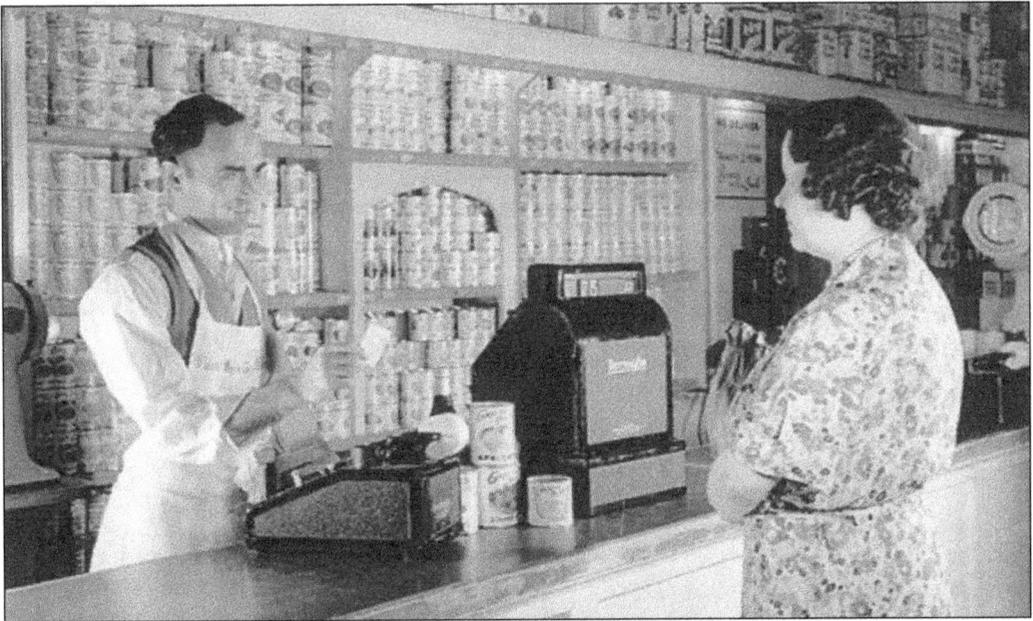

OPEN FROM 7:00 A.M. UNTIL 2:00 A.M. Corner stores were a perfect fit and an economically viable business for newcomers who had limited education and hardly spoke English. Early Chaldean immigrants arriving in Detroit had two choices: work in an automobile factory or in a small neighborhood grocery store. Nineteen-hour days were not a deterrent; almost every Chaldean without exception worked in a grocery store business at some time in his or her life. At the youthful age of 26, Joseph Marogi Sesi partnered with Sam Dabish; both partners had to work long hours in Detroit. Joe Sesi is seen here in 1926 while waiting on a customer at the service counter. (Courtesy of Josephine Kassab.)

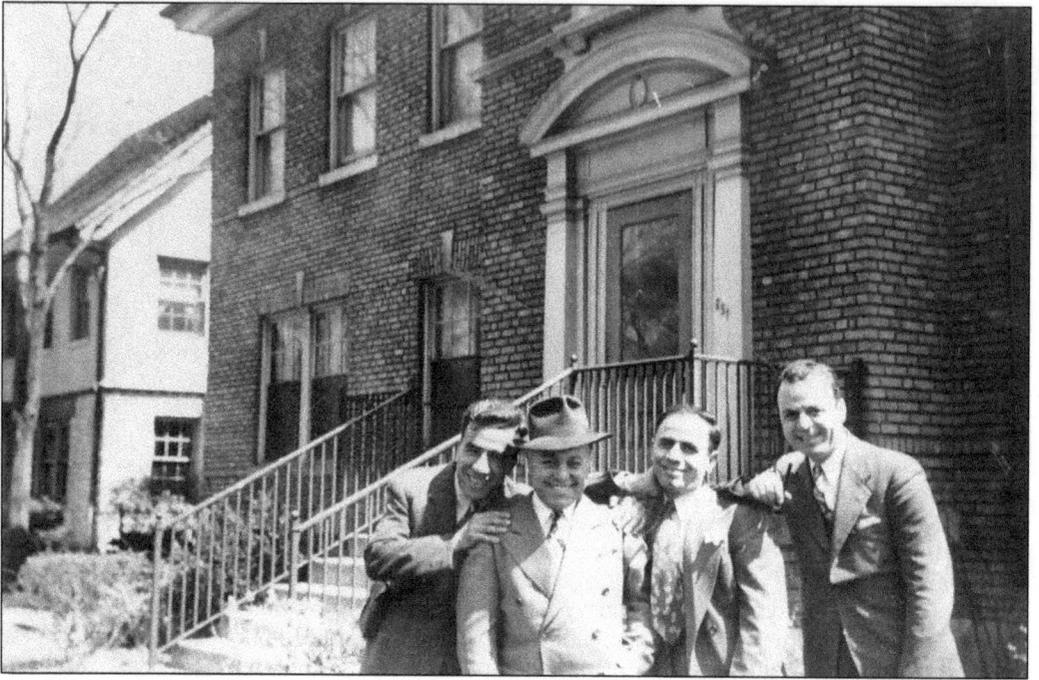

**A PROUD HOME OWNER.** Jack Najor (the photographer) shows his newly purchased home at 651 Boston Boulevard in Detroit to his cousins and friends. His house was designed by legendary architect Albert Khan, who was a friend, landlord, and customer at Safeway Market on Woodward and Euclid Avenues in Detroit. From left to right are Louie Denha, Aziz Najor, Selim G. Roumayah, and Joe Najor. (Courtesy of Julia Najor Hallahan.)

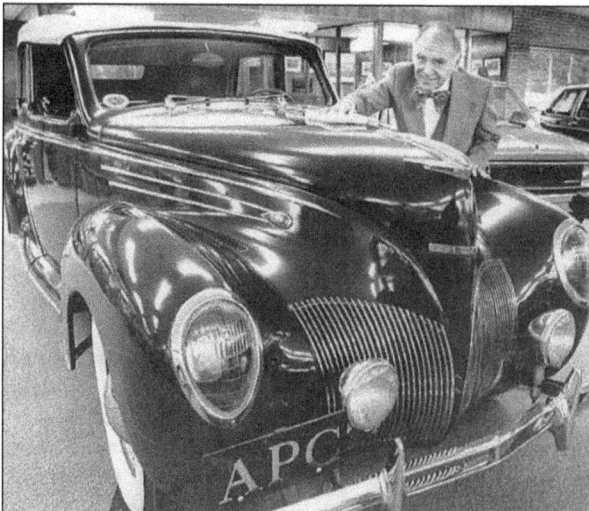

**A KEY OPPORTUNITY.** Joseph Sesi's grocery market, about seven blocks north of the Fisher Building on Second Avenue and Blaine Street, became a key connection for his next business venture. Young Joe met Henry Ford, who lived in the Boston-Edison neighborhood, where Joe's store was located. Henry and his family members were impressed with Joe's work ethic and offered him a position in auto-parts manufacturing. Joe opened the doors of his new Lincoln-Mercury dealership in 1947. In this photograph, Joe Sesi Sr. is polishing an antique Lincoln. (Courtesy of Josephine Kassab.)

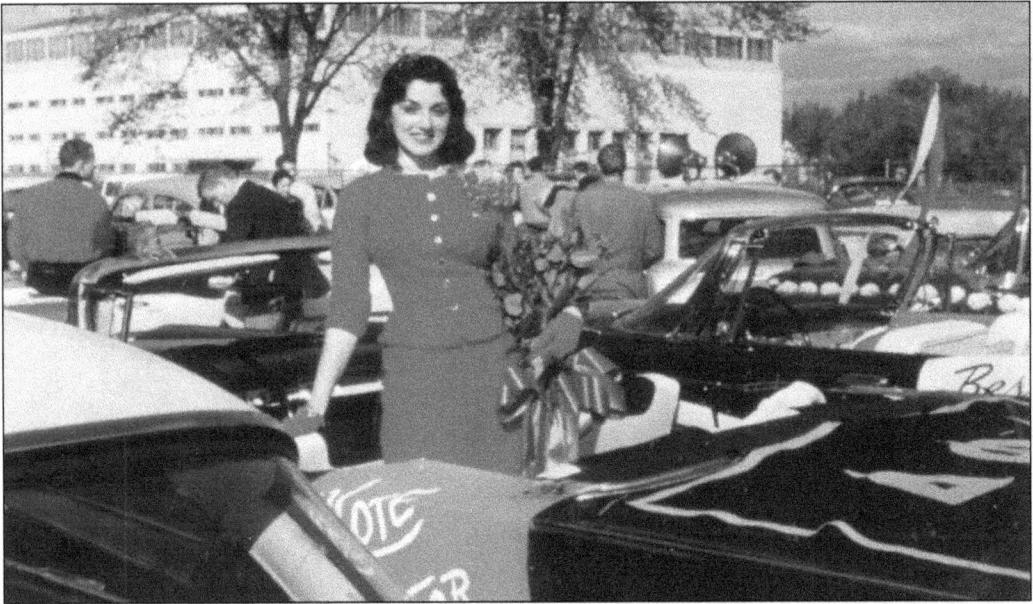

**"Vote for Julie, Everybody's Beauty."** This is what the sign here reads for Julia Najor Hallahan as a candidate for homecoming queen. In her sophomore year in 1957, Julia stands in front of the Field House at the University of Detroit. Detroit. Julia was instrumental, along with other Chaldean educators, in establishing the Chaldean language teaching endorsement in Michigan. She also contributed to the formation of Southfield schools' bilingual program in 1975. (Courtesy of Julia Najor Hallahan.)

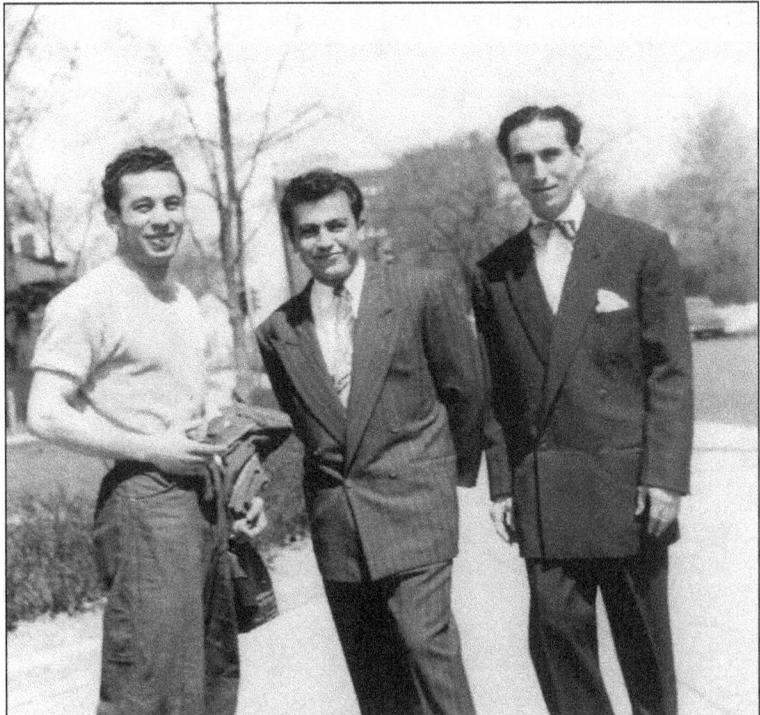

**College Life.** College buddies pose for a photograph in the spring of 1954 on Wayne State's campus in Detroit during their lunch break. Wayne State University was the college of choice for many Chaldean students who came from Iraq on student visas. From left to right are classmates Louis Stephen, Faisal Arabo, and Farage Hakim. (Courtesy of Faisal Arabo.)

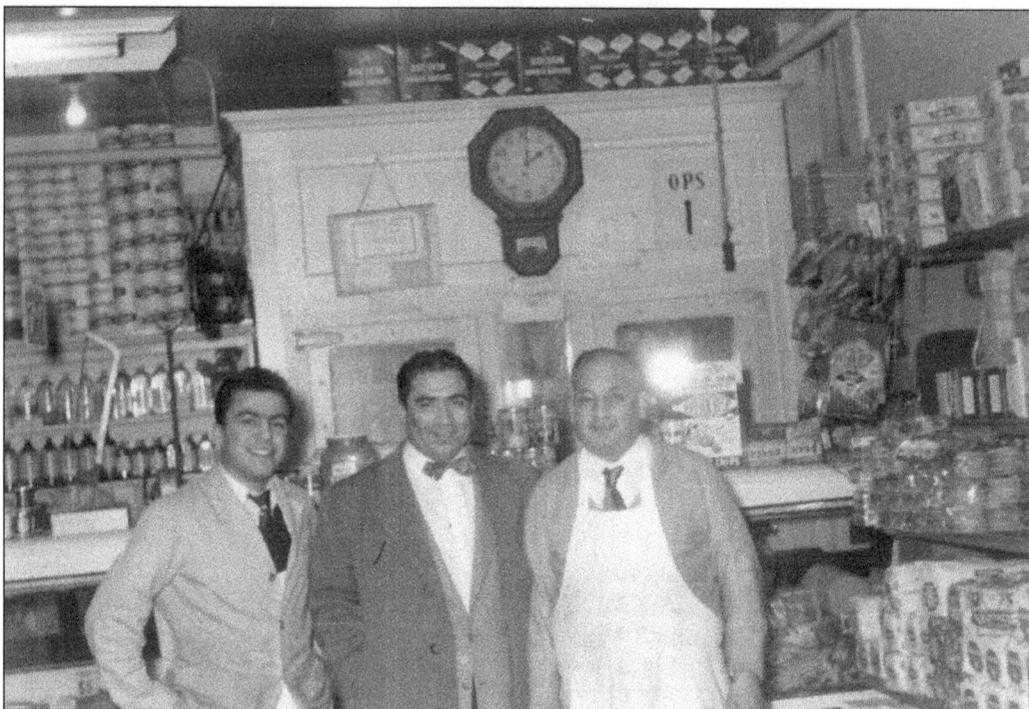

BREAK TIME. In 1953, Faisal Arabo worked part-time for store owner "Uma Gigee," or "Uncle Gigee," at the Vernor and John R. Market in Detroit during his freshman year at Wayne State University. From left to right are Arabo, Dean Aziz Shallal of Baghdad University, who was visiting Detroit, and Uma Gigee. Visiting an old friend at his shop is an old country tradition where one can have a chitchat and enjoy fresh chai (tea) or Turkish coffee. (Courtesy of Faisal Arabo.)

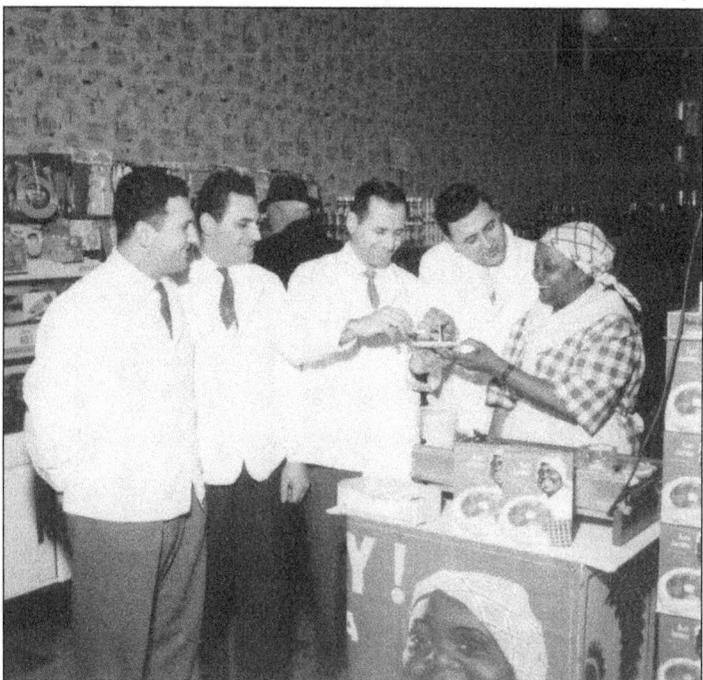

TASTE TESTERS. An Aunt Jemima representative offers a food sample to be tasted by customers, starting with the store owners at the Big Dipper Market. It was common for nationally known companies to promote products in big cities. Detroit was always on the list—a result of its diverse and cultured population during the Motor City's heyday. (Courtesy of Buddy Atchoo.)

**RALEIGH HOUSE, 1970.** Iraqi ambassador to the United Nations Taleb Shabib receives a check from Chaldean activist Faisal Arabo, a host of the *Arabic Voice* program based in Detroit. The check was donated to assist Palestinian refugees who were still living in refugee camps. From left to right are Sabah Roumaya (far left), Shabib (receiving the check), Gabe Essahaki, unidentified, Dawood Dalali, Arabo, and Dahafer Mansour. (Courtesy of Faisal Arabo.)

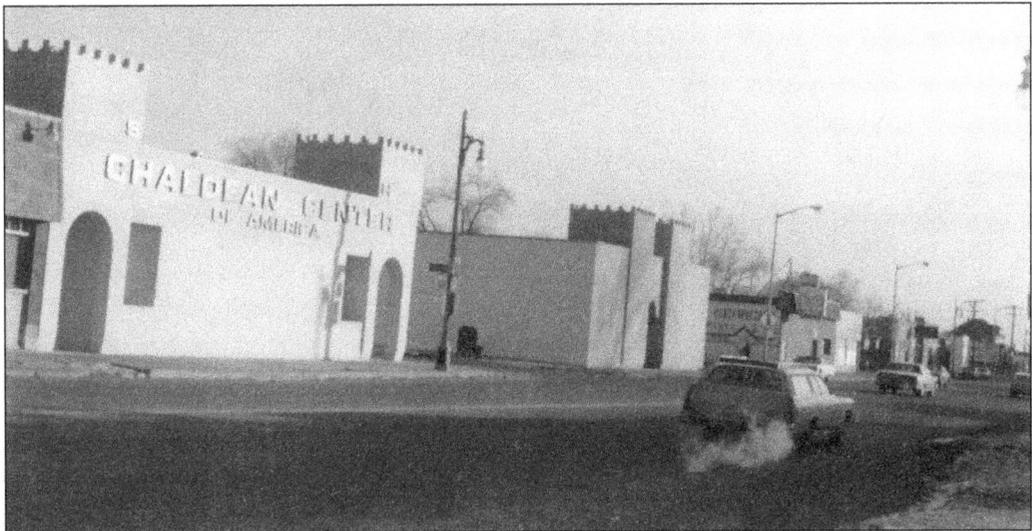

**A PLACE OF FAMILIARITY.** The Chaldean Center of America was established in Detroit on Seven Mile Road (between Woodward Avenue and John R. Street) in the 1970s, reaching out to Chaldean and Iraqi immigrants to offer support through cultural and educational programs. This photograph was taken in the early years of the center. It became an environment of comfort and support for Chaldean immigrants. The center also served as a home for other Chaldean cultural activities in Metro Detroit. (Courtesy of Rev. Jacob Yasso.)

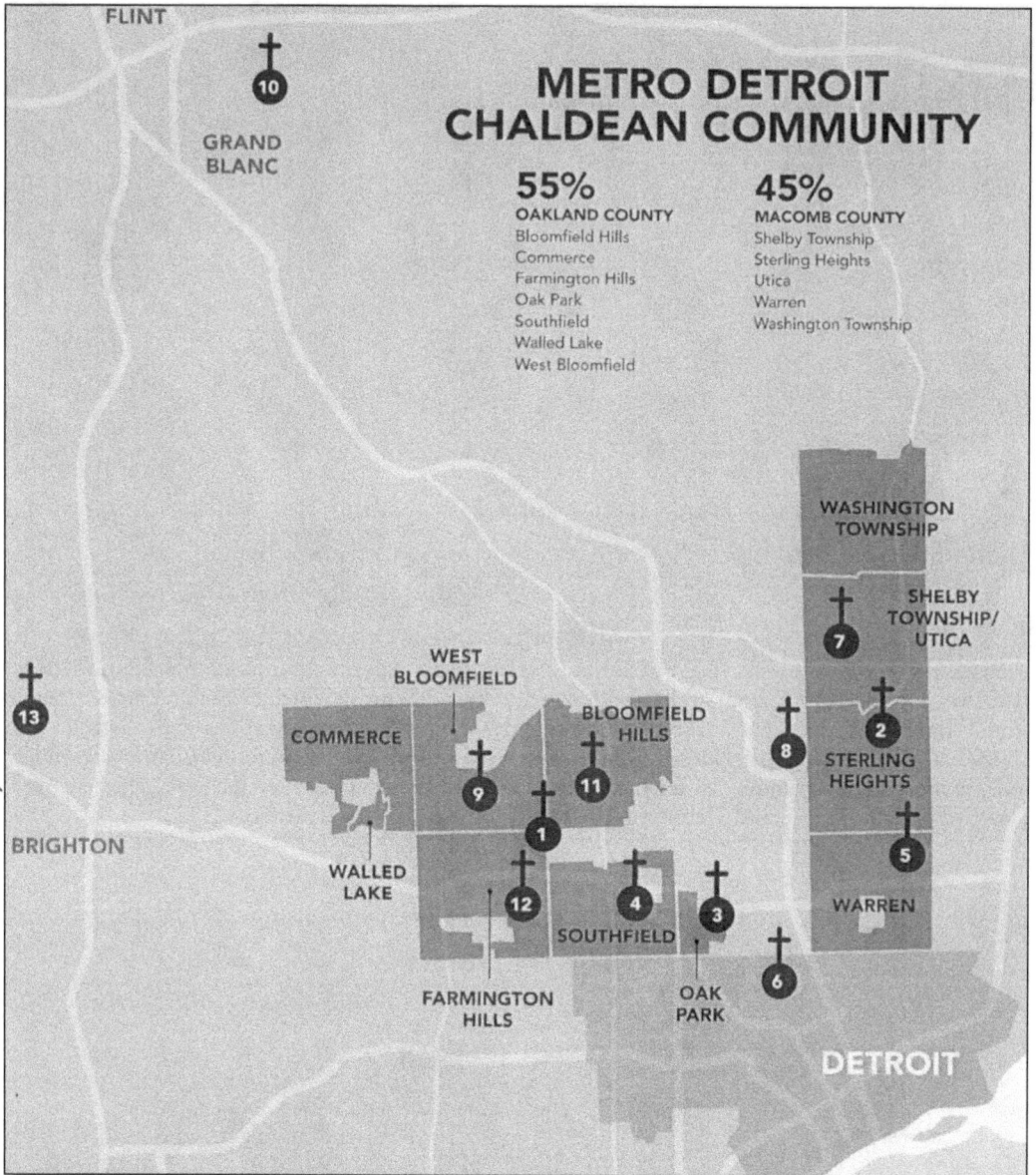

# METRO DETROIT CHALDEAN COMMUNITY

FLINT

GRAND BLANC

**55%**
**OAKLAND COUNTY**
Bloomfield Hills
Commerce
Farmington Hills
Oak Park
Southfield
Walled Lake
West Bloomfield

**45%**
**MACOMB COUNTY**
Shelby Township
Sterling Heights
Utica
Warren
Washington Township

WASHINGTON TOWNSHIP

SHELBY TOWNSHIP/ UTICA

WEST BLOOMFIELD

BLOOMFIELD HILLS

COMMERCE

STERLING HEIGHTS

BRIGHTON

WALLED LAKE

WARREN

SOUTHFIELD

FARMINGTON HILLS

OAK PARK

DETROIT

CHALDEAN PIONEERS. The excitement of new job opportunities meant new immigrants choosing to move to the Detroit area, following their relatives and cousins, where they could work, have a social life, freely express their faith, and send their children to good schools. The proximity of being within walking distance to work, church, and a community center was the deciding factor in choosing Detroit as a new home. Many Chaldeans live near the same areas as their churches. This map shows where the incoming immigrants were located by the location of Chaldean churches. Early Chaldean immigrants in the 1920s, 1930s, 1940s, and 1950s were concentrated in Detroit. In the 1960s, and 1970s, Chaldeans started moving to Southfield, Oak Park, and other suburbs of Detroit. In the 1980s and 1990s, Chaldeans spread out to Farmington, West Bloomfield, Warren, and Sterling Heights. In the 2000s, Chaldeans continued to grow in other cities such as Bloomfield Hills, Troy, and Shelby Township. (Art by Alex Lumelsky.)

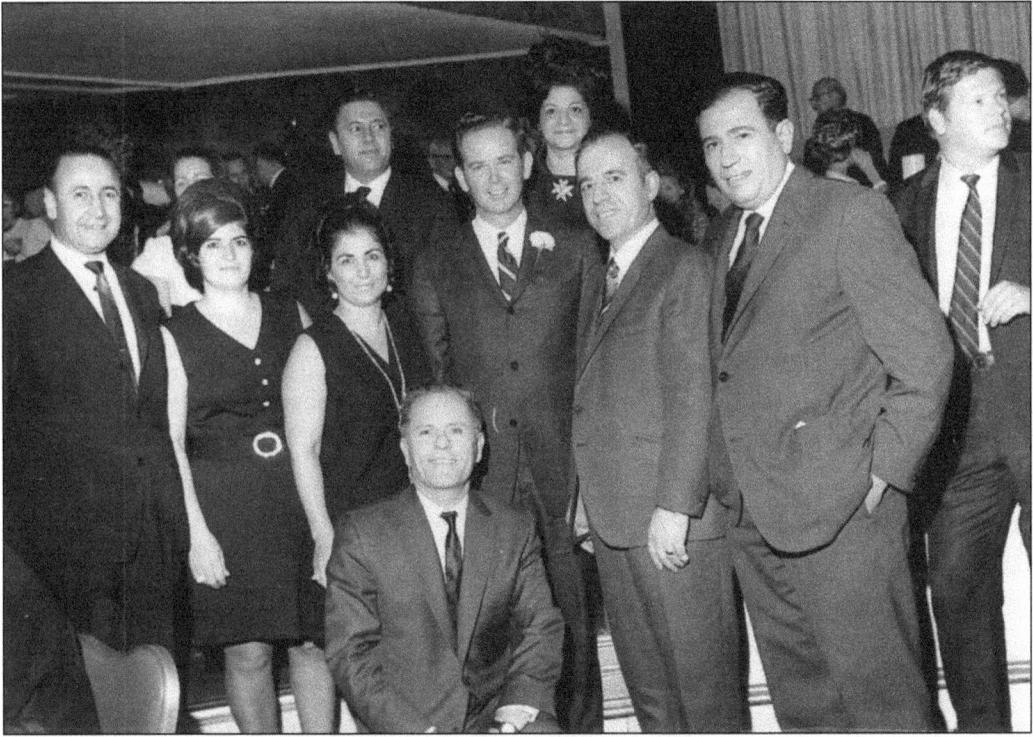

**CHALDEANS WELCOME MILLIKEN.** William Milliken, the longest-serving governor in Michigan history (1969–1983), enjoys the support of the Chaldean community at his dinner reception as a newly elected governor at the famous Latin Quarters in Detroit. Pictured from left to right are Karim Sarafa, Bernadette Sarafa, Virginia Denha, Salim Sarafa, Gov. William Milliken, Margaret Sarafa, Thomas Denha, Gabe Esshaki, unidentified, and (kneeling) Salman Sesi. (Courtesy of Judy Sarafa Jonna.)

**PRESIDENT CLINTON MEETING WITH THE CHALDEANS.** On October 21, 1996, Chaldean businessman Sam Danou hosted Pres. Bill Clinton, the most gifted political speaker and campaigner of his time, at the Fox Theatre in Detroit to raise money for his Clinton's campaign. The Chaldeans became one of the first Middle Eastern minorities to be recognized by an American president. Clinton was also the first president to meet with a Chaldean immigrant. The event was organized by Danou. (Courtesy of Sam Danou.)

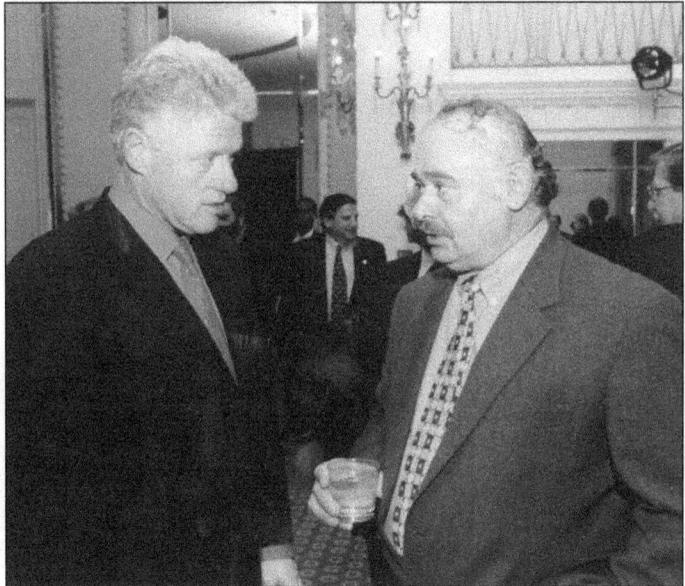

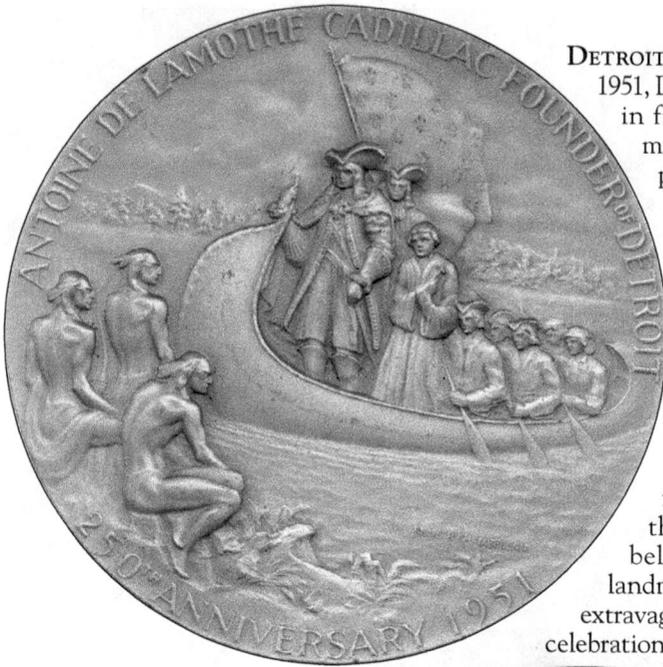

**DETROIT'S BIRTHDAY PARTY.** On July 24, 1951, Detroit celebrated its 250th birthday in front of city hall—the crowd was massive. "It was the biggest crowd of people I have ever seen in my life," recalled Jack Najor, a Chaldean pioneer who came to Detroit in the early 1920s. "The biggest crowd of all the weddings I have seen in my entire life." Pres. Harry S. Truman made a special visit to attend the celebration. The anniversary medal seen at left depicts Antoine de la Mothe Cadillac, a Frenchman and the founder of Detroit, who arrived in the city on July 24, 1701. The image below shows Detroit's skyscrapers, landmark buildings, and landscape. An extravagant parade was a part of the official celebration. (Both author's collection.)

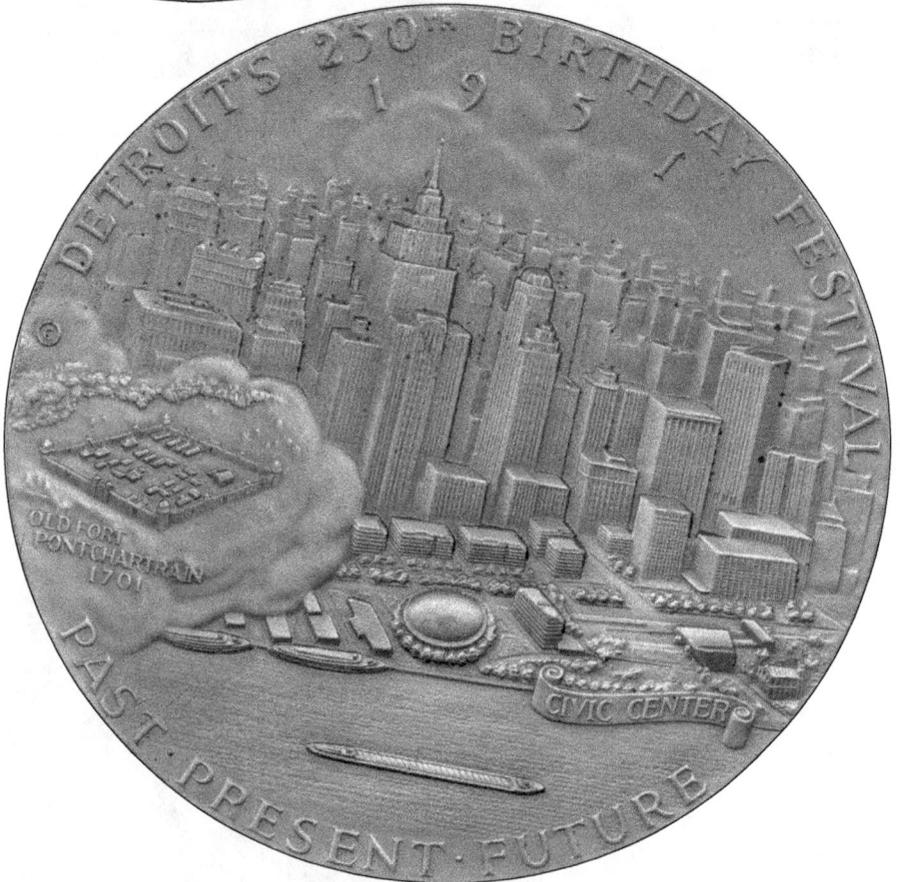

# *Five*

# CULTURAL ADAPTATION

Like other ethnic groups that have immigrated to the United States, Chaldeans adapted to American customs and lifestyles even as they retained pride in their heritage and preserved family values. They believe in and respect the US Constitution and share in all the rights and responsibilities of American citizenship, and many of them have served in the US Armed Forces. They are a proud part of the dynamic, multicultural populace of this great country, but many challenges still exist as they continue to gradually integrate into the American melting pot.

Early Chaldean immigrants who came from the villages can be described as simple, primitive people, and they were very family oriented. Many members of the family, including uncles, aunts, and in-laws, all lived together under one roof as they adapted to the new culture. Today, the marriage of cousins is not just out of the question but in fact taboo for American-born Chaldeans, but it was an essential part of the traditional culture. For married children to live with their family today is very rare. For the new generation, dating, studying out of state, and even living on one's own before getting married are all gaining acceptability and slowly becoming the status quo in Chaldean society.

Early Chaldeans also enjoyed a wide variety of sports. The new Chaldean Americans learned how to play baseball, hockey, and American football, which were not played in the old country. More and more young children also adapted to playing basketball and golf. In another cultural change, fewer Chaldeans have mustaches; it was exactly the opposite back home. For Americanized Chaldeans, shaving mustaches is no longer a problem, nor is the mustache still regarded as a symbol of honor or manhood.

The first generation of immigrants faced many challenges and adjustment hardships. Just like many other minorities, they adhered more to the traditional Chaldean culture and were less receptive to change than subsequent generations of Chaldeans born in the United States. As the proceeding generations become more Americanized, they become a part of the large American melting pot in which everyone can claim to come from somewhere else on the globe.

COTTAGE GETAWAY. Pictured here in the 1940s are Mr. and Mrs. Marogi Dickow, sitting on the left, with their family at the Matti's summer cottage on Cass Lake. Over the last three decades, some Chaldeans have chosen the west side (west of Woodward Avenue) as a place to live and have enjoyed being close to many lakes. For the kids, nothing can compete with a swim. Fishing, jet skiing, or a relaxing ride on a pontoon boat was an integrated and enjoyable adaptation for Chaldeans in the Great Lakes state. (Courtesy of Nadine [Dickow] Rabban.)

A DAY AT THE BEACH. Spending a day at the water's edge is an American pastime, especially in Michigan, the Great Lakes state. For young Chaldean men like those pictured here, going to the beach to catch some sun, checking out beauties in bikinis, or simply enjoying the music and surroundings was a favorite at Metropolitan Beach, east of Detroit. This photograph was taken in the summer of 1950. From left to right are Faisal Arabo, Prince Galozi, Louie George, and Joe Abdal. (Courtesy of Faisal Arabo.)

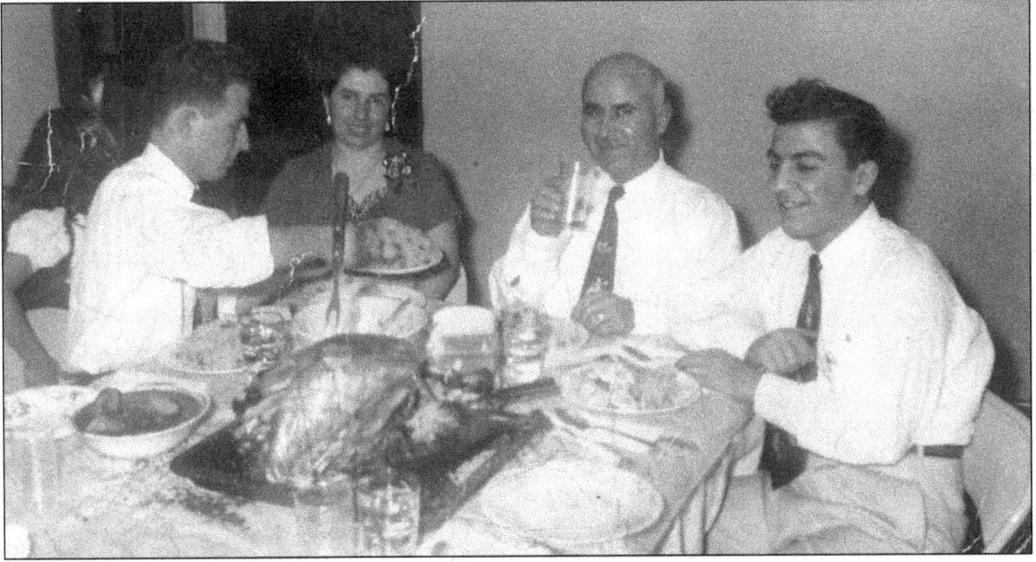

**THANKSGIVING AT THE HANOCHA HOUSE, 1952.** Chaldeans were quick to adapt American holidays and customs like Thanksgiving dinner. In the Chaldean villages of northern Iraq, a dinner of turkey was also celebrated at the eve of the new year, December 31. As an old tradition, every household would purchase a young turkey from a local farmer to be fattened for the New Year's feast. Seated from left to right are, Manual Najor, Mary Hanocha Shouniya, Yousif Hanocha Shouniya, and Faisal Arabo. (Courtesy of Faisal Arabo.)

**CHALDEAN GIRLS' PAJAMA PARTY.** In the late 1950s, more Chaldeans immigrated to America and more young Chaldean adults were attending American high schools and colleges, picking up new trends, making friends, and assimilating to American society. Samira Essa invited her friends for a pajama party at the Essa home in Detroit. Pizza and popcorn, Coca-Cola, listening to American music, and sharing stories before bedtime was a new enjoyment. Pictured from left to right are Vickie Saroki Sarafa, Josie Saroki Sarafa, Julia Najor Hallahan, Paula George, and Samira Essa. (Courtesy of Julia Najor Hallahan.)

**AMERICAN AT HEART.** Jack Najor's unique personality and colorful suits made him the talk of other Chaldean pioneers. Born on April 10, 1908, Najor chose Dorothy Cooper, as American as apple pie, to be his wife. In a summer in the early 1930s, Jack had one message to deliver at a social gathering: "Hear me out everyone, I'm in this great country of America. I did not come here to save money and return to the old country. I came to stay, and I'm not going back." (Courtesy of Corinne Najor Farrelly.)

**GOLDEN ANNIVERSARY.** A longtime commitment is always something to celebrate. Here, Jack Najor and his wife, Dorothy, celebrate 50 years of marriage in May 1983 at Topinka's Country House restaurant in Detroit. The anniversary celebration was a pleasant surprise for the couple that was planned by their 10 grandchildren. The night was filled with dancing, dinner, drinks, and loved ones. (Courtesy of Corinne Najor Farrelly.)

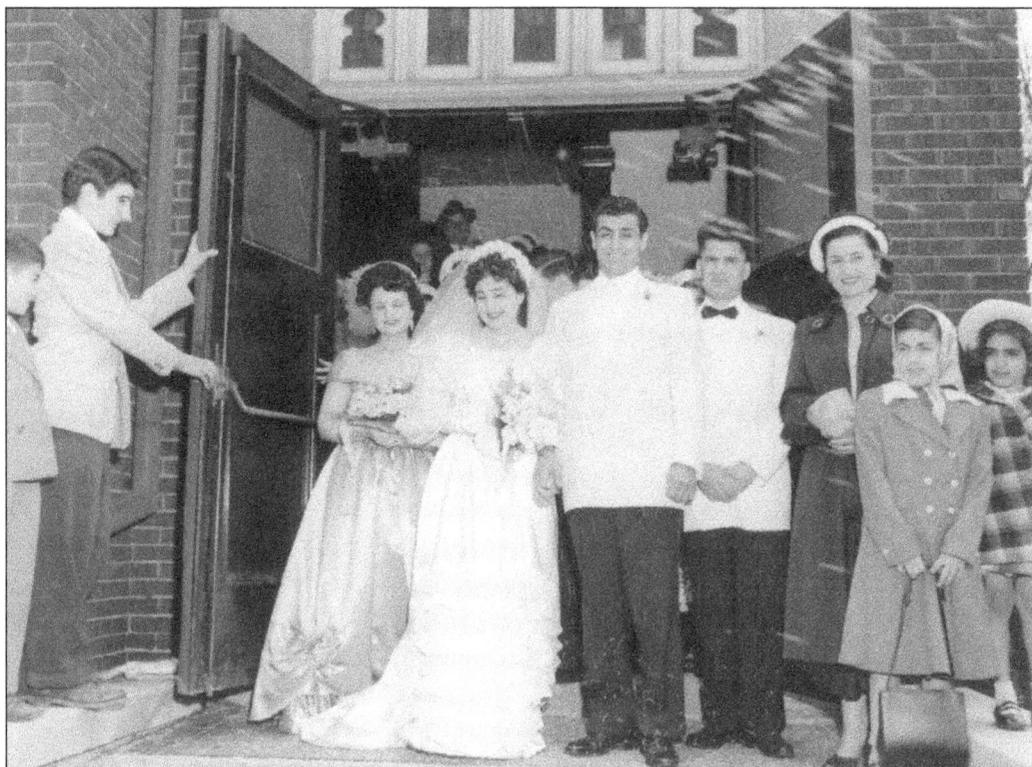

**WEDDING WISHES.** Peter Binno and Theresa Essa tied the knot on May 12, 1951, becoming husband and wife at Mother of God Church on Hamilton and Euclid Avenues in Detroit. As they are walking out of the church doors, well-wishers throw rice over the bride and groom, a long-standing American tradition as a sign of wishes for fertility and prosperity. Back in the old country, the tradition was to slaughter a sheep at the feet of the bride and groom, an ancient Mesopotamian custom. (Courtesy of Julia Najor Hallahan.)

**LEISURE AT LATIN QUARTERS.** Pictured here are elegantly dressed Chaldean women enjoying a ladies' night out at Detroit's Latin Quarters in the 1950s, a ritzy night spot that hosted legendary musicians on East Grand Boulevard. Women in Arab countries were somewhat restricted, not being able to freely walk or drive around without considering the time and place. Since moving to America, Chaldean women fully enjoyed the freedoms of education, travel, financial independence, and social events. (Courtesy of Mary Ann [Jalaba] Yono.)

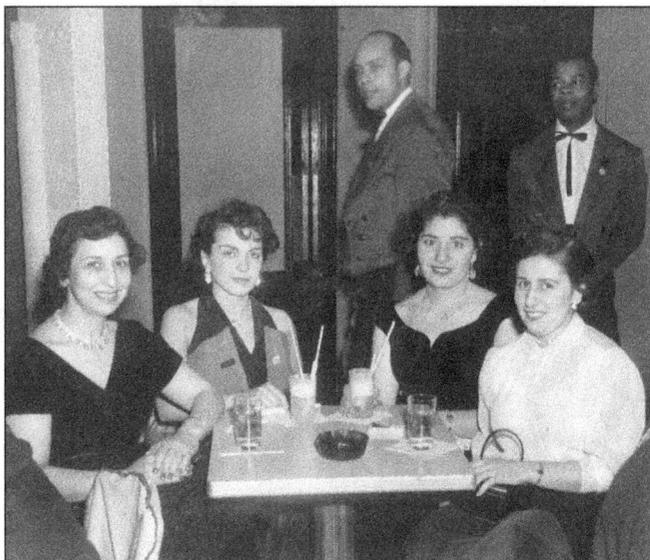

EVERYONE KNOWS YONO

Elect . . .

# Jerry A. Yono
## STATE REPRESENTATIVE
DEMOCRAT                    14th DISTRICT

Experienced - Vigor - Sober Judgement

No. 214 on Machine

VOTE IN THE PRIMARY, TUESDAY, SEPTEMBER 1, 1964

— JERRY A. YONO —

Believes in sound fiscal policies; tax reform; relief for property owners from exorbitant tax and tax benefits for retirees.

YONO — favors a review of the criminal code and penal policies.

VOTE FOR YONO — No. 214 ON MACHINE

POLITICAL ASPIRATIONS. Running for public office was a foreign concept for most immigrants, especially those who were minorities in a country governed by a dictatorship. "Vigor, Experienced and Sober Judgment" is how candidate Jerry Yono described himself. Yono was the first Chaldean to run for state representative. He won the August primary but lost in the general election in November 1964. (Courtesy of Jerry Yono.)

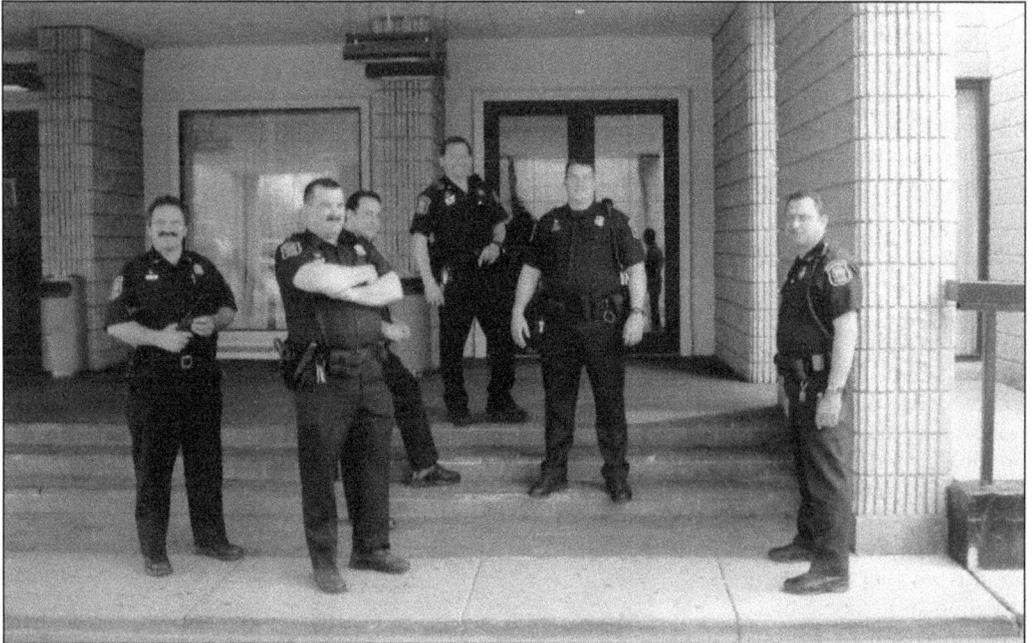

PRESIDENTIAL POLITICS, 1996. Officers guard the entrance of Southfield Manor, the Chaldean community's private club. The Chaldean Political Action Committee hosted First Lady Hillary Rodham Clinton twice at Southfield Manor. Many Chaldeans gathered to show support for Pres. Bill Clinton's reelection effort. They hoped to influence foreign policy and have sanctions on Iraq lifted. (Author's collection.)

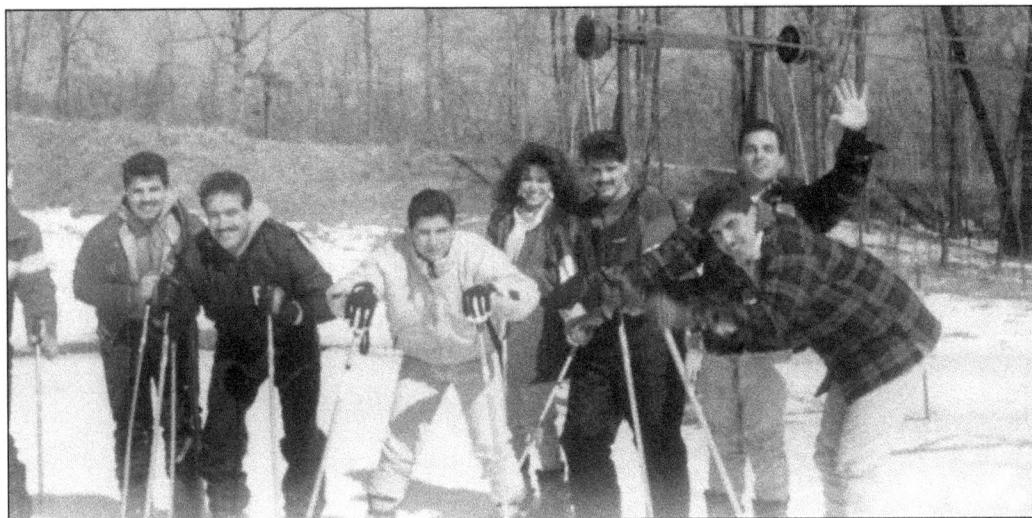

CHALDEANS SKIING. Like many Michiganders, most Chaldeans hibernate during the winter to keep warm—but not this group of youngsters. Adaptation to the winter season and the lifestyle of winter sports are enjoyed by the Chaldean American Youth Club (CAYC), pictured here. In the late 1980s, the CAYC planned a ski trip for club members and friends in White Lake, Michigan. From left to right are Khalid Kizi, Sohail Dayimiya, Manhal Shammami, Janan Al Attar-Zaia, Nashwan Kanou, Manhal Jabborie, and Amir Kizi. (Courtesy of Sohail Dayimiya.)

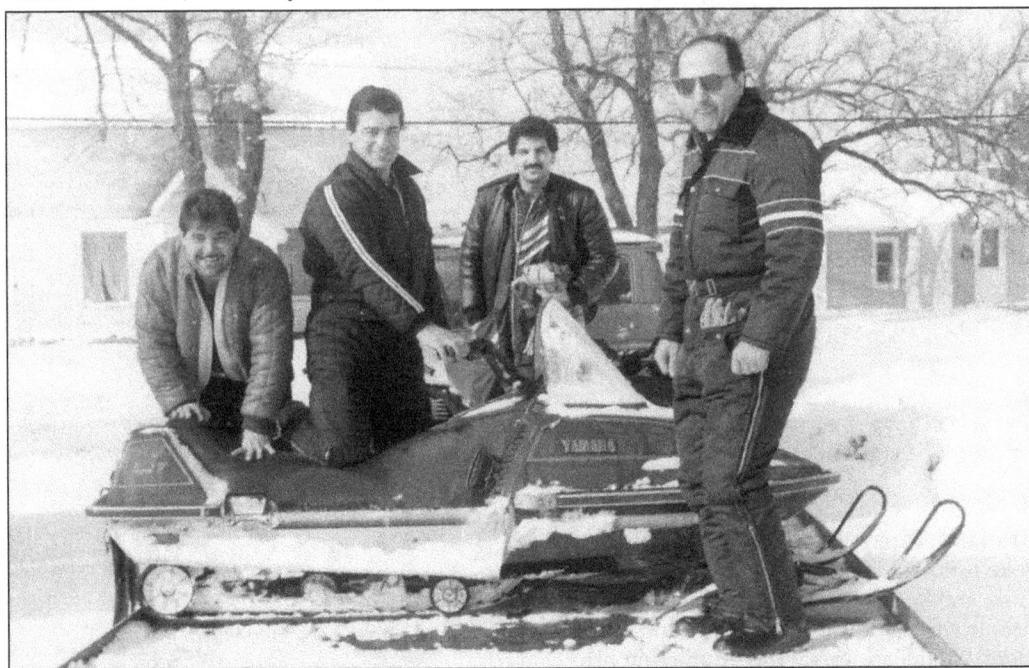

GEARING FOR SNOWMOBILING. Ready for an adventure, Sabah "Abo Nono" Isho and his buddies have gotten together to explore and snowmobile in northern Michigan's snowy winter season. Iraq, the birthplace to most Chaldean immigrants, does not have a full snow season. These Chaldeans are taking advantage of the four seasons in America's Midwest in the late 1980s. From left to right are Abo Nono, Saber Kassab, Talal Hanosh, and Edwar Jolagh. (Courtesy of Sabah "Abo Nono" Isho.)

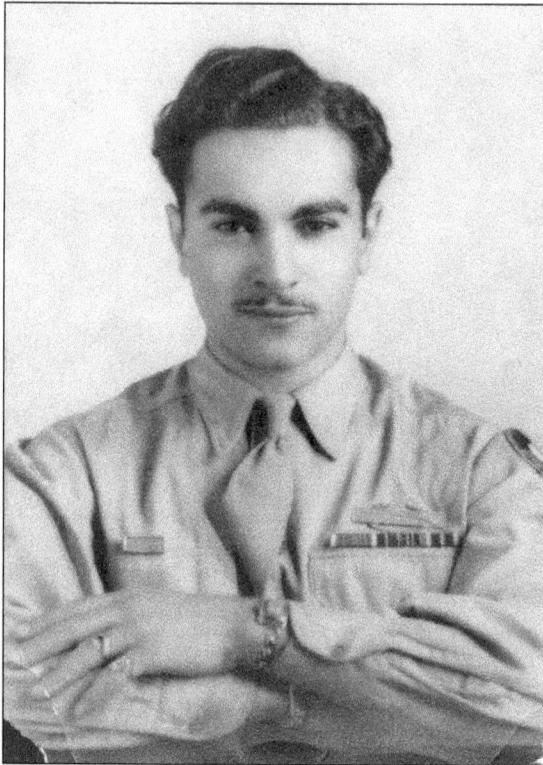

**WOUNDED IN NORMANDY.** Peter Paul Essa was born in Detroit in 1925 and was the only known Chaldean to fight with and witness Gen. George Patton's tanks landing in Normandy on D-Day. He served in the US Army in World War II from 1943 to 1945, holding the rank of private first class. Essa received several awards and medals, including a Purple Heart, a Combat Infantryman Badge, a battle star, and a good conduct medal. (Courtesy of Peter and Samira Essa.)

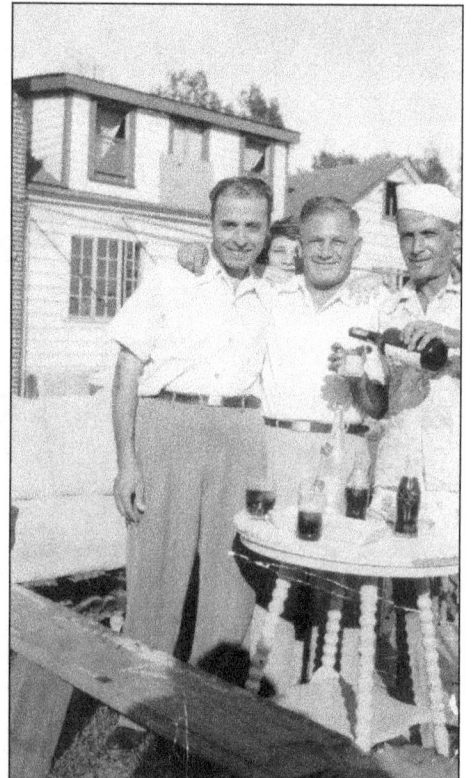

**STICKING TOGETHER.** Drinking rum and coke is not a Chaldean tradition. Scotch, arak, and beer were drinks of the common people when entertaining family and friends. Here, Chaldeans enjoy the summer months in Michigan. Long-life friends and business associates in this photograph were talking about business, politics, and community activities. From left to right are Marogi Dickow, Ruby (Najor) Huhn, Jack Najor, and Tom George. (Courtesy of Nadine [Dickow] Rabban.)

AT THE PARK. Americans in all parts of the United States enjoy barbecuing outdoors at local parks with family and friends. After World War II, Coca-Cola and other soft drinks were luxury refreshments consumed regularly by salary-secured households. Chaldeans in America adapted to and regularly enjoyed the American tradition of a picnic at a local park for birthdays, sports, and family reunions. This photograph was taken in 1980 at Metro Beach Park. (Author's collection.)

CLASS OF '87. Here, Chaldean seniors celebrate their graduation together at the annual College and High School Chaldean Commencement, organized by the Chaldean Federation of America (CFA) at Mother of God Church. If these graduates resided in a northern Iraqi village, socializing in the same manner may have been considered inappropriate. The Iraqi-born parents of these graduates embraced and adapted to the social manner of their teenagers growing up in American society. (Courtesy of Julie Hakim.)

71

HAPPY HOUR. Wherever people might be, to Chaldeans life revolves around business and entrepreneurship. If one is at a wedding, church, fundraising event, or even a funeral hall, talking business is the norm in Chaldean culture. From left to right are Richard Gergis (or "Gorgeous," as he liked to be called), Louis Stephen, Salman Sesi (back to camera), and charismatic business magnate Michael George (holding a cigar) in the 1980s. (Courtesy of Julie Hakim.)

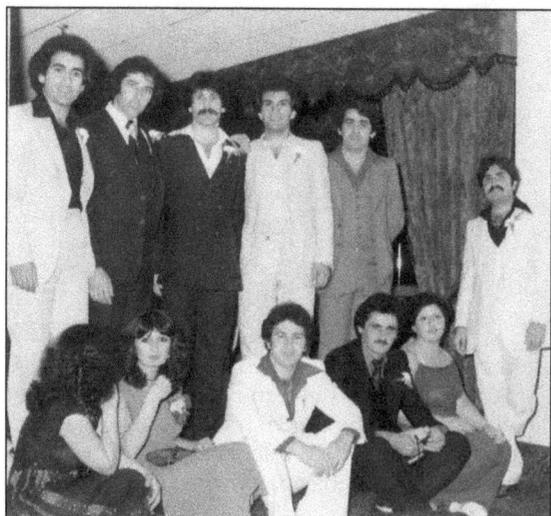

SOCIAL CULTURE IN THE 1970s. Social activity was very limited in Iraq. The mingling between men and women and the dress code of wearing Western clothes was not the norm in Iraq. In this photograph, whether a brother, sister, relative, or friend, all were free to join the socializing. Active young people participated in numerous community activities, including bingo, talent shows, and dancing. Seen here from left to right are (seated) Talia Karmo, Nazik Stephen, Zuhair Karmo, Nazar Stephen, and Nadia Atisha; (standing) Dr. Talat Karmo, Kirk Boji, Augeen Kalasho, Ismat Karmo, Jimmy Konja, and Mukhles Karmo. (Courtesy of Ismat Karmo.)

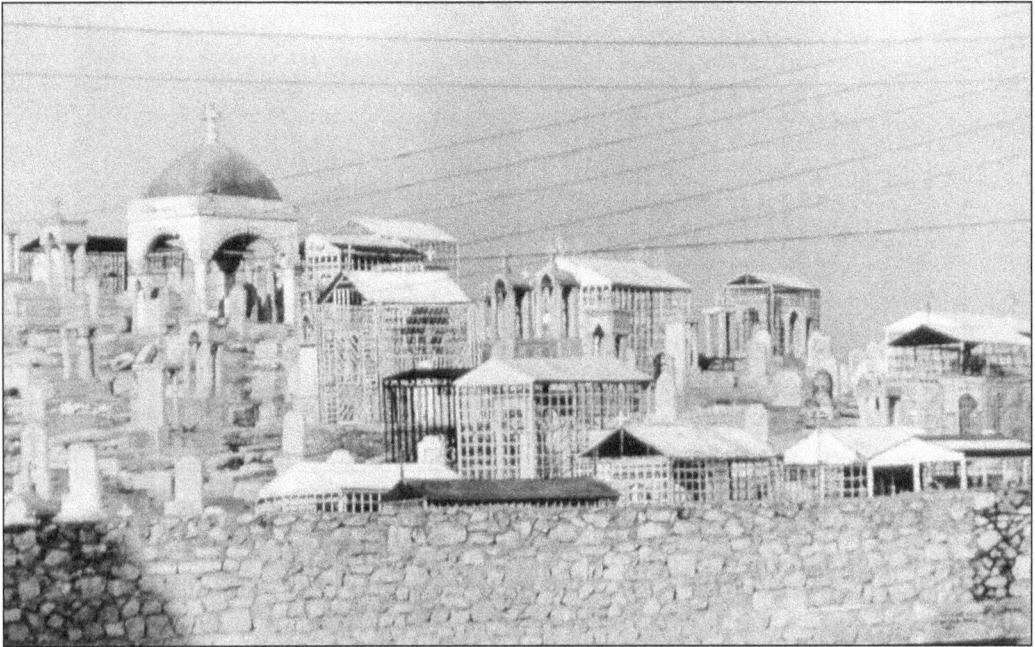

THEN AND NOW. The funeral-service business did not exist in Iraq or the Muslim countries of the Middle East. The custom, following the old tradition of "our grandfather" Abraham of Ur, was to bury the body of the deceased within 24 hours. In America, the deceased body goes through a process. Visitation, or viewing, of the body has changed in recent years in Chaldean culture in America. Decades ago, the viewing of the body would last as long as three to seven days. In the last few years, more people have adapted to American tradition, which is a one- or two-day visitation. Now, many families have preferred no visitation at all in fulfilling the wishes of the deceased. The burial day is the only day for one to pay their respects, whether at the church procession, cemetery (pictured below), or at the luncheon after the funeral. (Both author's collection.)

AUTHENTIC COOKING. Chaldean grandmothers and great-grandmothers never used measuring tools or kitchen timers while cooking. Reading recipes was unheard of in Iraqi villages. The most important ingredient used in the kitchen, according to the grandmother of the house, was "common sense." With common sense, people used their eyes, hands, and nose. In the last 30 years, three cookbooks have been published by Chaldean women. Julie Najor (wife of the late Ramzy Najor) published the first Chaldean cookbook in the 1970s, called *Babylonian Cuisine*. Samira Cholagh published her cookbook, *Treasured Middle Eastern Cookbook*, in 1998, and *Ma Baseema, Middle Eastern Cooking with Chaldean Flair*, was published by a dedicated team, the Chaldean American Ladies of Charity (CALC), in 2010. Proceeds from *Ma Baseema* go towards the support of the charity projects of the CALC organization. (Courtesy of Julie Najor, Samira Cholagh, and Huron River Press.)

# *Six*

# SOCIAL LIFE

Historically, Chaldean society was patriarchal, with the father as the head of the family. Women followed the traditional roles as wives and mothers—they were the heart and the nurturers of the family. Children were given a sense of responsibility toward each other and were taught to show respect and to honor their elders. Traditionally, Chaldean parents emphasize the values of morality, integrity, hard work, and strong family ties.

In the villages, marriages were often arranged, and they were lifelong commitments. Sons helped their fathers in the fields, and daughters helped with the household chores and the care of younger siblings. Chaldeans carried their strong family ties to America. Families often have many children, and cousins and relatives are often clustered together. It is not unusual for extended family members to live together in one house, with other relatives also living nearby.

Parents are less and less involved in the final decision of picking a future wife for their sons or a husband for their daughters, but choosing a Chaldean spouse known by the parents is always encouraged and embraced.

Food plays an important role in Chaldean social customs and culture. From the time food was depicted in the form of fruit in Garden of Eden—and food found throughout the Bible—it has not only been a matter of nourishing the body, but it is a way to imbed the body with sanctity. Many ingredients and dishes in Chaldean kitchens today are the same as Biblical dishes.

"The Chaldeans of Babylon enjoyed a high standard of living and surrounded themselves with richly beautiful buildings with enormous courtyards," wrote A.G. Mazour and John M. Peoples in their book *Men and Nations*. Just like their ancestors, the more fortunate and well-to-do Chaldeans enjoy the American dream of success. With more Chaldeans achieving success and financial stability, they are able to send their children to private schools and universities that reflect their economic prosperity and unity-centered culture.

GETTING MARRIED YOUNG. In the days of Mesopotamia, it was customary for girls to marry at a very young age, sometimes as young as 12. Pictured here are Abdel Karim Sesi and his wife-to-be, Jameela Zia Kinaia. Standing next to the groom in a white suit is Chaldean journalist and writer Yousif Hermiz Jammo. Jameela was about 14 years old on her wedding day in July 1939. By the early 1940s, the Sacred Heart Church in Telkaif decided after conferring with its archdiocese in Mosul not to marry girls under age 16. (Courtesy of Josephine Kassab.)

EXCHANGING VOWS. Louie George and his beloved wife, Suad Sarafa, are pictured here in Mother of God Church on Hamilton Avenue and Glen Court on January 30, 1955. This ceremony was served by Toma Bidawid (to the right of the cross) and Toma Reis (to the left of the cross), the first and second priests to serve at Mother of God. Choosing a partner is the most important decision to make in life for Chaldeans. An ideal partner is someone the family knows, comes from the native village, and has a good reputation; such honored standards were carried-on customs. (Courtesy of Anmar Sarafa.)

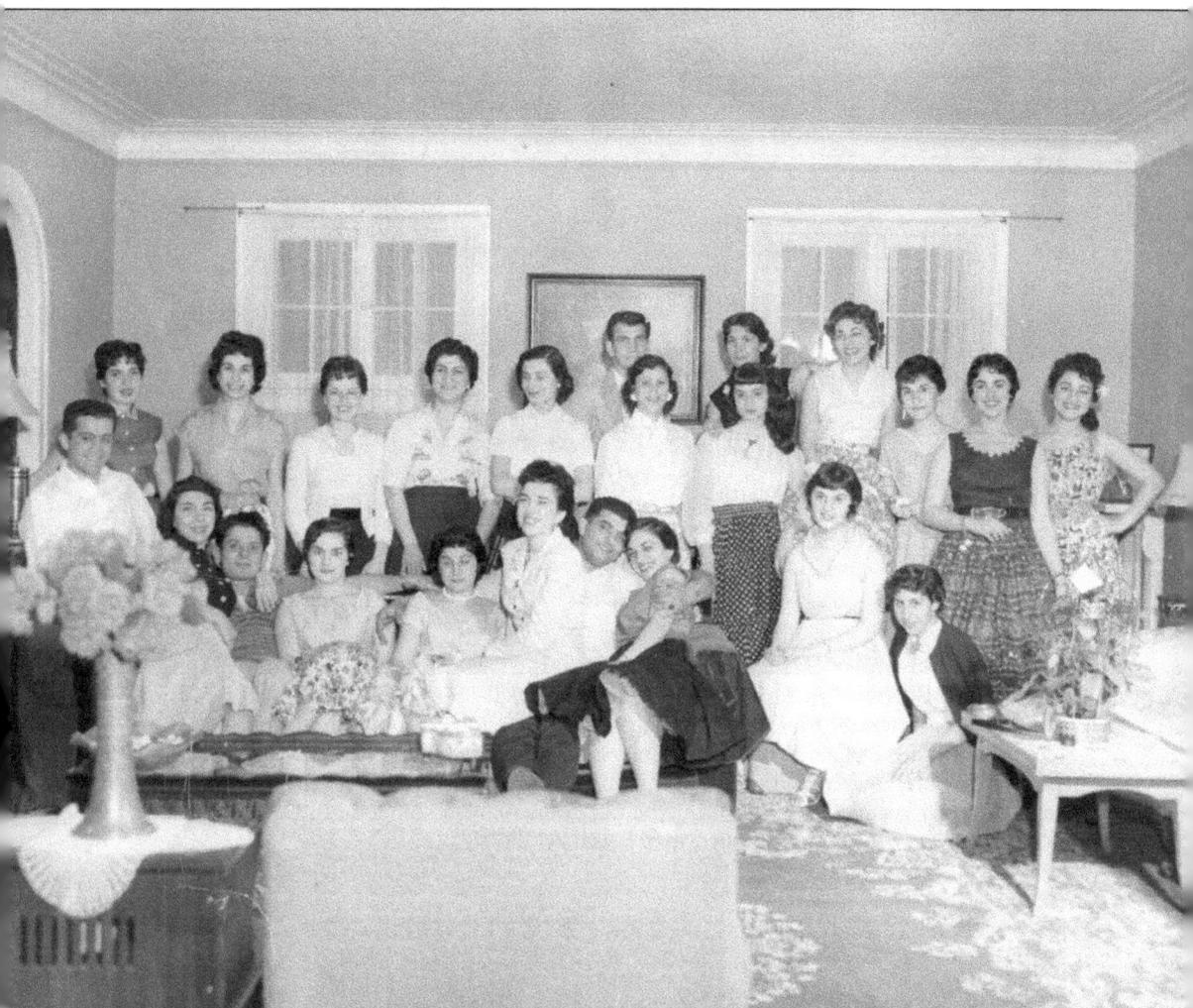

**LOVE IS ALWAYS A SLAVE TO BEAUTY.** Relaxed and happy young adult Chaldeans appear to be enjoying themselves, mingling and not quite dating but getting to know one another. The four gentlemen in this photograph are outnumbered and overwhelmed by the beauty and charming presence of the Chaldean women. Given a suitable surrounding and social climate, three out of the four men eventually married women in this photograph: Michael George (far left) married Najat Dekho (standing fifth from the right, in the black top); Fred Atto (sitting on the sofa, second from left) married Margaret Gabbara (wrapping her arm tightly around his neck); Johnny John (far right) sits with his future wife to his right and his sister-in-law-to-be to his left (extending his arm around her). The photograph was taken at Shaw Hakim's house in Grosse Pointe in the mid-1950s. (Courtesy of Julia Najor Hallahan.)

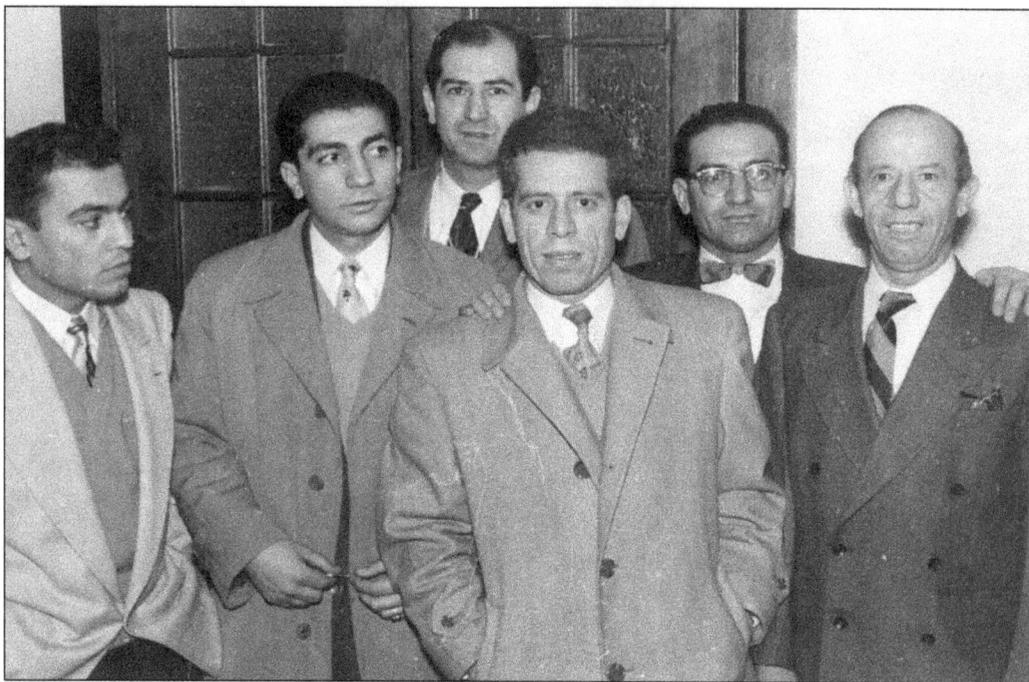

**FRIENDSHIP BONDS.** In this 1950s photograph of well-dressed men, friendship is the common denominator among different age groups and professions. From left to right are Faisal Arabo (community activist), Naim Raban (businessman), Gabriel Sheena (teacher), Louie Denha (grocer), George Jabborri (teacher/writer), and Joseph Esshaki (former hotel owner). Friends will call upon each other to visit a newcomer from the old country, visit someone in the hospital, or perhaps drive together to a funeral. (Courtesy of Faisal Arabo.)

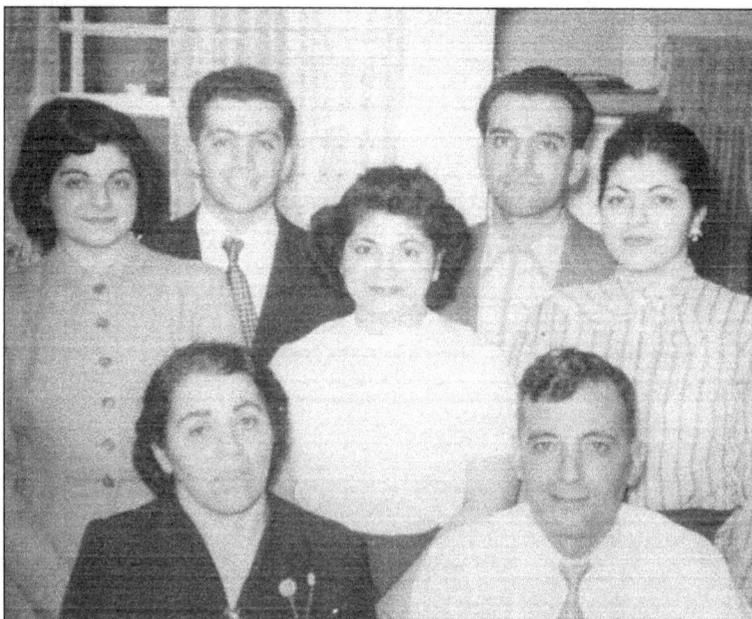

**NO PLACE LIKE HOME.** Chaldean families are generally tight knit. Family dinners were, and still are, rituals. Pictured here for an evening dinner is the George family in the early 1950s. Pictured from left to right are (seated) Naima George and Tom George; (standing) Margaret George, Mike George, Andrea George, Sharkey George, and Victoria George. (Courtesy of Buddy Atchoo.)

**Feast and Friends.** In this photograph from the mid-1950s, Tom Hakim (back center, between David Esshaki, to the right, and David Kassa, to the left) hosts a group of friends to honor a visiting guest from New York. The tradition of men being served before women was still observed at this time. Home-cooked food included baked, round *kubba*, *dolma* (stuffed grape leaves), *bulgur*, and Iraqi salad (cucumbers, tomatoes, parsley, onions, and beets). (Courtesy of Tobia Hakim archives.)

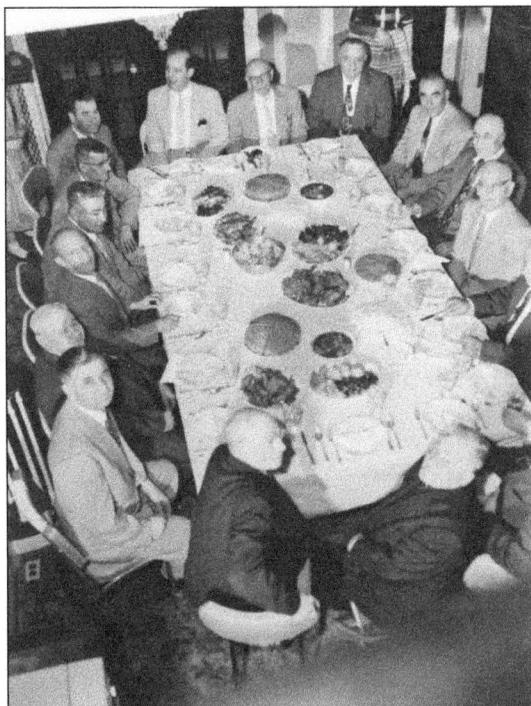

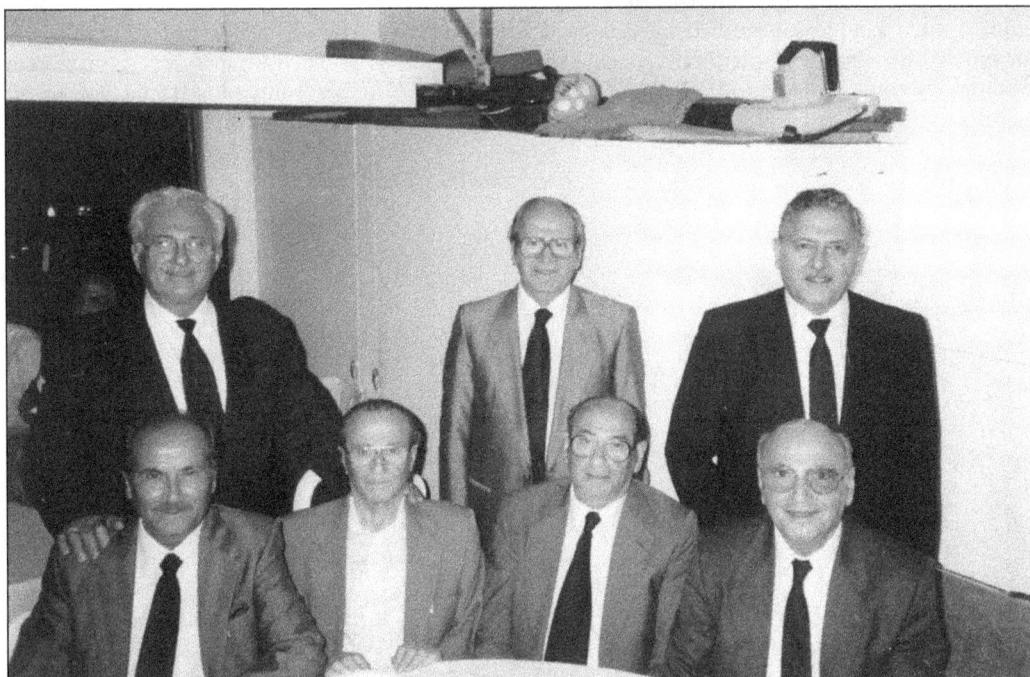

**Friends and Family.** The George brothers and a group of friends got together once a week to socialize, enjoy each other's company, and play a game of cards (*kohn kahn* and *wishliani*). The group took turns hosting at their respective homes. Seen here in the summer of 1992 at the George house are, from left to right, (seated) the George brothers Louie, John, Salim, and Harry; (standing) Jamil "Jimmy" Jonna, Buddy Atchoo, and Salim Sarafa. (Courtesy of Buddy Atchoo.)

GOOD 'OLE DAYS. Chaldeans are social people at heart and by nature, spending quality time with one another. Almost every Tuesday, these longtime friends, partners, associates, and cousins would enjoy dinner at a restaurant. Friendships are started and strengthened over a meal, which is the most powerful symbol of spirituality, notably by breaking bread and drinking wine. Pictured here from left to right in the late 1970s are Yousif Arabo, Gorgis Lossia, Manuel Meriam, Bahi Sesi, Mansour Sitto, Yousif Nahdir, Joe Acho, and Aziz Najor. (Courtesy of Julia Najor Hallahan.)

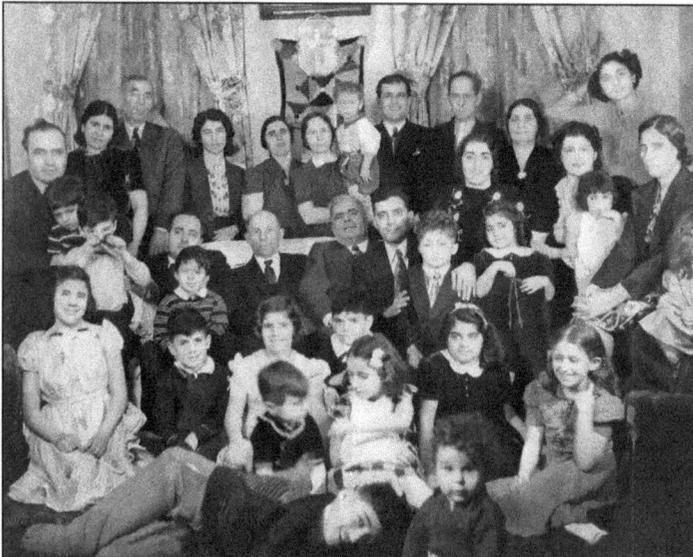

WONDERFUL MEMORIES AT TOM HAKIM'S HOUSE, 1930s. In accordance with cultural standards of Mesopotamian inhabitants, early emigrants from Telkaif, just like Tobia, were commonly the gracious hosts when there was a gathering. Everybody was invited, and the time and place were discussed at church after Sunday Mass. The tradition is still alive and well today. (Courtesy of Julia Najor Hallahan.)

**TRADITIONAL DANCE.** *Khigga* is a traditional Chaldean dance in the northern villages of Iraq. Boys and girls learn to dance the khigga in order to be prepared for the next wedding of a family member or relative. The khigga leader usually holds the handkerchief. As this photograph shows, practice makes perfect. The traditional dance also includes a flute player and the sound of drums. (Courtesy of Sabah "Abo Nono" Isho.)

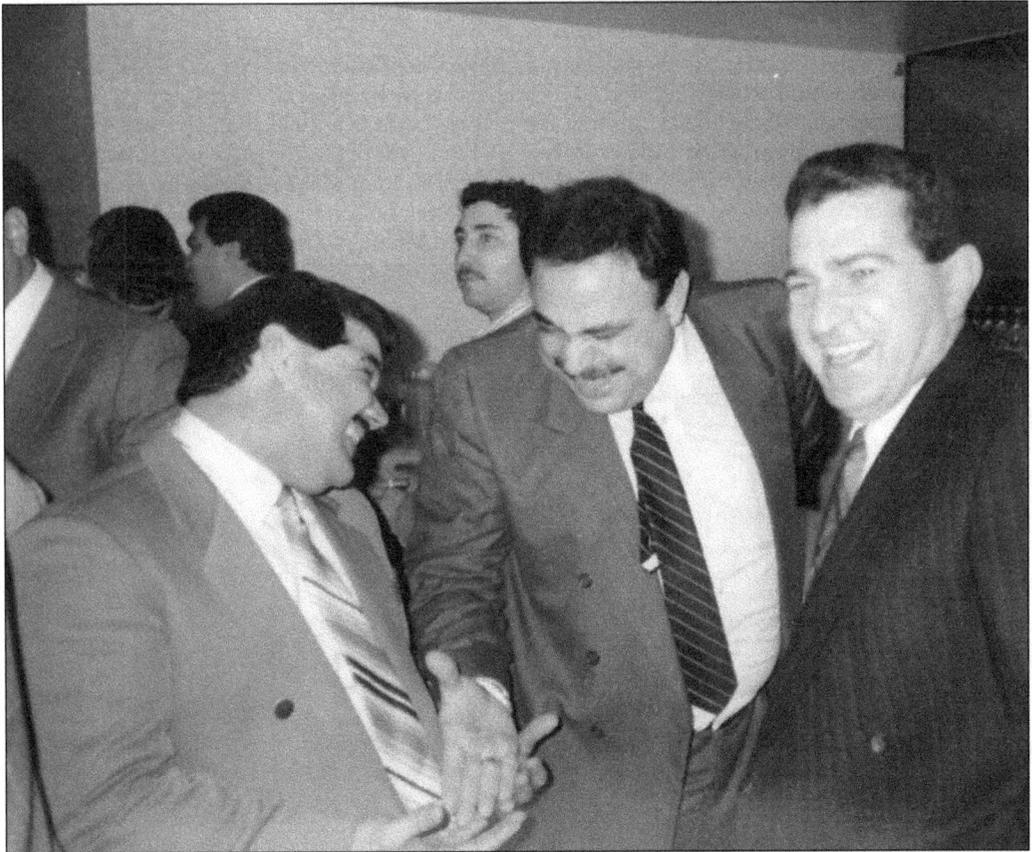

**A BET IS A BET.** When one loses a bet, it is a gentleman's promise that he will pay up. Here, Abo Nono (left) chats with his friend Eddie Zeer, who extends a handshake as a reaffirmation of his promise to pay the tab in full, including dinner and drinks. The bet was about who would win the 1997–1998 Stanley Cup championship. Mutual friend Zuhair "Steve" Karmo (right) acts as a witness. (Courtesy of Sabah "Abo Nono" Isho.)

**IRAQI SYMPHONY ORCHESTRA.** Baghdad, Iraq, in 1959 was the place and birth year of the Iraqi Symphony Orchestra. Many Chaldeans and Iraqi Christians were the cofounders and musicians; they brought to life the real spirit and beauty of music to lovers of tradition. Other ethnic/religious groups such as the Jewish community had a deep interest in Iraqi Maqam, the equivalent of jazz in American culture. Among some of the musicians are Albert Chaffoo (born to a Chaldean father and a Swedish mother), Fuad and Lewis Mishu, and Maurice Michel. (Courtesy of Maurice Michel.)

**MUSIC MASTER.** Nadhim Naim (center) is a popular violinist and composer of Iraqi folk songs. Many of his well-known songs were sung by legendary Iraqi singer Nadhim Al Ghazalie. Naim immigrated to Detroit in 1983 and still lives in the Metro Detroit area. These musicians accompanying Naim are violinist Samir Bashi (left), singer Sadoon Jabir (standing), and Al Shakerchi (right), playing the millenniums-old Mesopotamian instrument *kanon*, translated as "law." (Courtesy of Samir and Bernadette Bashi.)

82

A STAR IS BORN. At a Chaldean event in 1983 in Detroit, Ameed Asmaro sings with his two brothers, trying to follow the lead of the Jackson Five. But, young Ameed (center) is taking baby steps with his talent, starting his climb to fame by singing in support of oppressed Iraqi people. The event was organized by the Iraqi Democratic Union to build up support for the potential overthrow of Iraqi dictator Saddam Hussein. (Courtesy of Nabil Roumayah.)

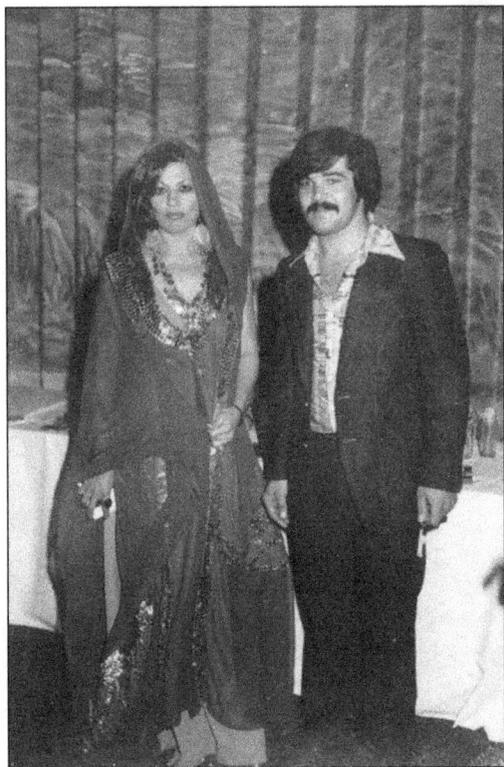

LEGENDARY IRAQI SINGER. Lamia Tawfic, a classical Iraqi folk singer, pays a visit to lovers of her music in Detroit, which included many generations, in the mid-1980s. Many of her fans described her singing as taking a journey on Aladdin's magic carpet and living the joyful dream of a rich sultan described in Arabian folklore tales *One Thousand and One Night*. In this photograph, Sabah Isho poses with the legendary singer at Roma Hall in Livonia. (Courtesy of Sabah "Abo Nono" Isho.)

EATERY OF BIBLICAL TIMES. *Gurgur*, a cousin of couscous, existed in the early days of the Bible and is a popular Chaldean dish loved by poor and rich alike. It is a symbol of pride in northern Christian villages in Upper Mesopotamia where wheat is locally grown. The soil is fertile, and rainwater is the only source of hydration. Gurgur is served as a main dish with lamb or chicken or as a side dish in the place of rice. (Courtesy of Huron River Press.)

YELLOW IN COLOR, RICH IN FIBER. *Pakota*, or *habbiyah*, is a bright, sunflower yellow, shelled barley dish known for its lusciously creamy texture. It is typically served with Iraqi salad and *turshi* (pickled vegetables). Pakota takes hours to cook and only minutes to ruin if not watched carefully. It is a specialty dish originating from the northern Christian villages in Iraq, and it is almost always cooked with lamb shanks. In America, pakota is now also cooked with chicken as a healthier option. Its distinct yellow color comes from using turmeric. (Courtesy of Huron River Press.)

**"WHAT IS THE MATTER WITH YOU? HAVE YOU EATEN PACHA OR WHAT?"** That is a typical reply to someone who talks too much and whose body is overcharged with calories from the dish. Pacha is an old, popular Iraqi dish, and people either love it or hate it. The dish consists of every piece of sheep flesh one can think of, including boiled head, ears, eyes, tripe, stomach, and trotters. Another addition, *kebaie*, or sheep stomach (pictured here), is the size and shape of a mango. Kebaie is made of lamb tripe pockets of stomach skin filled with stuffed rice, meat, garlic, and spice. *Mambar*, another unique addition, is a sheep's intestine filled just like a sausage casing, stuffed with a mixture of rice, meat, spice, and garlic, and closed on one end only. Both are usually served together in a bowl of steaming hot broth poured over small pieces of Arab flat bread, or *khubiz*. No meal is complete without *zangine* chai, a rich, well-brewed black tea. (Courtesy of Huron River Press.)

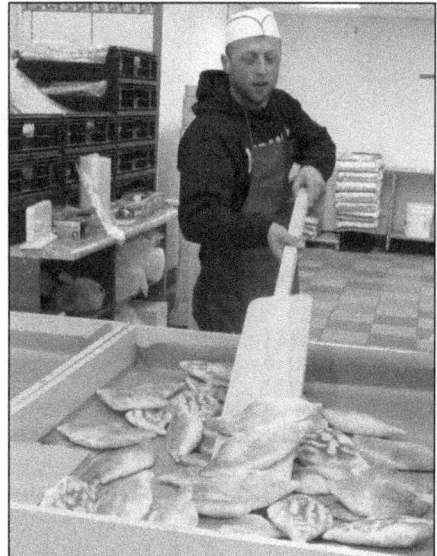

**HOT, CRISPY, AND CHEAP.** Iraqi *samoon*, or bread, is leavened flat bread made with flour, yeast, sugar, and salt. Once mixed together, the bread is kneaded and shaped before being baked in a brick oven at about 500 degrees Fahrenheit on a hot stone surface. Samoon is popular at Middle Eastern restaurants because of its crisp crust and soft interior. Pictured here is freshly baked samoon at an Iraqi bakery in Michigan. (Courtesy of Saher Yaldo.)

**MASGOOF, A CLASSIC DISH.** The original recipe of *masgoof* is live fish caught from the Tigris River bank. After catching the fish, the *sagaf* (the person cooking the fish) would start a fire from collected twigs formed into a circular shape. The face of the fish would be directed toward the current of the wind, with the fire following. Masgoof would be garnished with tomato, onion, parsley, and pickled mango on the side. Pictured here is the executive chef of Shenandoah Country Club, Furat Altawil. (Author's collection.)

**KING OF IRAQI DISHES.** The host is obliged to honor his guests with a classic Arab feast: *kharuf mahshi*, or *kuzi*, a baby lamb coated with clarified cow or goat butter. This dish is slowly roasted in an oven with pine nuts, almonds, raisins, onion, cinnamon, cloves, and cardamom. Kuzi is then served with heaps of rice. Such a feast would be eaten in silence as a sign of politeness toward the host. (Courtesy of *Ma Baseema*, CALC.)

GEYMER, "CRÈME DE LA CRÈME." If there is one word that describes *geymer*, it would be "delicious." Geymer is typically eaten with *silan* (a syrup made from dates) or honey, with warm, flat Arab bread. It is the ultimate breakfast. Geymer is made of marshland water buffalo's milk containing a high level of cream fat, which is what makes it so delicious. In one of his songs, legendary Iraqi singer Nadhim Al Ghazali referenced his "beloved milk-white beauty with geymer-like cheeks," who was richly appealing. (Courtesy of Samir Mishu.)

CHALDEAN PASTRY. Chaldean *kolaché* is an ancient cookie as old as the name Mesopotamia. It is often served with tea. Baked from scratch, the ingredients include flour, yeast, canola oil, water, nuts, sugar, and cardamom and a filling of walnuts, crushed dates, or coconut. They are glazed with egg batter and then baked. Kolaché cookies are typically made during the Christmas and Easter holidays. (Author's collection.)

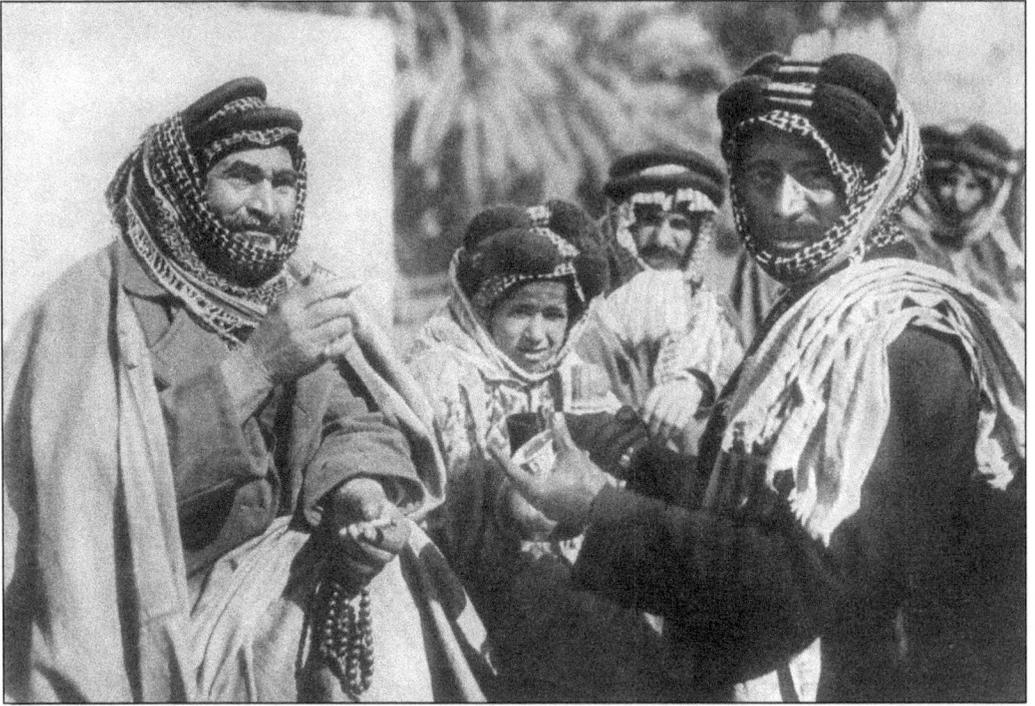

**SIP SLOWLY.** Gahwa Arabia (Arabic coffee) is the traditional hot beverage in Arabian Bedouin culture, which is known for its high morality and unconditional friendship and generosity (pictured here in 1919). Gahwa Arabia is a hospitality ritual, typically unsweetened and never served with cream or milk. A sheikh, the head of an Arabian tribe, takes pride in roasting and grinding the beans and serving it to his guests. The guest must not refuse, as refusing coffee is considered an insult to the host. Today, Chaldean families still carry the tradition of serving coffee or tea to their guests. (Courtesy of Al-Ekha'a Press House.)

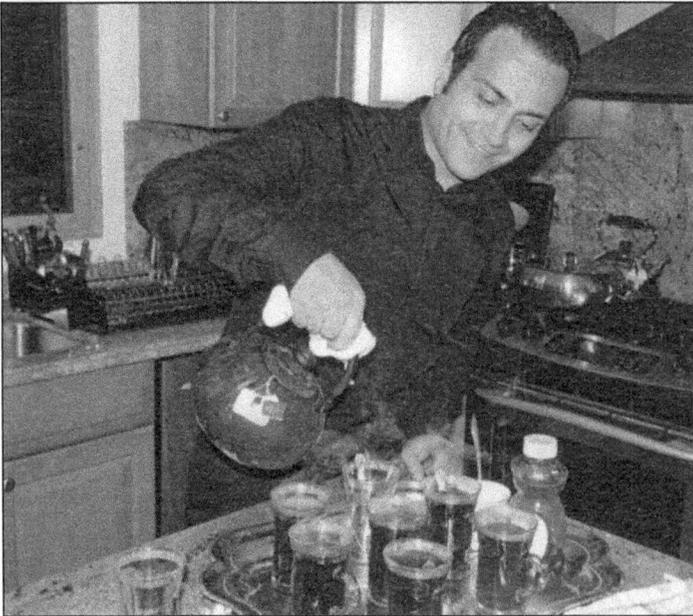

**CHAI TIME.** Chaldeans are tea drinkers by tradition; they know the taste of well-brewed tea. As pictured here, traditional tea is served in a small, delicate glass called an *istican*. After a rich, five-course dinner, *zangine* chai, which is thick and heavy, gets the majority of votes. Two or three rounds are a common amount for one person to consume. In Iraqi culture, as it is in many other cultures, there cannot be tea without dessert. Tea is served with *kolache*, *baksam*, and/ or baklava. (Courtesy of Samir Mishu.)

# *Seven*

# BUSINESSES AND MEDIA

Metro Detroit's Chaldean American community is known to be highly entrepreneurial. A 2007 study commissioned by the Chaldean American Chamber of Commerce and conducted by Walsh College and the United Way confirmed that this reputation is well deserved. The survey revealed that 61 percent of Chaldean households own at least one business, and nearly 40 percent own two or more.

Chaldeans own an estimated 15,000 businesses in Michigan, including approximately 90 percent of Detroit's convenience stores and liquor stores. This is a tradition carried over from Iraq; Islam forbids the sale of alcohol, which resulted in Christians and non-Muslims owning all the country's liquor stores. When they immigrated to the United States, many bought liquor stores because they knew that business inside and out and had a history of success.

Chaldeans also own an estimated 80 out of the 85 supermarkets in Detroit, as well as many more in the suburbs. They also have a high concentration of ownership in suburban gas stations, hotels, food service, real estate holdings and development, wireless communications stores, and franchises of major brands such as Dominos Pizza, Dunkin' Donuts, Tim Hortons, and Mr. Pita.

When Chaldeans first arrived in the United States, there were several Arabic media outlets. As they started to acculturate, they desired to have media that spoke Chaldean (Aramaic), their native tongue. Like other ethnicities that concentrated in a metropolitan area, the Chaldean community has had several print, broadcast, and online media outlets over the years. From TV Orient (now MEA TV and Radio) and the *Detroit Chaldean Times* in the 1970s and 1980s to the *Chaldean Voice* radio show and the *Chaldean News* today, there are several bilingual newspapers and radio and television stations keeping the community abreast of weddings, births, deaths, and news that impacts the community. They also provide entertainment features such as music, TV shows, and movies from back home.

These media outlets were born out of necessity, as Detroit's mainstream media largely ignored the community in the past; however, as Chaldeans have become an important part of southeast Michigan, local newspapers and TV news now prominently feature the community. Today, Chaldean media exists to preserve the Chaldean heritage.

*February 27, 1957*
*2900 Brush at Brewster*
*Detroit, Michigan*

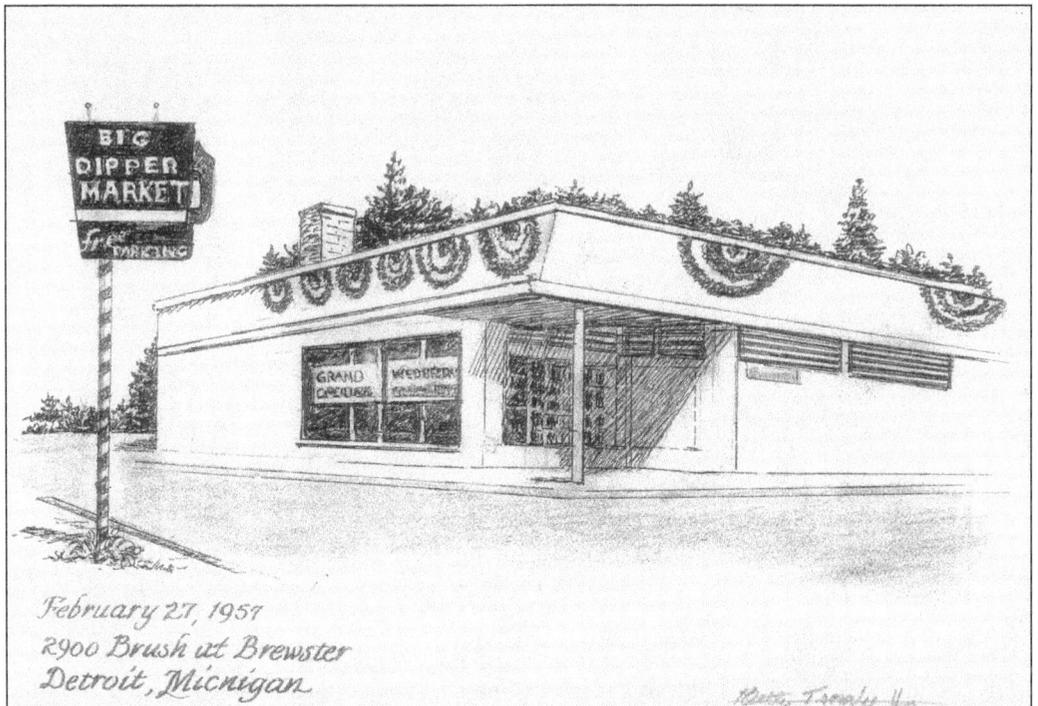

**ONE OF DETROIT'S LARGEST MARKETS.** Four young Chaldeans, who grew up in the small village of Telkaif, dreamed of working together. After they immigrated to America, their partnership dreams became a reality when they opened one of the largest supermarkets in their new hometown of Detroit. On February 27, 1957, Big Dipper Market opened its doors to serve the Detroit community. (Art by Betty Trombetta.)

**GRAND-OPENING SALES.** Today, sale advertisements from multiple grocery stores are included in every household mail slot. In the 1950s, the Big Dipper Market was one of the few that created a handbill advertising low-price grocery and sale items for its grand opening. The Big Dipper owners were sure to include grocery and canned items commonly used in any household, including Maxwell House coffee for 79¢, a dozen large eggs for 39¢, and a five-pound bag of Domino sugar for 39¢. (Courtesy of Buddy Atchoo.)

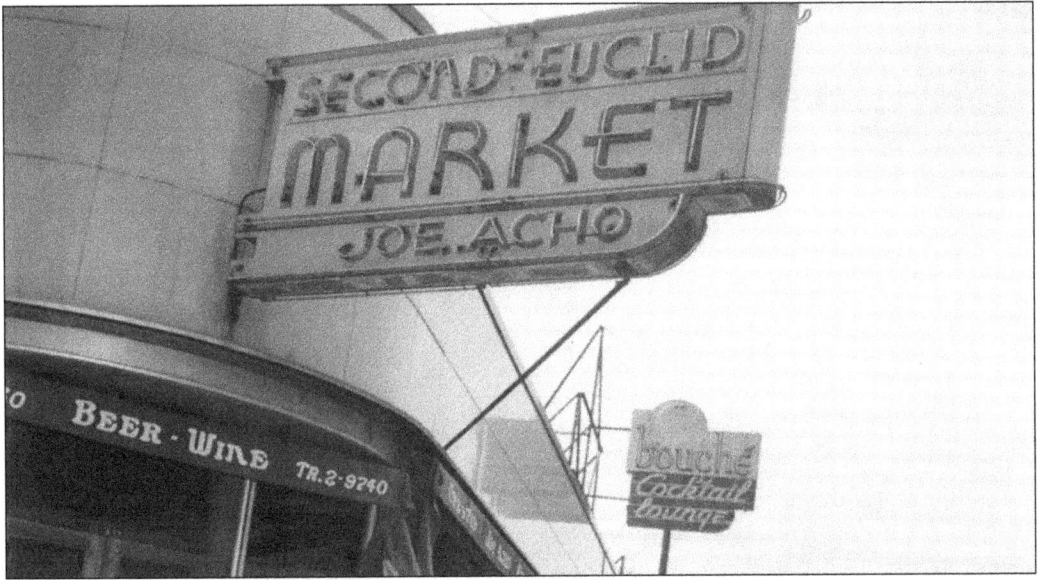

**SECOND AND EUCLID MARKET.** Corner stores at one time were the lifeline of the city. But, for new Chaldean immigrants, it was the "cane of the blind man" as the old Chaldean saying goes, which explains the virtue of the other relatives in business. That meant having a job, learning the language, and learning the trade. "The entire community is very closely tied to the grocery trade. The strong business connections provide an additional means by which family ties are cemented," said Dr. Mary Sengstock, professor at Wayne State University. (Courtesy of Jane Shallal.)

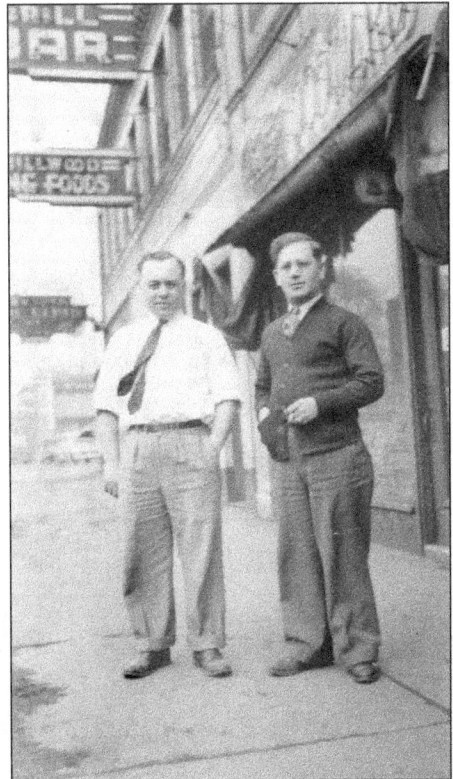

**COUSINS, BUSINESS PARTNERS, AND BEST FRIENDS.** Jack Najor and Aziz Najor opened their first business, Safeway Market, on Woodward and Euclid Avenues in Detroit in the 1930s. Partnering in business with family members, relatives, or friends was very common in the Chaldean community. Seven different partners claimed the ownership of the supermarket pictured here, four of which carried the last name Najor. (Courtesy of Julia Najor Hallahan.)

**SPOILED BY VARIETY.** Eddie Bacall stands behind the selling counter at Drug & Party Fair in Livonia in 1979. He is not doing his homework at the store; he is making a cigarette order for the next day. His count total was 128 different cigarette brands, including different flavors, sizes, nicotine levels and filters, non-filters, light, and ultralight. It took 30 to 45 minutes for two people to check inventory and place a cigarette order. Back then, a carton of 20 packs sold for $4.49 plus a four-percent tax. (Author's collection.)

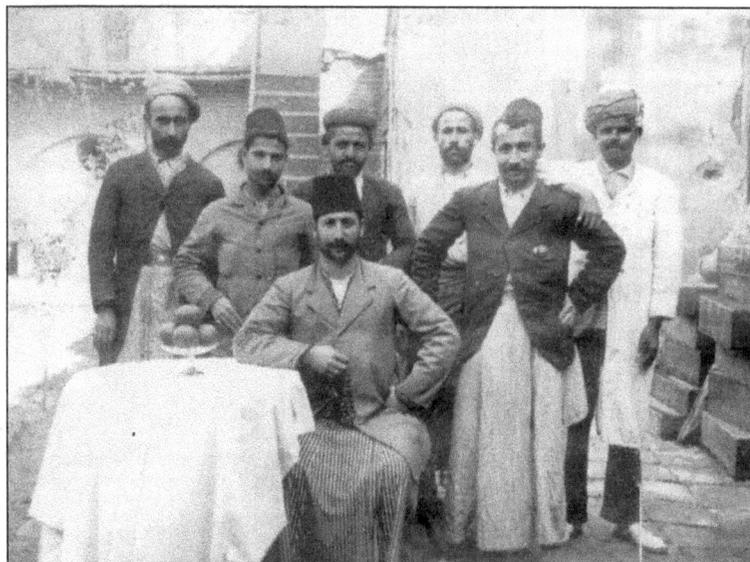

**HOTEL CHIEFTAIN.** A proud hotel owner from Telkaif is surrounded by employees from the northern villages of Iraq. Chaldean workers often left their hometowns for better jobs and more promising economic opportunities in the capital of Baghdad and other major Iraqi cities of Mosul and Basrah. (Courtesy of Al-Ekha'a Press House.)

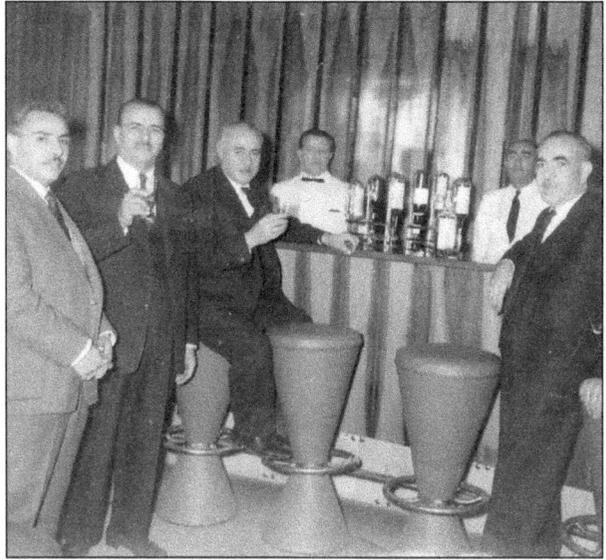

BAGHDAD'S FINEST. Pictured here is Yacoub Mansoor Habboo (sitting) enjoying a drink with other prominent business associates at Baghdad Hotel, which he built from the ground up. Habboo was a well-connected businessman. From 1969 to 1970, he was jailed and sentenced to death for being a "free mason"; however, Saddam Hussein was under on-going pressure from international and foreign leaders. He was finally ordered to be released—but with only one ear. "A lesson to be learned," whispered secret service (Jihaz Al-amin) to one of his family members at his release. (Courtesy of Walid Habboo.)

BAGHDAD HOTEL. Chaldeans introduced the concept of the modern-day hotel in Iraq and have owned many hotels in Baghdad, Mosul, and Basrah since the 1920s. The Baghdad Hotel was a five-star accommodation, the equivalent of the Ritz-Carlton in America. The Chaldeans of Detroit have made significant inroads in the hospitality business. Since the early 1990s, they continue to adapt, utilize their knowledge, and move forward with innovative ideas. (Courtesy of Walid Habboo.)

**ALL SMILES.** Chaldean and die-hard Detroiter Joe Shaya (known for his charismatic smile), standing on the left, was the longtime owner of the famous Zeek's Fruit & Produce on Seven Mile Road and Schaefer Highway in Detroit. Shaya shows his support for both Detroit mayor Coleman Young (poster in the background) and councilman Gill Hill (center) in the late 1980s or early 1990s. The man on the right is unidentified. (Courtesy of Linda Shaya.)

**BUSINESS BRAVERY.** It is no surprise to see Chaldean-owned businesses outside of Detroit and even in distant areas of Michigan. The Frankenmuth Brewery, in the tourist town of Frankenmuth, about 80 miles north of Detroit, has been in operation since 1862. Brothers Haithim and Anmar Sarafa were determined to save the 150-year-old landmark brewery from closing down. Both men are University of Michigan graduates with degrees in law, accounting, and money management. They bought the brewery with absolutely no background in the beer business. (Courtesy of Frankenmuth Brewery.)

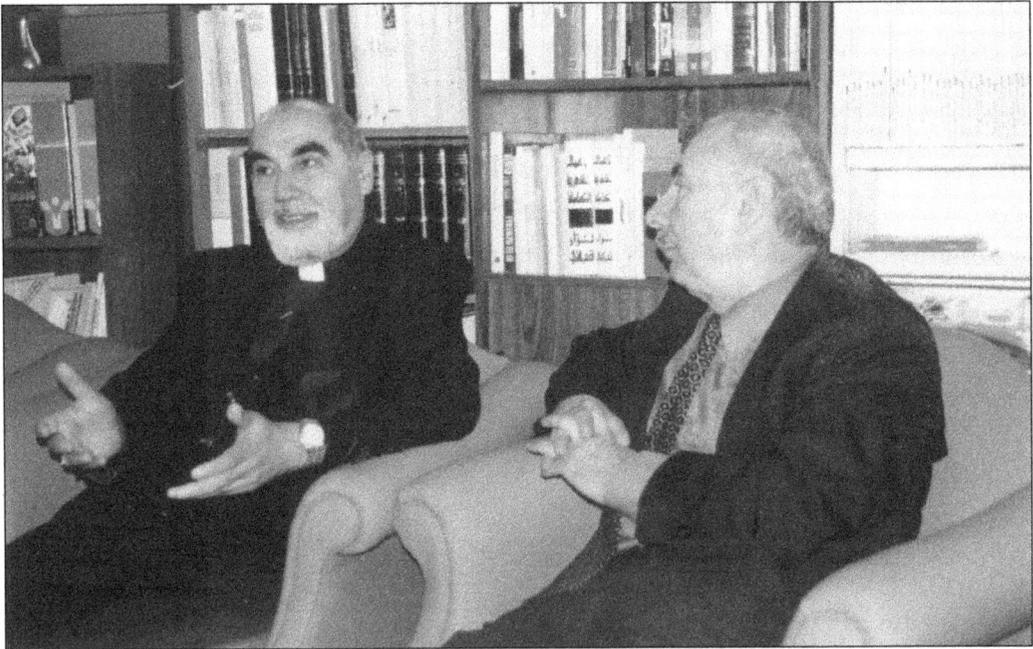

**FREEDOM OF THE PRESS.** Seated on the left is Bishop Ibrahim Ibrahim of St. Thomas, Chaldean Diocese, of the United States. He is meeting with Fuad Manna, publisher of *Al Muntada* magazine, a monthly publication in Michigan. Mar Ibrahim Ibrahim urged Manna to continue constructive dialogue with Chaldean and non-Chaldean organizations to better serve the community. (Courtesy of Fuad Manna.)

**KURDISH CONNECTION.** In the mid-1990s, distinguished Kurdish leader and pragmatic politician Barham Saleh visited friends and relatives in Detroit. Saleh ate lunch one day at *Al Muntada* magazine's office in Oak Park. From left to right are (seated) Ghazi Shafo and Fuad Manna; (standing) Sabah Putrus, Saleh, Ramzy Kas-Gorgis, and Samir Putrus. (Courtesy of Fuad Manna.)

**POWER OF THE PRESS.** Founded in 1949, *Al-Mashriq* (or *The Orient*) was the first weekly Arabic newspaper published in Detroit. Hanna Yatooma was the paper's owner and editor. The community was so small compared to today's Chaldean community that Yatooma often collected subscription dues from readers at wedding halls and funeral homes. He kept a very close eye on Chaldean community activities such as weddings, communions, and deaths. For the latter, he reserved a corner of page 6, where large Arabic print read, "*Subhan hay albaqi*," which translates to "The glory of the living rest" to list who had passed away. When Yatooma approached retirement age, he sold the newspaper to Napoleon Bashi, a Chaldean activist in the mid-1970s. (Courtesy of Faisal Arabo.)

**PASSION BEFORE PROFESSION.**
Hanna Yatooma (third from left), founder and publisher of *Al-Mashriq* newspaper in Detroit, asked Napoleon Bashi (center), a regular columnist, to take over the decades-old newspaper so he could rest and enjoy retirement. The strong-minded Bashi had to choose between working for a living or his passion of writing. Reluctant at first, Napoleon chose the latter in January 1983, against his family's wishes. (Courtesy of Samir and Bernadette Bashi.)

**MARTYR OF FREEDOM.** "My chest is wide open, let them come and kill me," said Napoleon Bashi to a Chaldean messenger sent by the Iraqi government at his grocery store in Hazel Park on August 17, 1982. Bashi was often critical of Saddam Hussein's regime and expressed his views in *Al Mashriq*. "He was gunned down on January 11, 1983, by a single bullet to his heart by a professional hit man and died shortly after 1:00 a.m.," said police lieutenant James McGuough. This photograph shows Napoleon standing (with his sister Elizabeth at Noble Market) at the exact spot where he was later shot. (Courtesy of Samir and Bernadette Bashi.)

**Chaldean Detroit Times**

كلدان ديترويت تايمز

Bringing the World to the Chaldean and Arab Community Since 1990

Tuesday, January 1, 2013 — Number: 501 | Volume:2

**Zia Mansour Oram**
January 1, 1912 – November 13, 2012
"A Village Legend"

Zia & Shamasos Oram (center) with 12 children, left to right: Randy, Gary, John, Joe, Zuhair, Amir, Amira, Suham, Stephanie, Ann, Christine and Nancy

**BILINGUAL PUBLICATION.** The *Chaldean Detroit Times* has been in circulation since 1990, published by Amir Denha. The newspaper provides updates on the community's social events, weddings, funerals, and state government concerns. Currently, the *Chaldean Detroit Times* is one of the few bilingual publications in Arabic and English in the Detroit area. (Courtesy of the *Chaldean Detroit Times*.)

**the Chaldean News**
www.chaldeannews.com

A SEASON of CHANGE
New Patriarch elected;
Pope steps down

INSIDE
PREPARING FOR EASTER
MARCHING FOR LIFE

**THE DAILY ON CHALDEANS.** Founded in 2004, *The Chaldean News* is the community's only English-language publication. Published out of Metro Detroit, the monthly magazine is a popular source for the latest news, stories, and unique articles on Chaldeans, and it offers useful resources and raises awareness inside and outside of the Chaldean community. (Courtesy of *The Chaldean News*.)

**THE FALLEN OF LOST DREAMS.** The Chaldean community steadfastly remembers the men and women who were robbed and murdered at their places of business. Most were immigrants who came to America in pursuit of the American dream, seeking both religious and economic freedom, working 16-hour days to support their families and communities. They are still mourned by wives, husbands, children, parents, and extended family. The community remembers them and their families with love and compassion. (Courtesy of *The Chaldean News*.)

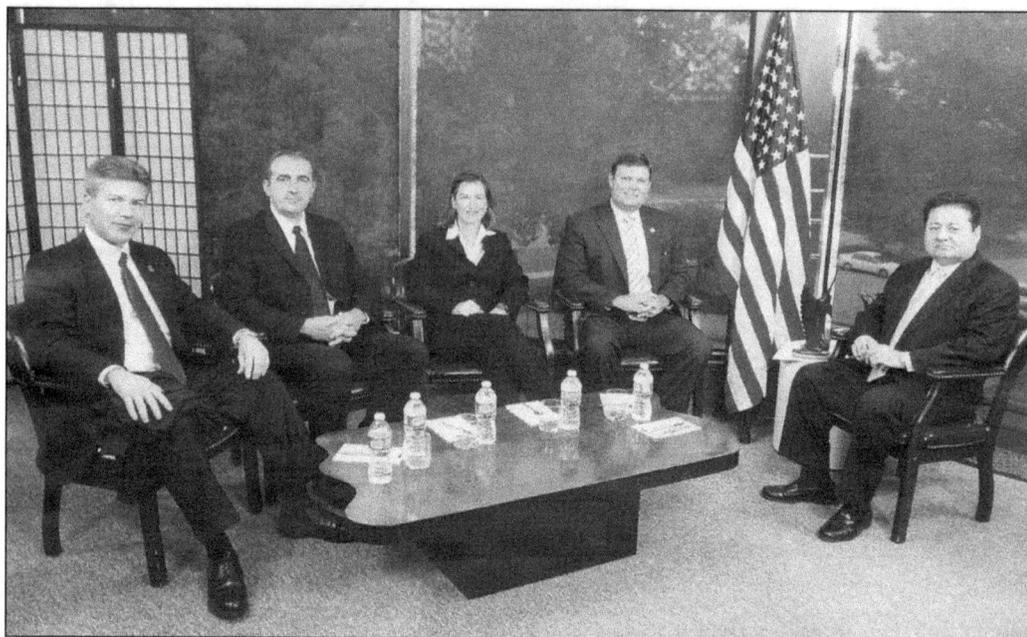

**MIDDLE EASTERN AMERICAN TV.** Known as MEA, this TV and radio station is a well-known channel in the Greater Detroit area, broadcasting via cable networks all over the United States, 24 hours a day, seven days a week. More and more viewers engage and call during live broadcasting to discuss current issues and events. Issues concerning immigration laws are a hot topic. The station was launched on August 3, 1986, by Norman Kiminaia, who sold it to current president Wally Jadan in 1998. (Courtesy of Wally Jadan.)

**THE BANK FOR SMALL BUSINESSES.** In the last decade, many banks have merged, and new acquisitions were the goal of most national banks to yield a healthy return for stockholders. With that, though, the commitment to help small businesses succeed was no longer followed nor offered by these major banks in Metro Detroit. A handful of Chaldean businessmen recognized this shortcoming and decided to open their own bank, the Bank of Michigan. In June 2007, the Bank of Michigan was named the fastest-growing bank in southeast Michigan by *Crain's Detroit Business*. Today, the Bank of Michigan meets and strives to exceed the daily needs of small businesses, such as taking in deposits and making small loans. (Author's collection.)

# *Eight*

# ORGANIZATIONS AND CLUBS

As the Chaldean community continues to grow geographically and in population, many active and enthusiastic members of the community have established a plethora of organizations and clubs that serve, educate, inform, and entertain. Many educational, charitable, and social functions and services are coordinated and implemented through these Chaldean organizations.

Some groups work closely to build bridges between cultures as a way to promote constructive dialogue. Others exist to serve the growing needs of the community and preserve its culture. Many organizations have made a positive impact in preserving and adhering to fading Chaldean customs, including the CIAAM (Chaldean Iraqi American Association of Michigan), the CALC (Chaldean American Ladies of Charity), the CFA (Chaldean Federation of America), and the *Chaldean Voice* radio program. Much hope is invested in the long-awaited cultural center in West Bloomfield, which will open in 2016.

The 2003 US-led invasion of Iraq resulted in widespread persecution of Chaldeans and other religious minorities by Islamic fundamentalists. Some two-thirds of Iraq's Christians, more than 800,000 individuals, became displaced as refugees all over the world. Many arrived in the United States needing a variety of humanitarian services having fled their homes with only the clothes on their backs.

The United States Commission on International Religious Freedom (USCIRF) reports, "While Christians and other religious minorities represented only 3% of the pre-2003 Iraq population, they constitute approximately 15–20% of registered Iraqi refugees in Jordan and Syria, respectively. Christians account for 35 and 64%, respectively, of all registered Iraqi refugees in Lebanon and Turkey." The Adopt-a-Refugee Family Program, under the auspices of the Chaldean Federation of America, actively distributes nearly $1 million annually to these Christian refugees. Another charitable organization aiding the refugees in the United States is the Chaldean Community Foundation (CCF), which is part of the Chaldean American Chamber of Commerce.

Looking to the future, the many organizations within the community plan to increase their services to refugees, expand their programming and educational opportunities for members, and continue to be the voice for Michigan's vibrant and growing Chaldean American community.

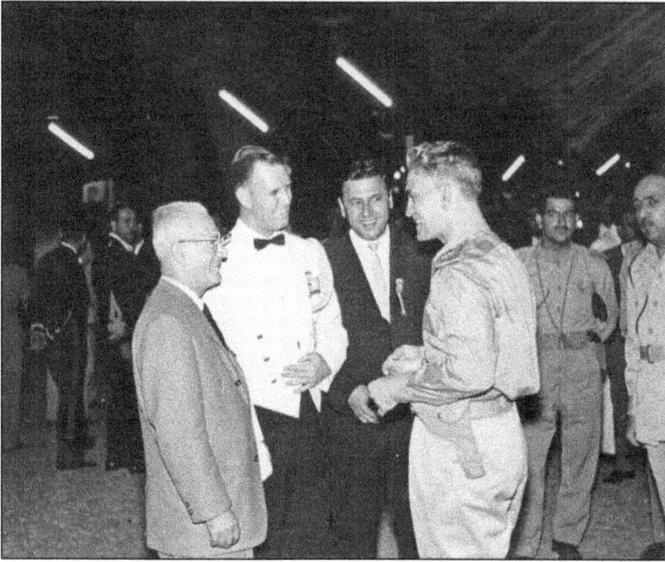

MAINTAINING POLITICAL TIES. Over the decades, the influential Chaldean leaders of Detroit maintained a warm and cordial relationship with the rulers of Iraq. In the late 1950s, Chaldeans were often invited by the government of Iraq to visit the old country to witness the progress made since they left. Pictured here from left to right are Jack Najor, an American consul in Baghdad, Gen. Salim Sarafa, and Prime Minister Abdel Karim Qasim, wearing a pistol. (Courtesy of Judy Sarafa Jonna.)

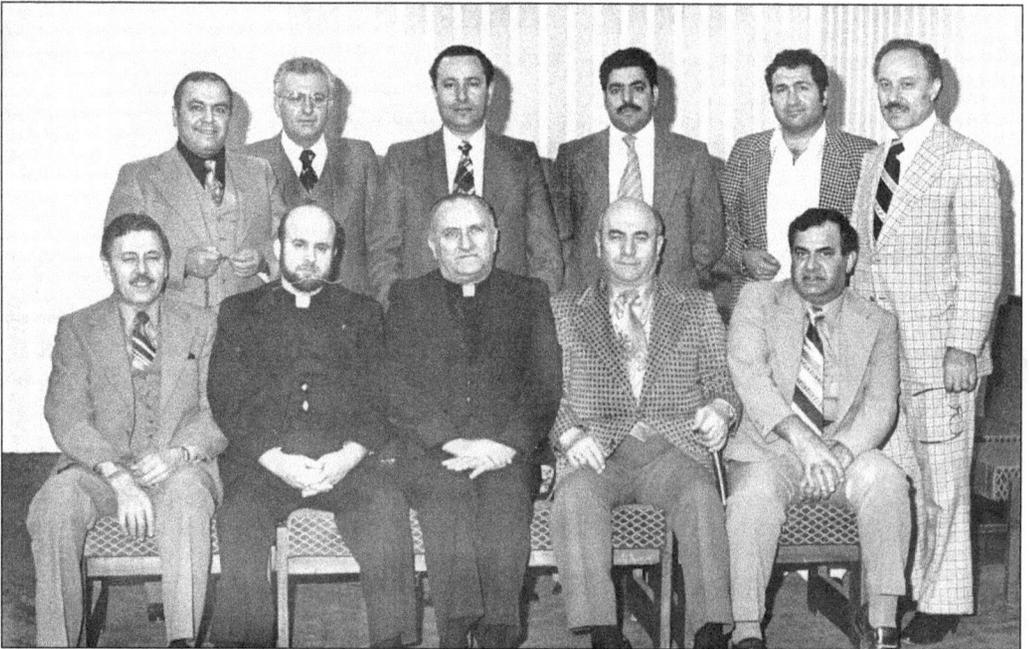

PRESIDENTIAL INVITATION, 1980. Iraqi president Saddam Hussein received a Chaldean American delegation during a visit to their home country. Hussein wanted to establish greater links between the United States and Iraq and encouraged all Iraqis abroad to visit—without government harassment. Pictured here are, from left to right, (seated) Salim Sarafa, Fr. Abdul Ahad Shara, Fr. George Garmo, Yousif Nadhir, and Manual Meriam; (standing) Faisal Arabo, Jimmy Jonna, Ramzy George, Mahdi Al-Delemi, unidentified, and Jimmy Jerdak. (Courtesy of Faisal Arabo.)

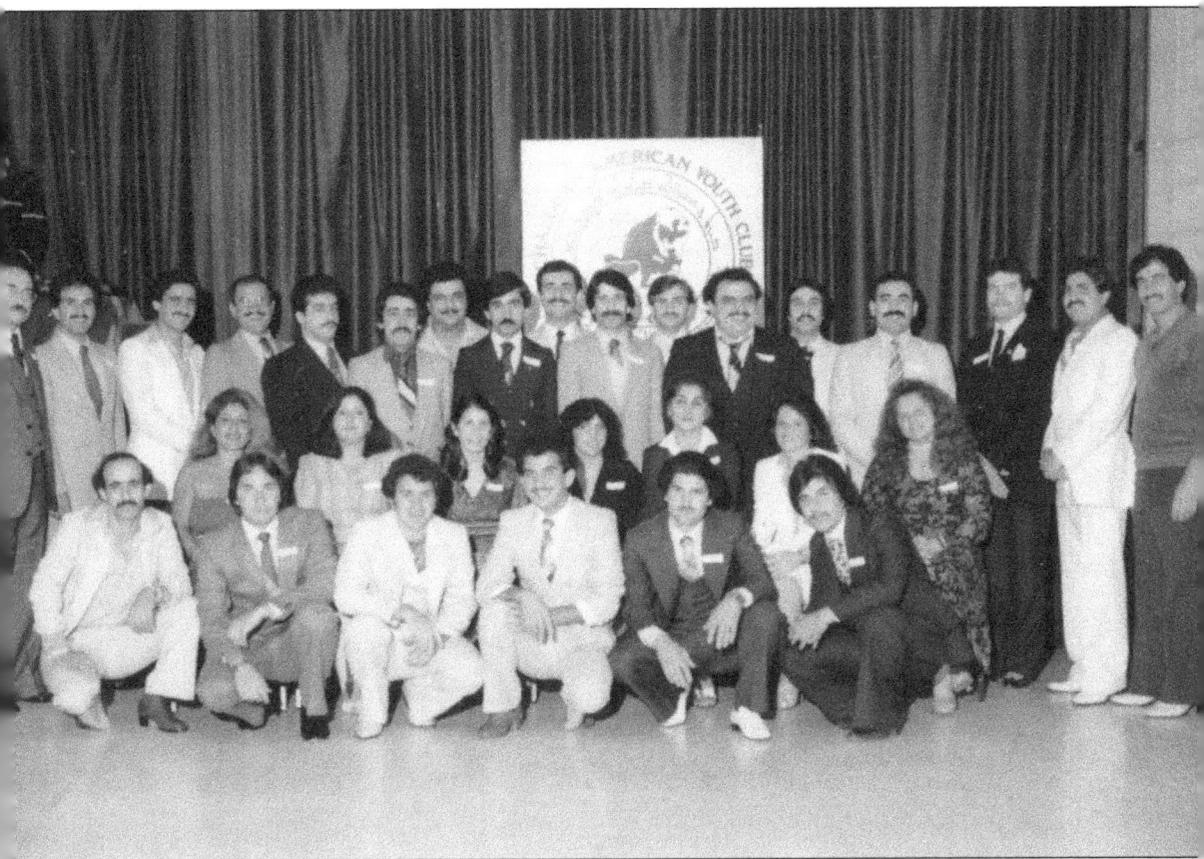

**CHALDEAN AMERICAN YOUTH CLUB OF MICHIGAN.** Founded in 1953, Salim Sarafa spearheaded the effort to form a club for the Chaldean youth. "He is very articulate, speaks excellent Arabic and English, and knows how to read and write in Aramaic," stated Sam Dabish, author of *The History of the Iraqi Community in America.* Seen here from left to right in 1973 are (first row) Wadi Yono, Najah Kajy, Zuhair Karmo, Mouafak Karmo, Fawzi Dalli, and Showki Konja; (second row) Janette Shallal, Sajida Atisha, Gloria (Saffar) Kassa, Nadia (Dickow) Karima, Carol Khami, Ann Oram, and Helena Kassa; (third row) Dhafir Nona, Ismat Karmo, Nazar Stephen, Nabeel Yousif, Amer Asmar, Najib Konja, Saher Haddad, Augeen Kalasho, Imad Zeer, George Kalabat, Samer Kassab, Mukhles Karmo, and Dhia Babbie; (fourth row) Adel Sesi, Jamal Kalabat, Mike Kassa, and Ray Saffar. (Courtesy of Fawzi Dalli and Najah Kajy.)

**FIRED UP BY ENTHUSIASM.** Young, eager children ages 6 to 11 are coached by soccer-loving athlete Sabah Hermiz Summa. Before the start of a game, Sabah gets his team excited with a pregame pep talk. Teaching kids how to be team players, following the rules of the game, and shaking hands and congratulating each other at the end of every game. This photograph was taken in the 1990s. (Courtesy of Sabah Hermiz Summa.)

**TEAM PLAYERS.** The Detroit Police Department supported the birth of the Chaldean youth soccer team. The team was part of the Detroit Police Athletic League (PAL) and was trained and managed by semiprofessionals of the Iraqi Soccer Club (ISC). Standing on the far left is team trainee Nadhir Zoma. Standing on the far right is team manager Norman Holens. This photograph was taken in the late 1970s. (Courtesy of Nadhir Zoma.)

SOCCER: LIVE IT AND LOVE IT. In 1981, the ISC of Michigan played against the White Eagles (a Polish American team) at Mount Clemens Stadium. After three competitive soccer matches and two red cards, the ISC beat the White Eagles 2-1. Budweiser beer was the ISC's main sponsor. (Courtesy of Nadhir Zoma.)

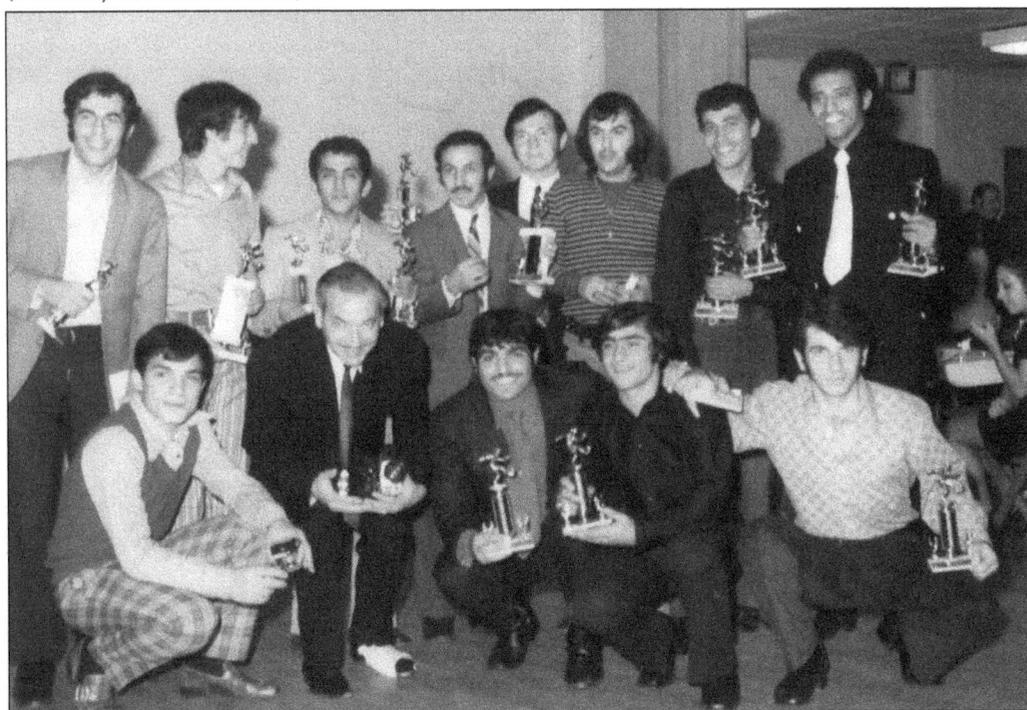

TASTE OF VICTORY. Soccer was an important part of life for youth and adults alike in Iraq. Played in the streets and allies, the passion for soccer was carried by players from their country of birth to their new hometown of Detroit. Photographed here is the ISC celebrating its victory against Club Stona during the state championships in 1971. The score was 2-0. (Courtesy of Nadhir Zoma.)

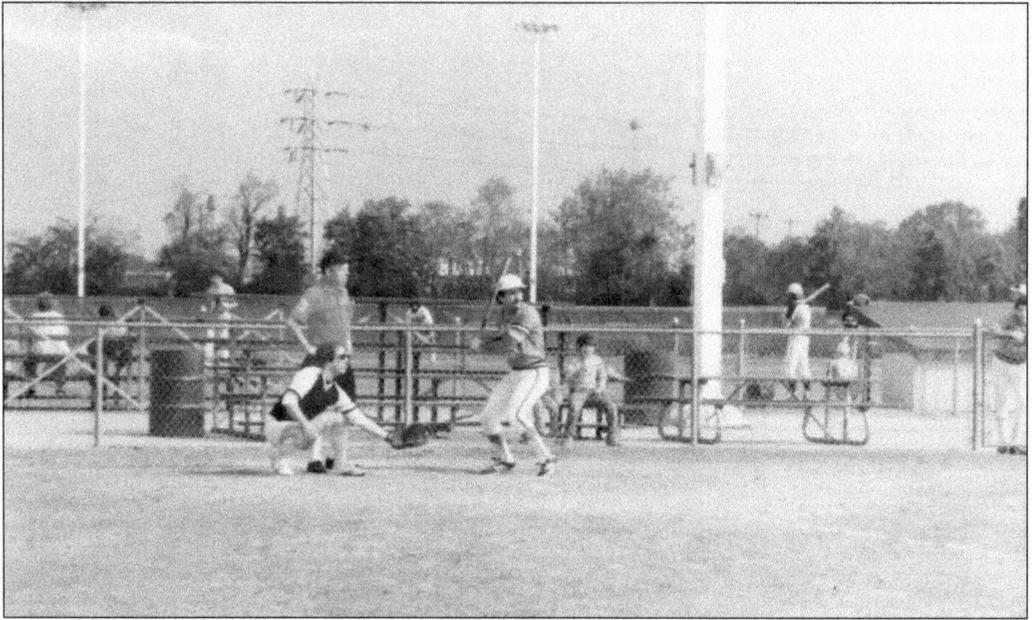

LEARNING TO PLAY BASEBALL. Chaldeans in America, just like those in the United States, began to view sports as a natural outlet from a long and tiring day of work. For many new immigrants, baseball is a foreign sport, unlike soccer, which is an international game played all over the world. Here, Chaldeans from the area of Seven Mile Road and Woodward Avenue play baseball on the Michigan State Fairgrounds in the early 1980s. (Courtesy of Tom Kyriakoza.)

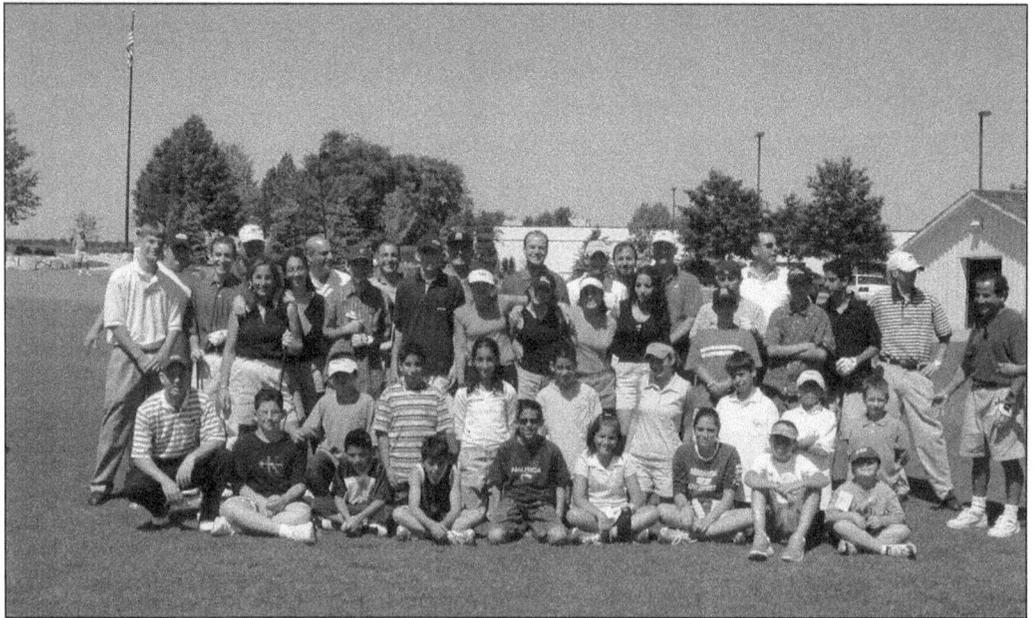

PARENT-CHILD GOLF TRIP. The board of directors of the Chaldean Iraqi American Association of Michigan (CIAAM) sought the value of investing in the future by teaching youths the basic skills and techniques of golfing. In an effort to promote and support the sport of golf at Shenandoah Country Club, Doug Saroki (a CIAAM member and golfer), organized this golf trip for 40 to 50 kids and their parents to Big Rapids at Ferris State University in 2001. (Author's collection.)

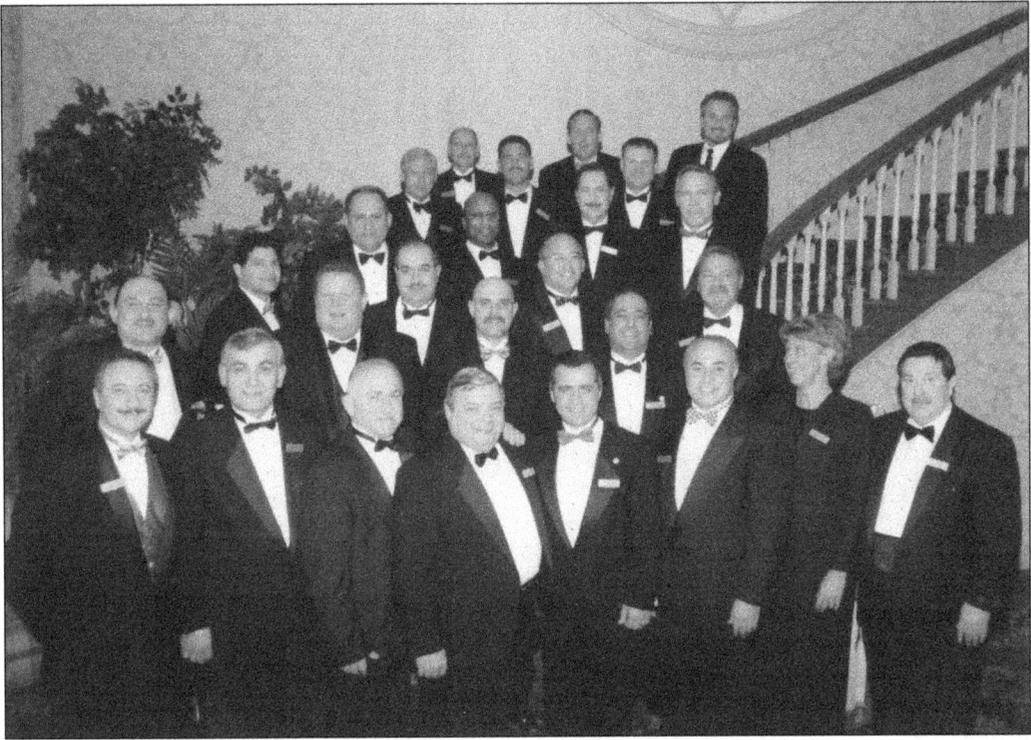

BLACK-TIE EVENT. The Associated Food Dealers (AFD) hosts an annual dinner event to award their dedicated members and associates. The AFD was founded in 1916 to service food and beverage retail stores. With a strong membership base, the AFD continues to be an effective lobbying power in Lansing. Since its establishment, it has merged with gas station retailers and is currently called the Associated Food and Petroleum Dealers (AFPD). Its new office is located in West Bloomfield, with Auday Arabo serving as the chief operating officer. (Courtesy of Jerry Yono.)

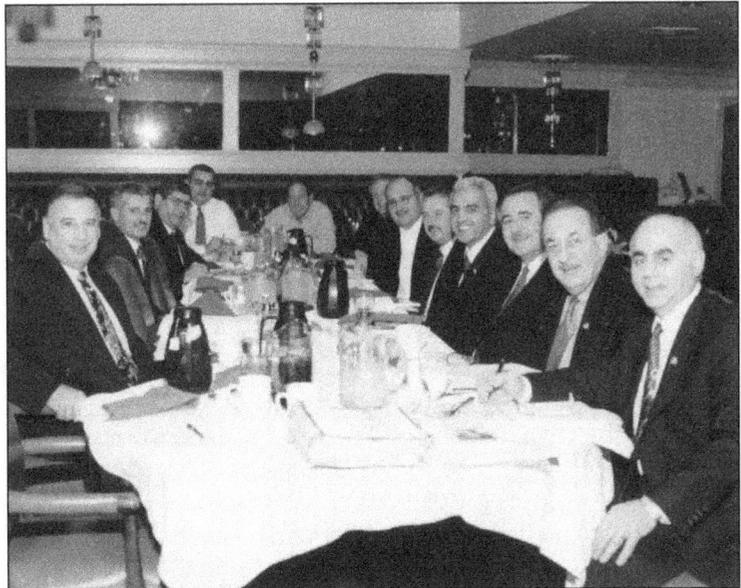

CHECKS AND BALANCES. A knowledgeable team with diverse backgrounds is what makes a successful organization or club. Pictured here is the CIAAM Board of Directors meeting held at Southfield Manor in September 2002. The meeting was about the consequences of closing the golf course during the construction of the new Shenandoah Country Club. (Author's collection.)

**CIAAM, THE MOTHER OF ALL ORGANIZATIONS.** After many failed attempts to establish a club in 1937, 1941, and 1942, a general membership meeting was held at Danish Hall in Detroit on April 24, 1943. "On that night, the membership meeting resulted in electing 12 members to the Board of Directors, with Zia Nalu being the first president," stated author Sam Dabish in his book *The History of the Iraqi Community in America*. It took more than 20 years to buy four acres of land in Southfield. With the support of many community leaders and the personal involvement of Michael J. George, Southfield Manor, a 24,000-square-foot building, was constructed and opened in 1981 (pictured here). The facility included banquet halls, meeting rooms, a dining room exclusively for members, and a library. (Author's collection.)

**THE PRIDE OF THE CHALDEANS.** The new Shenandoah sits on 147 acres of land in the heart of West Bloomfield with an 18-hole public golf course. Shenandoah also used the model of its preceding club, Southfield Manor (sold to Comcast in 2004). Both clubs have strived to preserve the core values of the Chaldean culture and are the result of the members' social and cultural bond. CIAAM members are the stockholders of Shenandoah Country Club. It was ranked as one of the top dining establishments in the state. (Art by Betty Trombetta.)

SOAKING UP CULTURE. The Chaldean Cultural Center (CCC) is a nonprofit organization that will serve the community by preserving and showcasing the history, traditions, arts, and culture of the Chaldean people from ancient times to the present. The organization has done so by designing a small cultural center and museum that will house authentic and replicated artifacts, multimedia presentations, hands-on activities, and immersive environments for visitors of all ages. It will consist of five galleries that serve as a time line, which begins in ancient Mesopotamia and tells the powerful stories of Chaldean religion, immigration, and who the Chaldeans are today. The center is currently within Shenandoah Country Club in West Bloomfield and is expected to open in the spring of 2015. The future plans of the much-expanded cultural center (pictured here) are under way and yet to be determined. (Courtesy of Victor Saroki & Associates.)

THE CHALDEAN RESOURCE. The Chaldean American Chamber of Commerce (CACC) is a business outreach organization that connects Chaldeans with non-Chaldean businesses and professionals. Representing over 1,000 businesses, its membership serves as a resource for the Metro Detroit community in regard to issues such as assistance for refugees and global collaboration. The CACC holds many events, such as annual dinners, golf outings, and luncheons. The Chaldean Community Foundation (CCF) is the charitable arm of CACC. The CCF is a non-profit with many services offered, including refugee sustainability and training, housing, job search, and teaching English as a second language, in addition to free, limited health-care services and immigration support. (Author's collection.)

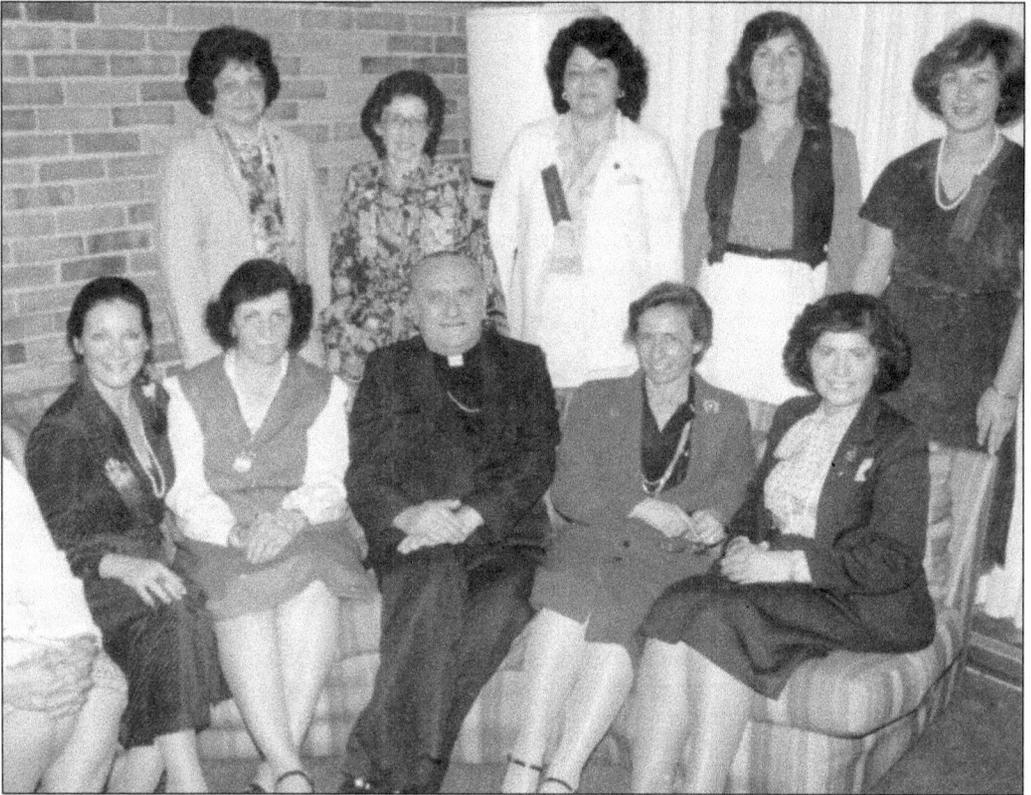

**WOMEN OF GOOD WILL.** The Chaldean American Ladies of Charity (CALC) was founded on May 9, 1961, in Detroit. The founding members were Mary Dabish, Margaret Sarafa, Norma Karmo, Alice Yono, and Jamila Thomas. The CALC is known to be one of the oldest Chaldean community organizations, and it still adheres to the same mission: working together to provide help for those in need through education, and advice and providing emotional and economic support. The founding members are pictured here with Bishop George Garmo in the 1970s. (Courtesy of Jane Shallal.)

**THE VOICE OF TRUTH.** *Kala Kildaya* is Aramaic for "Chaldean voice." The *Chaldean Voice* radio program was born in Detroit in February 1980. It played a major role in connecting Chaldean people from all over the world by broadcasting news, activities, and international news. It broadcasts every week to Sourath- and Arabic-speaking listeners as "the voice of the Christian Catholic faith," spreading the gospel of faith and love through preaching. The program receives funding from listener support and donations. Pictured here are Saher Yaldo (on computer) and Showki Konja (handling paperwork). (Courtesy of Saher Yaldo.)

HOME FOR RETIREES. Chaldean Manor, in Southfield, is a home for the independent senior community. It was built in 1997 and has 63 apartments. Many residents live next door to a relative or friend; residents socialize, share home-cooked food, participate in games (volunteered by organizations), and walk to church (Mother of God) in the same complex. "Placing an elderly parent in a nursing home is quite rare among Chaldeans," said Dr. Mary Sengstock. In fact, in the minds of many Chaldeans, it is regarded as shameful. (Courtesy of Saher Yaldo.)

FOSTERING THE FAITH. The Eastern Catholic Re-evangelization Center (ECRC) has focused on increasing the awareness of Jesus Christ since 2001. The center continually fulfills the mission of evangelizing the Catholic faith through financial grants from the Chaldean Diocese and support from the bishop and the community. The ECRC offers 25 different programs throughout the year for youth and adults. Pictured from left to right are the three founding members, Karam Bahnam, Neran Karmo, and Fr. Frank Kalabat (now bishop). (Author's collection.)

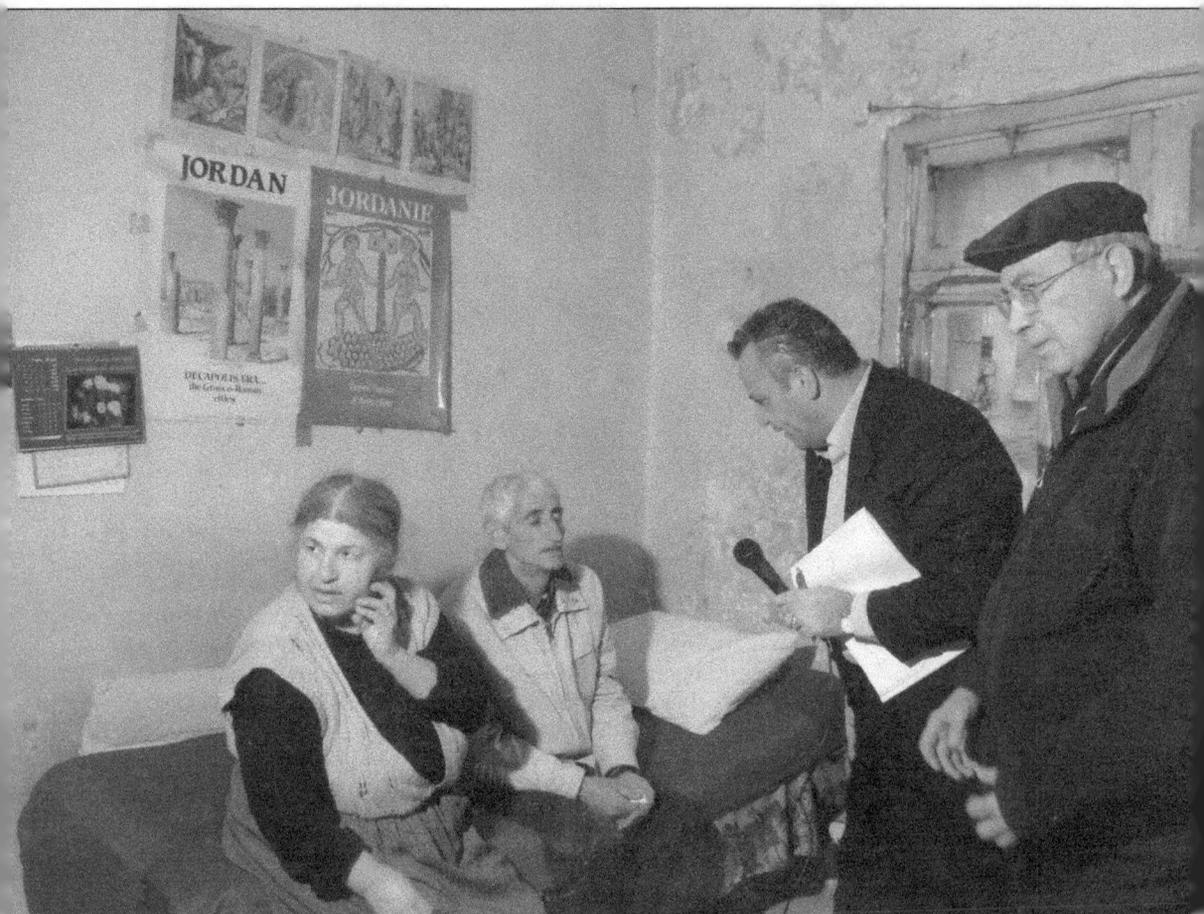

**PAYING IT FORWARD.** A refugee is one who is left homeless by war or persecution. The mission of the Adopt-a-Refugee Family Program, run completely by volunteers, is to administer financial aid to Christian refugees suffering from violence, hunger, homelessness, and poverty forced upon them because of their religious beliefs. Since 2007, through the generosity of donors, the program has helped thousands of displaced Christians escape persecution and strive to regain a sense of normalcy in their everyday lives. The program has sent over $1 million in 2014 to over 850 families in Syria, Jordan, and Lebanon. Most refugees await permanent resettlement for years, hoping to go to a stable country such as the United States, Canada, or Australia. Unable to legally work or even send their children to school, these refugees are caught in a hopeless state of limbo. Here, program chairman Basil Bacall listens to a struggling family in Jordan with Jesuit priest Yousif Burby. (Courtesy of the Adopt-a-Refugee Family Program.)

# Nine

# NEW CHALDEANS OF AMERICA

The growth and progress of the Chaldean community is amazing in many different areas, ranging from businesses, education, and career development to building a flourishing community and maintaining a sense of culture.

Many contributing factors keep the Chaldean community growing together and helping one another. One is the Bank of Michigan, which serves the needs of community businesses that were flushed out by other banks. The Chaldean American Chamber of Commerce, with Martin Manna acting as chief operating officer, takes the lion's share of credit for educating elected officials on the importance of the Chaldean business community. Its annual awards dinner attracts so many politicians that it is somewhat of a miniature US Senate floor on the night of the "State of the Union" address. There is also *The Chaldean News*, a monthly magazine printed in English that serves as a way for readers to stay informed about political, business, social, and entertainment news in the community.

The vast majority of the first and second generations of American-born Chaldeans embrace their parents' culture and heritage. Traditional Chaldean foods, music of all kinds (including Arabic and Chaldean), and dances like the khigga are still enjoyed by most Chaldean Americans, including the younger generations. The annual Chaldean Music Festival draws members from all parts of the community.

At the Chaldean Cultural Center in West Bloomfield, scheduled to open in 2015, visitors will be able to appreciate images, exhibits, and original artifacts that pay respect to the roots of the Chaldean culture and tell their story from ancient Mesopotamia to the present day.

Today's younger generation can only appreciate and give great tribute to the early Chaldean pioneers who chose America as their new home. The generations that have followed have become increasingly successful in both entrepreneurial pursuits and professions like medicine, law, accounting, and teaching.

It is a pleasant surprise to see the growing number of Chaldeans born in America who are joining the priesthood. Ordained in 2004, Andrew Younan is the first American-born Chaldean priest. Currently, there are at least six Chaldean priests serving in the Chaldean churches of Metro Detroit, and seven more are studying in the Chaldean seminary.

In all regards, the Chaldean community has a promising future in one of the greatest countries in the world: the United States of America.

POLITICAL CLOUT. As the Chaldean community's population and influence grew in the 1990s, politicians and political parties increasingly sought its support. In the summer of 2002, Chaldean American leaders and businesspeople met at Southfield Manor with Michigan Democratic Party chairman Mark Brewer (center), along with members of the Arab American community. (Author's collection.)

PATRIARCHAL VISIT. In June 2002, the Chaldean patriarch of Babylon visited the United States. Detroit has always enjoyed the top spot on the patriarch's visitation list. Southfield Manor, the Chaldean social and cultural club, always held a dinner reception in his honor. Mar Raphael I Bidawid, is seated in the center. After dinner, guests approached his table to greet him and kiss his ring as a sign of respect. (Courtesy of Najib Karmo.)

PROUD MEMBERS, OLD FRIENDS. Enjoying a dinner in Southfield Manor's member dining room in 1999, Baghdad College alumni and Jesuit graduates were joined by active members of the club bulletin committee. From left to right are Frank Konja, Dr. Ramzi Jiddo, Dr. Mishtak Abbou, David Nona, Dr. Adhid Miri, and Eddie Bacall. (Author's collection.)

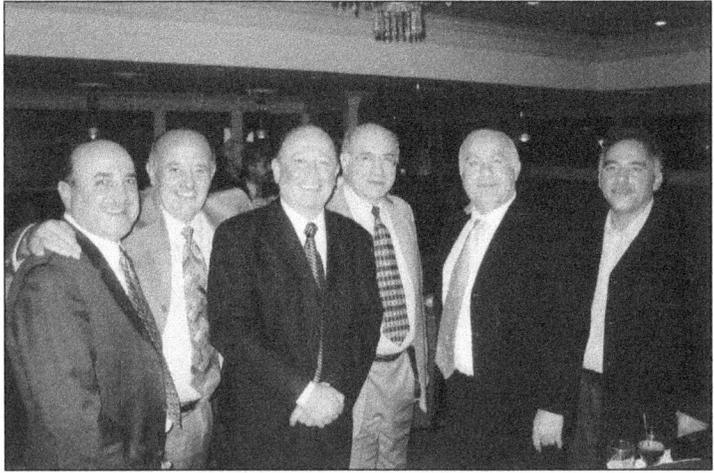

THE GRAND OPENING. *"Youma Tarikhinaya Ta-umm de-ian kildaya,"* in Aramaic translates to "it is a historical day for the Chaldean people!" That was the opening line of the speech at the ground-breaking ceremony for the new Shenandoah Country Club on October 10, 2002, by its president, the author of this book, Jacob Bacall. Pictured here is the traditional ribbon-cutting at the grand opening of Shenandoah in the spring of 2005. Standing behind the big blue bow are Michael George, a charismatic and instrumental community leader, the CIAAM Board of Directors, and Comerica Bank chairman and CEO Ralph W. Babb Jr. (second from left). (Author's collection.)

THE DOCTORS ARE IN. Karl and Julie Kado immigrated to the United States from the northern villages in Iraq in the early 1970s. They met in a college class at the University of Detroit in 1976 and got married in 1978. The newlyweds felt it was a calling from God to have 12 children; only nine survived. The first six children, Rachel, Herman, Jessica, Julie, Karl Jr., and Jenna, are all medical doctors who graduated from Wayne State University. Kimberly, the seventh child, is in her first year of medical school; Stephanie, the eighth, is in her senior year as a pre-med major; and the last child, Nicole, is a junior pre-med major. Pictured here is the Kado family cheering at Karl Jr.'s graduation in 2011. (Courtesy of Karl and Julie Kado.)

ENGAGEMENT CELEBRATION. *Tanitha* means "promise," when the groom has proposed and the bride has accepted. A celebration is usually held at the bride's home with family, relatives, and friends. With a priest's blessing, engagement rings are exchanged. The groom's family brings flowers and candles, along with large platters of sweets and nuts. It is a custom and tradition for the family of the groom to pay for all wedding expenses—almost never the bride's family. (Author's collection.)

PRESERVING CULTURAL TRADITION. This is an example of a Chaldean tradition being passed down from generation to generation. Simone Oraha follows in her grandmother Anne Bacall's footsteps in a pre-wedding *henna* party. A henna party includes henna paste, which is applied to the palm of the hands and leaves an orange stain lasting about two weeks, symbolizing good luck and fortune to the newlyweds. Simone and Anne are each dressed in a *galabia*, a long, colorful gown with elaborate embroidery and embellished with decorative gold and silver coins and beading. (Author's collection.)

FRIENDS NIGHT AT SHENANDOAH. On Tuesday nights, there is eating, drinking, and *narghila*, the preferred choice of smoking, in this relaxed atmosphere. Narghila smokers choose the flavored and fragrant tobacco of their choice. In the 1844 memoir of Maria Theresa Asmar, she refers to narghila as the "most commonly in use among the ladies of Mesopotamia." Pictured from left to right are Dr. Shakib Halaboo, Dr. Raad Kasmikha, and Francis Boji enjoying life. (Author's collection.)

DETROIT'S NEW ADDITION. Music has tremendous power to connect people around the world. The Motor City earned its reputation of great musical enterprise with many music festivals, creating sounds of hip-hop, country, Motown, rock n' roll, rhythm and blues, and jazz. The annual Chaldean festival brought Middle Eastern music, dance, and food, adding a new, diverse culture to Detroit. (Courtesy of Martin Manna.)

MEET THE MAYOR. The Chaldean festival is held annually in the summertime at the Southfield city grounds. Here, Brenda Lawrence, the mayor of Southfield, gladly participates in the Chaldean festival in August 2008. It draws thousands of people from all over the state of Michigan. Pictured from left to right are Ramzi Kas-Gorgis, Samir Shukri, Nabil Roumayah, Mayor Lawrence, Dr. Jacob Mansour, Adel Petros, and Augeen Kalasho. (Courtesy of Nabil Roumayah.)

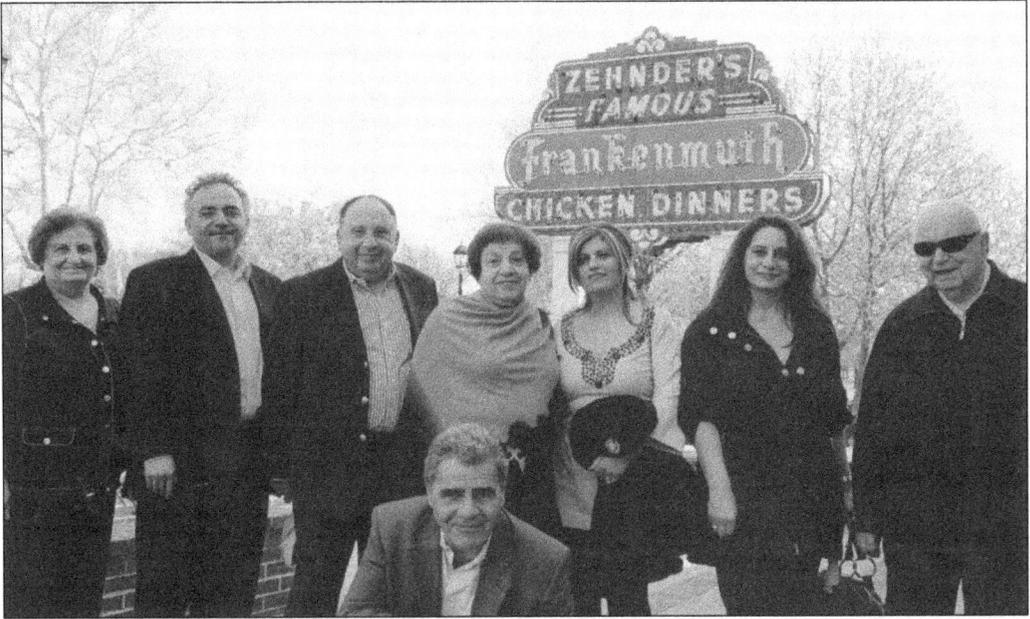

**SOUTHERN CHALDEANS.** A tight-knit Chaldean community resides in Knoxville, Tennessee: the Mishus, a collection of about 20 families. They frequently visit their friends and relatives in Michigan to participate in weddings, funerals, anniversaries, and special music concert appearances in Detroit. Pictured here are the Mishus with friends in front of the century-old Frankenmuth landmark in the 2000s. (Author's collection.)

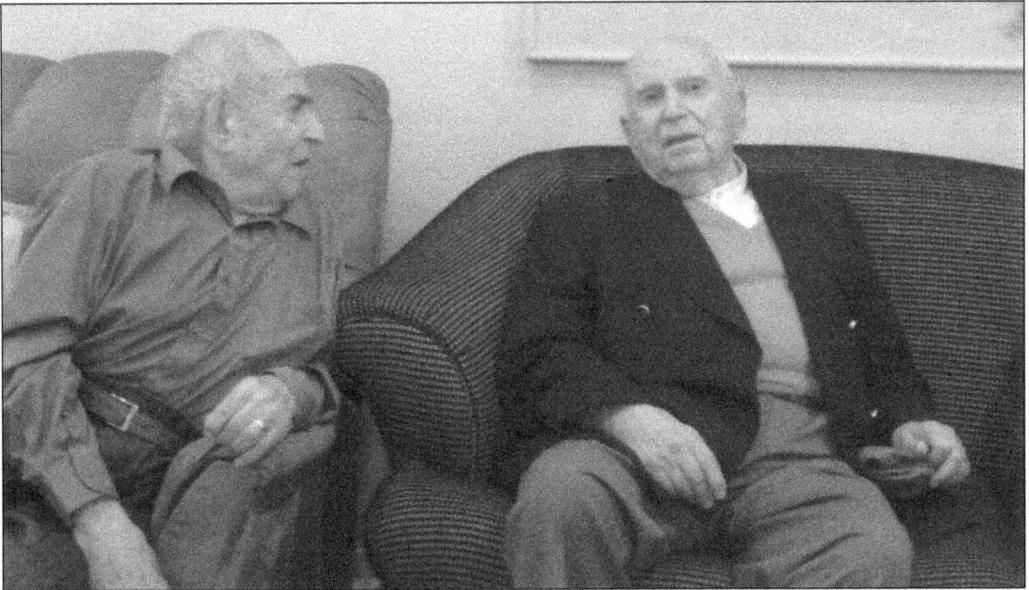

**OLD-TIMERS.** Fuad Mishu of Knoxville (right) visits with longtime friend Yousif Kiryakoza at the latter's Commerce Township home. Both men were more than 90 years old in 2012. They lived through the consequences of the British occupation of Mesopotamia in 1917 and watched from afar the American-led invasion (2003) that befell Iraq. The discussion between the two men went on about how history repeats itself and how it has tragically impacted the Iraqi minorities. (Author's collection.)

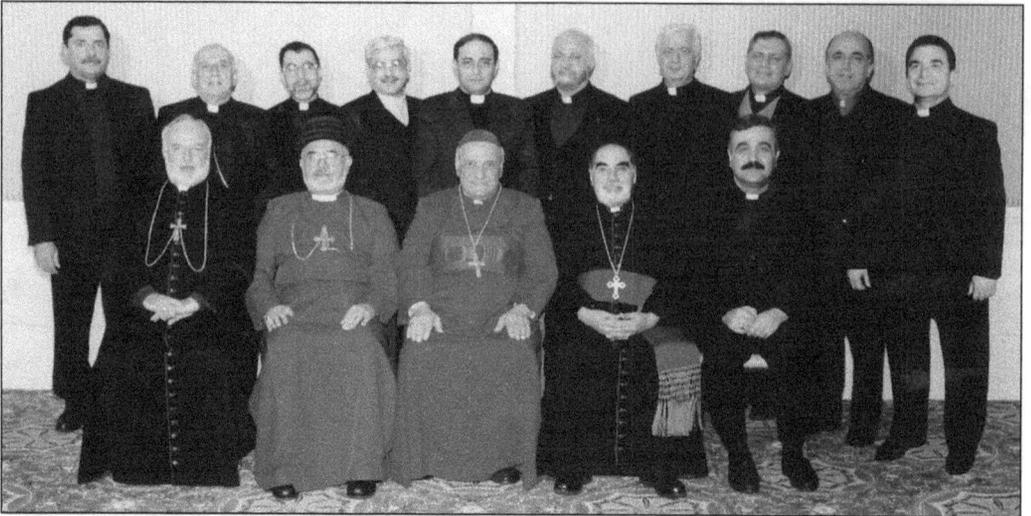

**NEVER LOSE HOPE.** For almost five centuries, and for the first time in America, on November 22, 1996, a meeting was held between Chaldean patriarch Raphael Bidawid of Babylon and Assyrian patriarch Dinkha IV of the Assyrian Church of the East, along with other clerics from both churches. Fr. Sarhad Jammo (now bishop) invited both churches for the consecration of his new St. Joseph Chaldean Church in Troy. The meeting to reunite both churches led to another meeting in Chicago the following year, where historical agreements were signed between the sister churches. After many attempts at unity, there is still hope that one day both churches will reunite. (Courtesy of Raad Kathawa.)

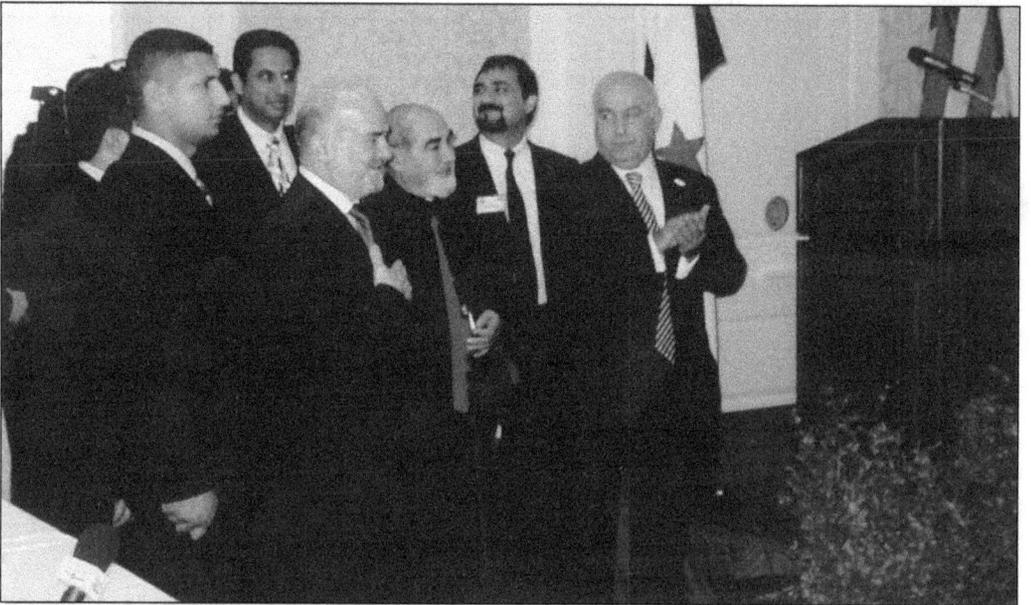

**IRAQI PRIME MINISTER VISITS CHALDEANS.** Since the fall of Saddam Hussein, Prime Minister Ibrahim Al-Jaffary, Iraqi parliament chairman Al-Najeefy, and many government ministers have visited Detroit. In this photograph, Prime Minister Al-Jaffary meets with Chaldean community leaders and activists at Shenandoah Country Club in West Bloomfield. One of the most heated topics that arose was the Christian cleansing in the Arab world, specifically the extinction of Chaldeans in Iraq despite the 6,000 years of history in Mesopotamia. (Author's collection.)

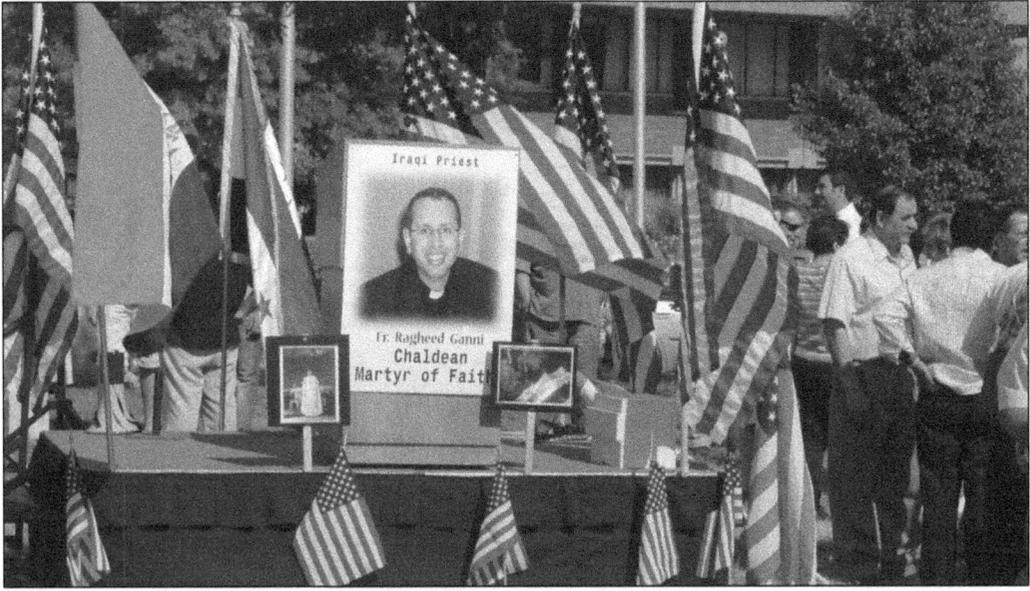

**MARTYRS OF FAITH.** On June 10, 2007, as the midday Mass at Holy Spirit Church in Mosul, Iraq, ended around 12 p.m., Fr. Ragheed Ganni and three deacons who served with him were getting ready to exit the church. As they were leaving, in broad daylight, four gunmen sprayed them with bullets, leaving the bodies lying in the street for hours after the attack, with no one in sight. Muslim extremist insurgent groups were accused of the killing, but no one was ever brought to justice. (Courtesy of Saher Yaldo.)

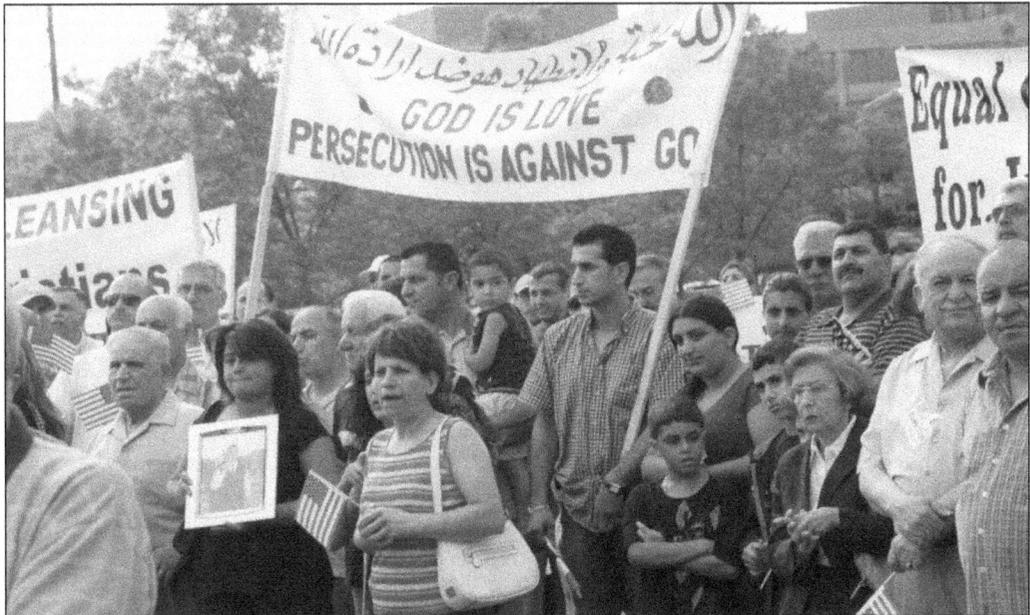

**MARCHING FOR PEACE.** The Chaldean community in Michigan held a rally in the city of Southfield to protest against the bombing of churches and the killing of priests and bishops in the major Iraqi cities of Baghdad, Mosul, and Basrah. According to a United Nations estimate, two-thirds of Iraqi Christians have fled since the American-led invasion of Iraq in 2003; the largest Chaldean migration ever in Chaldean history. (Courtesy of Saher Yaldo.)

JUDGE OF JUSTICE. Judge Diane Dickow D'Agostini is a first-generation Chaldean American, the daughter of Salim and Suham Dickow. Like others, her parents came to America in pursuit of the freedoms and opportunities that this great country shines upon all immigrants. Diane displays great respect for the position and the people she serves, ensuring justice and accountability for all. She also devotes much of her time to educating youth about the dangers of drug use and its consequences. (Courtesy of Burt Kassab.)

"KLINT FOR STATE REP." At least two other young Chaldeans ran for state representative but fell short of needed votes, with luck not going toward the direction of their stream. But, the Chaldeans of Michigan are proud to see young, energetic attorney Klint Kesto now occupying the seat of the 39th House District of Michigan. With a strong background in community involvement, Kesto continues to inspire other young Chaldeans to follow his lead. (Courtesy of Klint Kesto.)

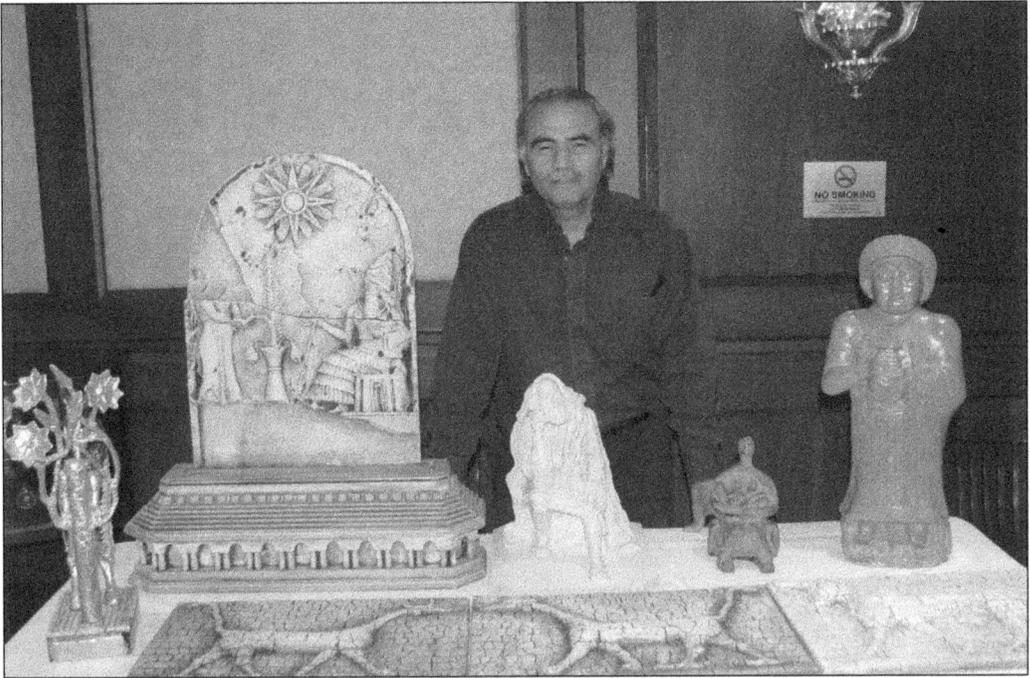

**WORKS OF ART.** One of the founding members of the Chaldean Association of Fine Arts (CAFA), Chaldean artist Sabah Wazi was born in the town of Alqosh, a northern village of Mosul, Iraq. He specializes in sculptures of Mesopotamia and paintings displaying the culture of the Babylonians, Assyrians, and Chaldeans. He has won several awards. Wazi has participated in many galleries and exhibitions throughout the United States. When 20,000 original artifacts were stolen from the Iraqi museum in Baghdad, Wazi decided to replicate the items of lost history. "To make a copy of each stolen piece as a possible replacement will take me three to five lifetimes . . . and that is a copy . . . without the age history of the artifacts," said Wazi. (Courtesy of Sabah Wazi.)

**CELL PHONE REVOLUTION.** *The new Chaldeans of America are more interactive with technology. "The wireless gold rush is not over yet," said Saber Ammori, the CEO of Wireless Vision.* Launching their business in 2004 in a small office space with only five employees, Wireless Vision is now the largest T-Mobile premium retailer in America, and it is still expanding. Ammori has almost 200 mobile stores operating in 13 states across America. With the recent acquisition of Catcorp Company, Wireless Vision is one step ahead in furthering the growth of the company. (Courtesy of Miranda Jarjosa and Wireless Vision.)

**PAPAL APPROVAL.** November 24, 2007, was a special and historical day for Chaldeans. The Papal Consistory elevated Mar Emmanuel III Delly, the Chaldean patriarch, and 22 other bishops to be cardinals. The ceremony included the full regalia of Vatican traditions. Chaldeans from all over the world traveled to St. Peter's Square in Rome to celebrate the historical event. (Author's collection.)

**LIVING TO SERVE.** For someone to dedicate his or her entire life to the Christian faith is a complex decision; it also involves a crossroads of emotions for the family members involved. In March 2010, Adnan and Zuhoor Foumia and their two sons watch their only daughter, Amanda, be ordained as Sister Mary Christine at Mother of God Church. She dedicated herself to fully serve the needy, the sick, and the unfortunate. (Courtesy of Saher Yaldo.)

**AL-QASR AL-GUMHURIY, THE REPUBLIC PALACE, BAGHDAD, IRAQ, 2003.** Chaldean activists involved from various organizations from the Detroit area visited the office of deposed Iraqi president Saddam Hussein. The Mercedes-Benz is waiting, but Saddam is not in it; he was long gone but had not yet been found. Pictured from left to right are Fr. Philip Najim, Showki Konja, Steve Garmo, Dr. Ramzi Jiddou, Fawzi Dalli, Joseph Kassab, Bishop Ibrahim Ibrahim, and Dr. Noori Mansour. (Courtesy of Saher Yaldo.)

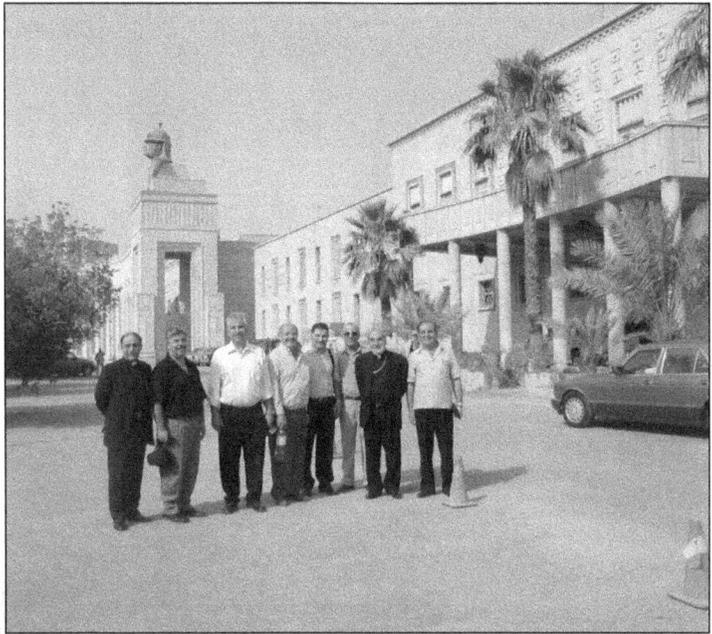

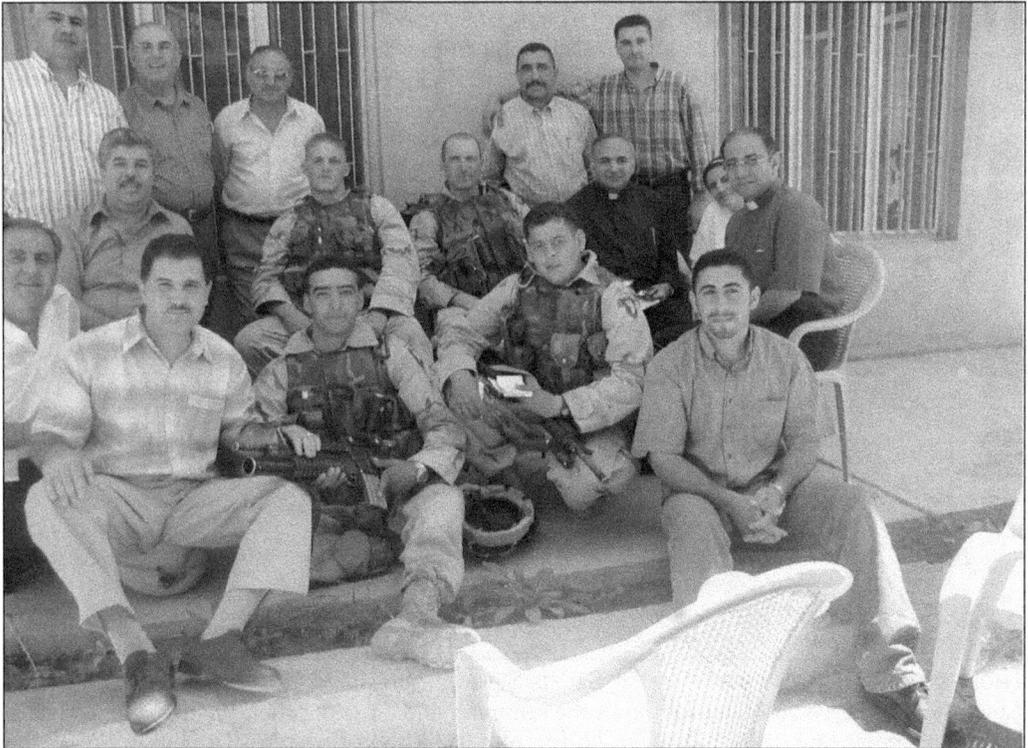

**HUMANITARIAN MISSION IN IRAQ.** Chaldean activists and church leaders from Detroit visited Baghdad, Mosul, and Basrah after the fall of Saddam Hussein in March 2003. Pictured here is the missionary team offering humanitarian assistance to the needy, sitting with locals and US soldiers from the 2nd Cavalry Regiment. These soldiers stopped to greet locals during their patrol in the village of Telkaif. (Courtesy of Saher Yaldo.)

**IF YOU FEEL CALLED BY GOD, REACH FOR CHALDEAN SISTERS.** The Ordination of Chaldean Sisters was founded in Baghdad in 1922 under the leadership of Patriarch Yousef VI Emmanuel II Thomas, the Chaldean patriarch of Babylon. Their order in Michigan is one of the 27 provinces in the world. The sisters continue to be available for loving service through ministries of education and social services. Here, they stand with Mar Ibrahim N. Ibrahim (center) on December 8, 2013, at Our Lady of Perpetual Help Church in Warren. (Courtesy of Saher Yaldo.)

**THOSE WHO BELIEVE IN HIM SHALL BE SAVED.** Several young Chaldean men born and raised in America felt their vocation: enrolling in the seminary and devoting their life to the priesthood. Since the appointing of Rev. Ibrahim N. Ibrahim as bishop of Eastern Rite Catholics in the United States in 1982, at least nine churches have been built and 10 priests have been ordained. Pictured here is the ordination ceremony of Fr. Andrew Seba (center, in a white and black robe) in June 29, 2013. Surrounding him are recently ordained Chaldean priests and seminarians with Chaldean clergymen and Bishop Ibrahim at Mother of God Church in Southfield. (Courtesy of Saher Yaldo.)

# BIBLIOGRAPHY

Asmar, Maria Theresa. *Memoirs of a Babylonian Princess: Volume I and Volume II*. London, UK. Henry Colburn, Publisher, 1844.

Bak, Richard. *The Story of Ethnic Detroit: Metropolitan Detroit Guest Guide*. Royal Oak, MI. Hour Media, LLC, 2001.

Bazzi, Michael. *Tilkepe: Past and Present*. Mosul: Gumhuria Printing (Arabic Edition), 1969 and 1991 editions.

Chaldean American Ladies of Charity. *Ma Baseema*. Ann Arbor: Huron River Press, 2010.

Dabish, Sam (Shamoun). *The History of the Iraqi Community in America*. Baghdad: The Iraqi Printing Press (Arabic Edition), 1975.

Gill, Anton. *The Rise and Fall of Babylon*. New York: Metro Books/Quercus Publishing Plc, 2011.

Hassoun, Amer Bader. *The Book of Iraq*. Damascus: Al-Akha Printing (Arabic version), 1995.

Mazour, Anatole and John Peoples. *Men and Nations: A World History*. New York: Harcourt Brace Jovanovich, Inc., 1975.

*Metropolitan Detroit Guest Guide 2001*. Detroit: Hour Media, LLC, 2001.

Munier, Gilles. *Iraq: An Illustrated History and Guide*. Northampton, MA: Interlink Publishing Group, Inc., 2004.

Nasrallah, Nawal. *Delights From The Garden of Eden*. Bloomington, IN: 1st Books Library/Author House Publishing, 2004.

Perry, Bryon. *The Chaldeans*. Troy, Michigan: Tepel Brothers Printing Company, 2008.

Porter, Emily. *Memoirs of Maria Theresa Asmar: An Iraqi Woman's Journey into Victorian England*. Aman: Fadaat for publishing and distribution, 2009.

Rassam, Suha. *Christianity in Iraq*. Herefordshire, UK: Action Publishing Technology, Ltd., 2005.

Saroki-Sarafa, Josephine M. and Julia Najor-Hallahan. *The Chaldean American Community*. Oak Park, MI: Eastern Graphics and Printing.

Sengstock, Mary C. *Chaldeans in Michigan*. East Lansing, MI: Michigan State University Press, 2005.

Stephen, Louis J. "The Chaldean Directory." Eastpoint, MI: Nu-Ad Inc., 1998 and 2007.

Visit us at
arcadiapublishing.com

www.ingramcontent.com/pod-product-compliance
Lightning Source LLC
Chambersburg PA
CBHW080608110426
42813CB00006B/1446